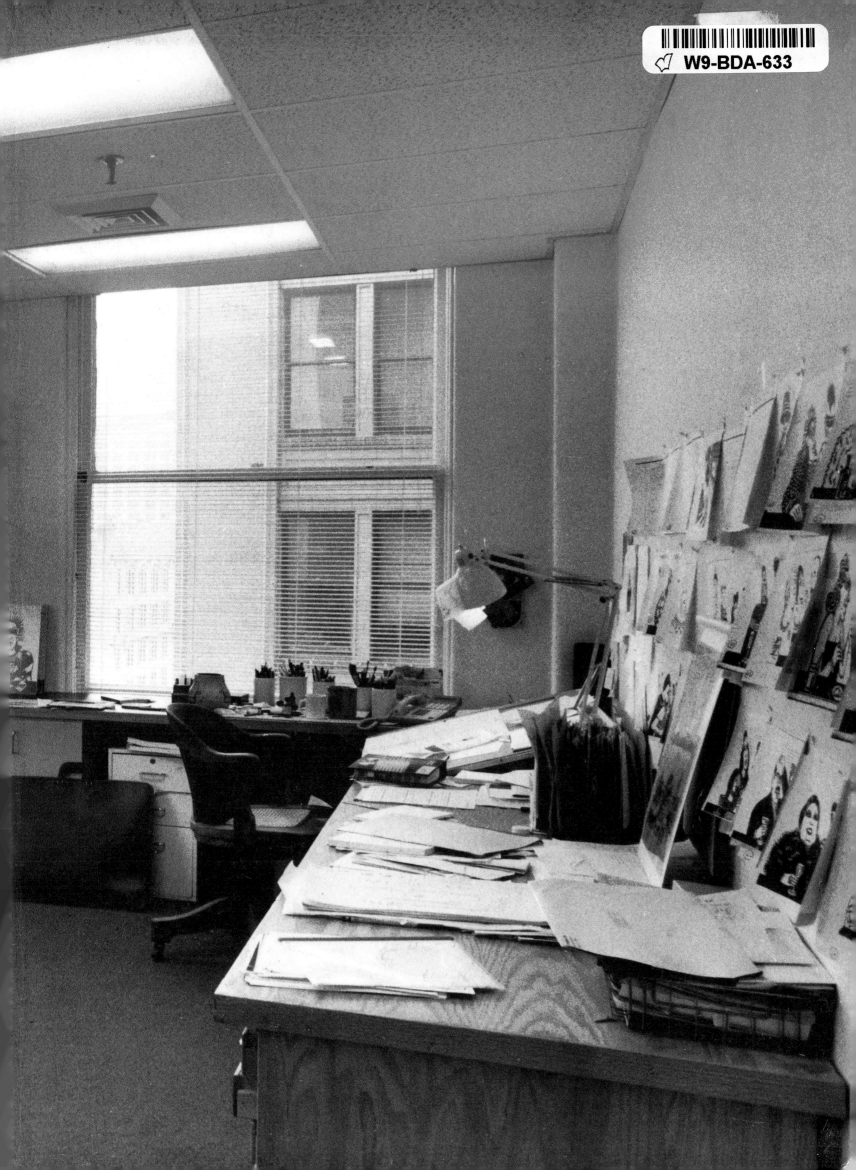

American Illustration|6

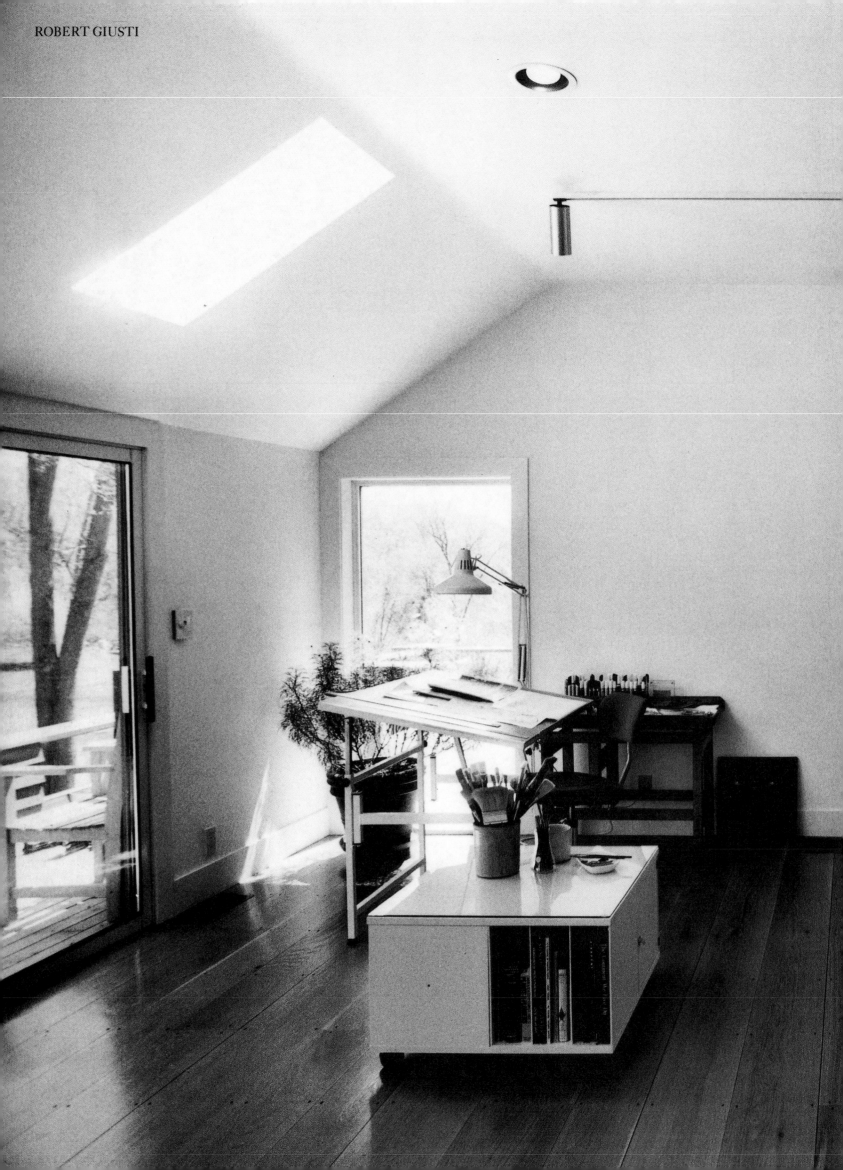

American Illustration |6

*The sixth annual of American editorial, book, advertising,
poster, promotion art, unpublished work and film animation.*

EDITED BY EDWARD BOOTH-CLIBBORN

BOOTH-CLIBBORN EDITIONS

PROJECT DIRECTOR: *Donna Vinciguerra*
BOOK DESIGNER: *Walter Bernard*
ASSOCIATE DESIGNER: *Colleen McCudden*
PROJECT ASSISTANTS: *Rosalie Winard, Susan Willmarth,*
John Labbé
COPY EDITOR: *Tita Dioso Gillespie*
MECHANICALS: *Brian D. Brege, Anne C. Fink*
FRONT END PAPER PHOTOGRAPH: *Jonathan Atkin*
BACK END PAPER PHOTOGRAPH: *Elton Robinson*
TITLE PAGE PHOTOGRAPH: *Arthur Meyerson*

*Captions and artwork in this book have been supplied by
the entrants. While every effort has been made to ensure
accuracy, American Illustration, Inc., does not under any
circumstances accept any responsibility for errors or
omissions.*

*If you are a practicing illustrator, artist, or
student and would like to submit work to the next annual
competition write to:*
AMERICAN ILLUSTRATION, INC., 67 IRVING PLACE
NEW YORK, NEW YORK 10003 (212) 460-5558

*American Illustration, Inc., Call for Entries
Copyright © 1987 American Illustration, Inc.*

*Distributed in the United States of America
and Canada by:
Harry N. Abrams, Inc., 100 Fifth Avenue
New York, NY 10011
ISBN 0-8109-1870-6*

FRANCE BOOK DISTRIBUTION:
*© 1987, Sté Nouvelle des Éditions du Chêne, Paris
pour l'édition en langue française
ISBN: 2.85108.531.X
Dépôt légal: n° 5186–octobre 1987
34/0692/3*

*Book trade in the United Kingdom by:
Internos Books, Colville Road
London W3 8BL England*

*Book trade for the rest of the world:
Hearst Books International, 105 Madison Avenue
New York, New York 10016 USA*

*Direct mail, world:
Internos Books, Colville Road
London W3 8BL England*

*Direct mail USA, Canada:
Print Books, 6400 Goldsboro Road
Bethesda, MD 20817*

Published by Booth-Clibborn

Printed and bound in Japan

*Copyright © 1987 Polygon Editions
S.A.R.L., Basel, All rights reserved.*

Contents

The Jury

Ken Kendrick

Ken joined the Image Group in December 1986 after a position at BBDO where he worked on Diet Pepsi and Dupont television. Before that, Ken served as senior art director for news at The New York Times and as art director of its magazine section.

He has also held the positions of creative director for the Spanish International Network and associate art director of New York Magazine. He has been awarded gold medals by The Art Directors Club, The Society of Publication Designers, The Society of Newspaper Design and The Cover Show. His work has been published in America as well as in Japan, West Germany, Poland and Czechoslovakia. He was educated at the University of Georgia and Pratt Institute.

Michael Keegan

Michael is assistant managing editor/news art for The Washington Post. He held the positions of design director and senior editor at The Los Angeles Herald Examiner from 1979 to 1985, taking the newspaper through two major design changes. He spent eight years working at The Minneapolis Tribune and The San Francisco Examiner. His work has been recognized by the New York Art Directors Club, The Society of Publication Design, the American Institute of Graphic Arts and the Los Angeles Society of Illustrators.

Paula Scher

Paula holds a Bachelor of Fine Arts degree from the Tyler School of Art. She worked as art director for CBS Records and designed two new magazines for Time Inc. She wrote and designed two books and is the author of articles on design practice and theory.

As a founding partner in Koppel & Scher, she counts Manhattan/Blue Note Records, European Travel & Life and Swatch Watch U.S.A. among her clients.

She has been honored with gold medals from the Art Directors Club and The Society of Illustrators and with four Grammy nominations from the National Association for Recording Arts and Sciences. She has also been granted awards by Graphics, Print Magazine, Novum Grabrausgraphik and the American Institute of Graphic Arts.

Paula's designs are in the collections of the Museum of Modern Art, the Library of Congress, the Beauborg Museum and the Maryland Institute of Art. She has served on the board of directors of the American Institute of Graphic Arts. She teaches a senior portfolio class at The School of Visual Arts.

Don Ivan Punchatz

After studying at the School of Visual Arts and Cooper Union, Don spent several years as an agency and studio art director. Since he began free-lancing as an illustrator in 1966, he has completed assignments for virtually every national advertising and editorial market.

His "concept determines style" of illustration has won awards and recognition from numerous professional shows and publications. He also continues to exhibit his work at galleries and museums internationally.

Christopher Pullman

Christopher is design manager for WGBH Boston, which produces more than 25 percent of public television's prime-time programming, including "Nova," "Masterpiece Theatre," "Frontline" and "This Old House."

He holds a graduate degree in graphic design from Yale University, where he has also taught for several years. He still maintains that affiliation as a visiting critic.

From 1976 to 1986 Christopher served on the board of the Design Management Institute. At present he is on the national board of the American Institute of Graphic Arts. He has published articles on design for television.

Patricia von Brachel

Patricia is Newsweek's senior art director, responsible for the weekly design of the domestic edition. She has been with Newsweek since 1985. She was art director of New York Magazine from 1981 to 1985. Prior to that, she was art director of Look magazine and associate art director of New Times magazine.

Patricia studied at the School of Visual Arts. She has received honors from The Society of Publication Designers and the Type Directors Club.

Introduction

Welcome to the sixth edition of *American Illustration*.

For the last six years we have, like Rolls Royce, been committed to the pursuit of excellence. Our objective has been to bring together the very best of all that's best in American illustration. Not because we are a club hoping to gain respectability or perfect our prestige, but because we believe that, in a world where money has become a kind of deity, it is important that we take the lead in showing younger illustrators that, while it is easy to be a copyist and thus gain success and riches, it is much harder—yet much more worthwhile—to seek the satisfaction that comes from developing a unique talent.

We have a few simple guidelines which ensure that inclusion in *American Illustration* goes a long way towards encouraging younger people working in our particular field.

To begin with, our selection jury is an independent body, comprising art directors and art editors drawn from right across America. Their selection of work submitted is thus representative of a pan-American view.

The jury is committed to honouring the highest standards of work. Each item submitted is judged on its merit, both as a conceptual idea and on its execution.

The work selected is divided into two sections: commissioned and published work for print and film, and unpublished work. This opens up opportunities for any illustrator to present their work to the jury.

We mount no exhibition of the finished work, preferring to use this annual as a showcase. We believe this is the right way to do things because, in the main, the work selected was conceived for the printed page at the outset.

We always give each item of work a page to itself, and offer no advertising space in the annual. Thus the work gets given the treatment it rightly deserves.

Finally, we offer no awards. We have believed, from the beginning, that inclusion in *American Illustration* is accolade enough. As our standards are of the highest, only the highest standards will be included.

If you are reading this book for the first time, I welcome you. If your work has been included in our annual for the first time, welcome. If you believe that the highest standards of illustration are worth pursuing in America, then welcome again. On every count, I hope you are glad to be here. And, for my part, I hope you will both enjoy the work, and be encouraged to work towards even higher standards next year.

Our principles remain the same: to collect together the best work each year, judged in the light of unbiased opinion. It is that which, I believe, gives us the right truly to call this annual *American Illustration*.

Edward Booth-Clibborn

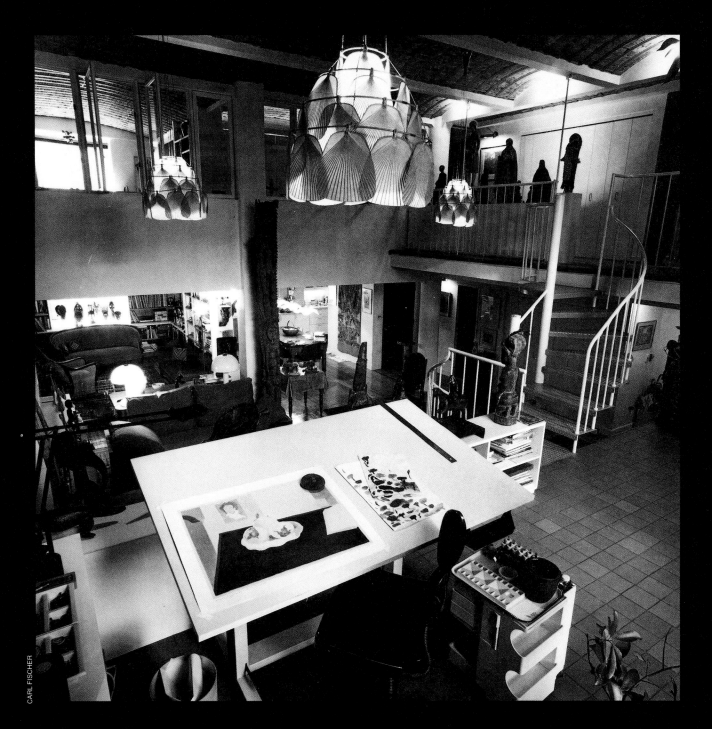

CARL FISCHER

MILTON GLASER

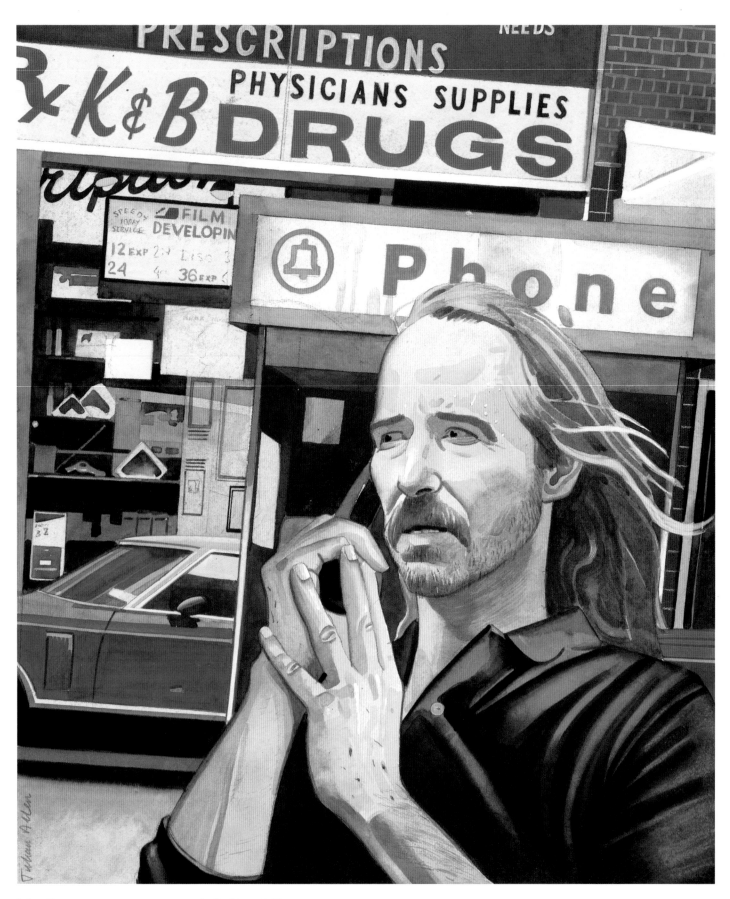

ART DIRECTOR
Derek Ungless

DESIGNER
Raul Martinez

PUBLICATION
Rolling Stone, April 24, 1986

PUBLISHING COMPANY
Straight Arrow Publishers, Inc.

WRITER
John Phillips with Jim Jerome

Julian Allen

In an ironic episode ("Nailed") from his autobiography, John Phillips, suffering from drug withdrawal, uses a drug store pay phone to locate his drug dealer; he is unsuccessful. However Julian Allen is successful in portraying Phillips's feelings. Medium: Gouache.

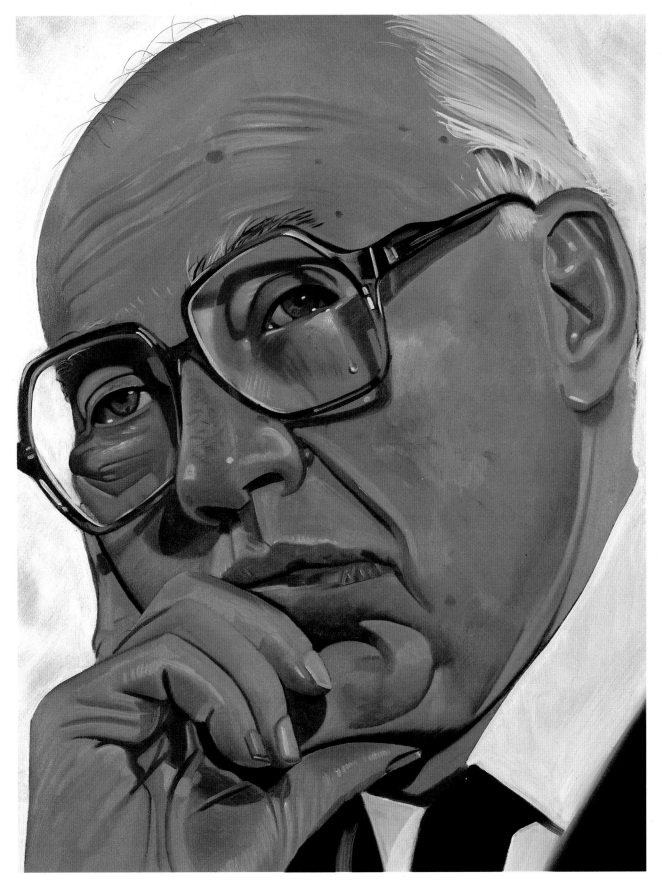

ART DIRECTOR/DESIGNER
Fred Woodward
PUBLICATION
Regardie's, April 1987
PUBLISHING COMPANY
Regardie's Magazine, Inc.
WRITER
Warren Rogers

Julian Allen

Julian Allen was asked to accentuate the "Blind Emotion" of those involved in Iran Scam. Medium: Oil.

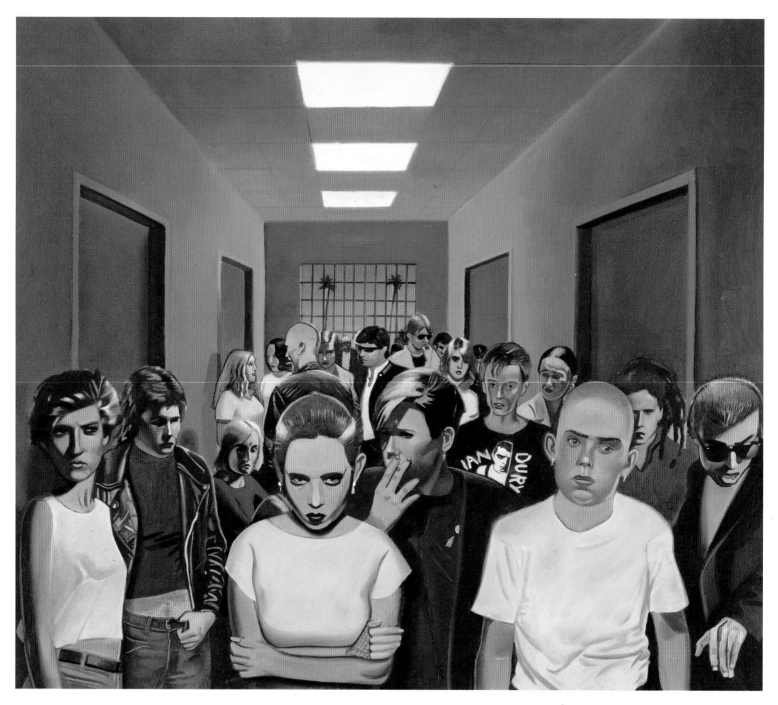

ART DIRECTOR
Derek Ungless
DESIGNER
Raul Martinez
PUBLICATION
Rolling Stone, November 20, 1986
PUBLISHING COMPANY
Straight Arrow Publishers, Inc.
WRITER
Roberta Ostroff

Julian Allen

The story of young people in Los Angeles committed by their parents to psychiatric treatment centers ("Growing Up Behind Locked Doors") demanded a striking, compelling image. Julian Allen focused on the different characters and abstracted their surroundings, making a picture more symbolic than realistic. Medium: Acrylic.

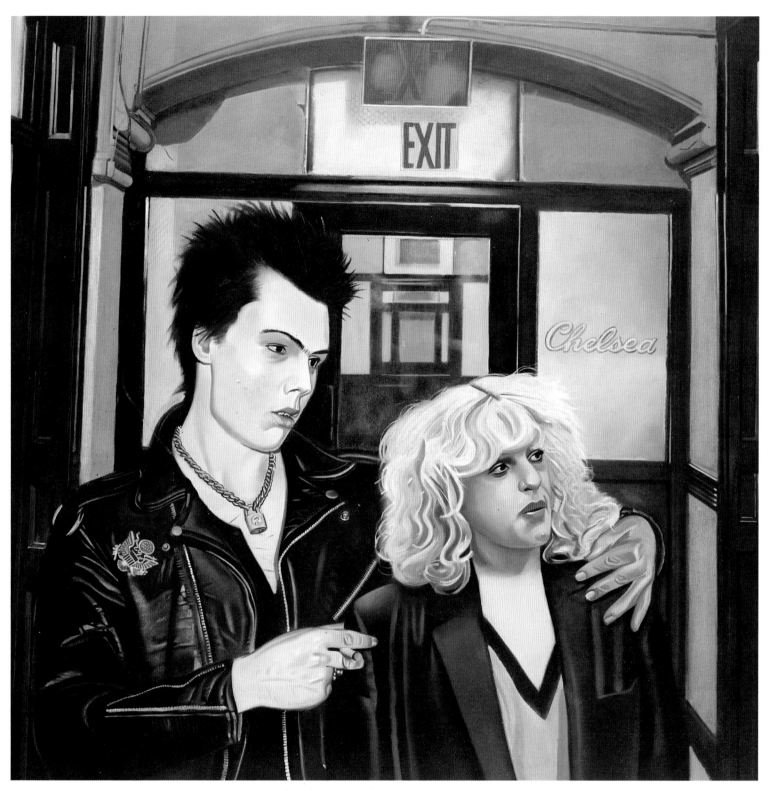

ART DIRECTOR
Charles Churchward

DESIGNER
B.W. Honeycutt

PUBLICATION
Vanity Fair

PUBLISHING COMPANY
Condé Nast Publications

Julian Allen

Julian Allen's three illustrations are part of a
self-generated series of paintings on the subject of
scandal: "Profumo and Christine Keeler" shows the
British government official and the prostitute; "Sid
and Nancy" the relationship between punk rocker
Sid Vicious and his girlfriend Nancy Spungen; "Jean
Harris and the Diet Doctor" recalls the tragedy of the
love affair between the head of a posh girl's school
and the philandering doctor. All were done for a
Vanity Fair article called "Fatal Couples." Medium: Oil.

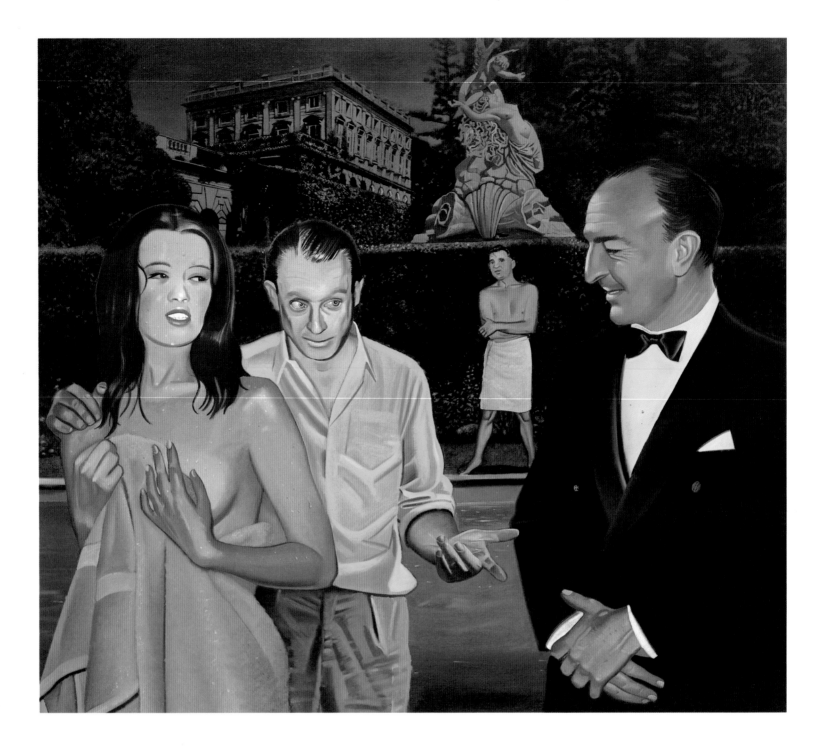

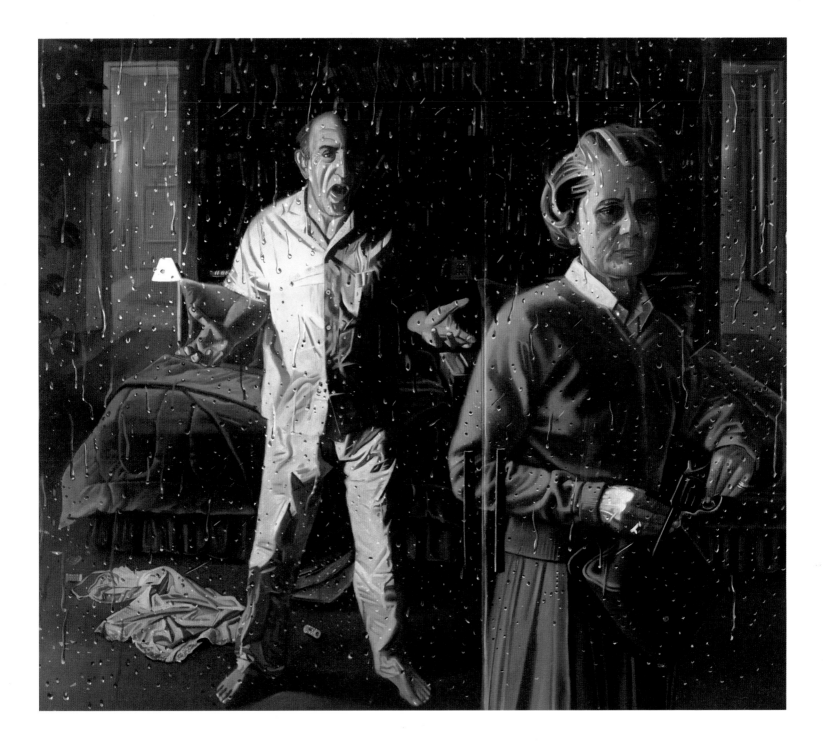

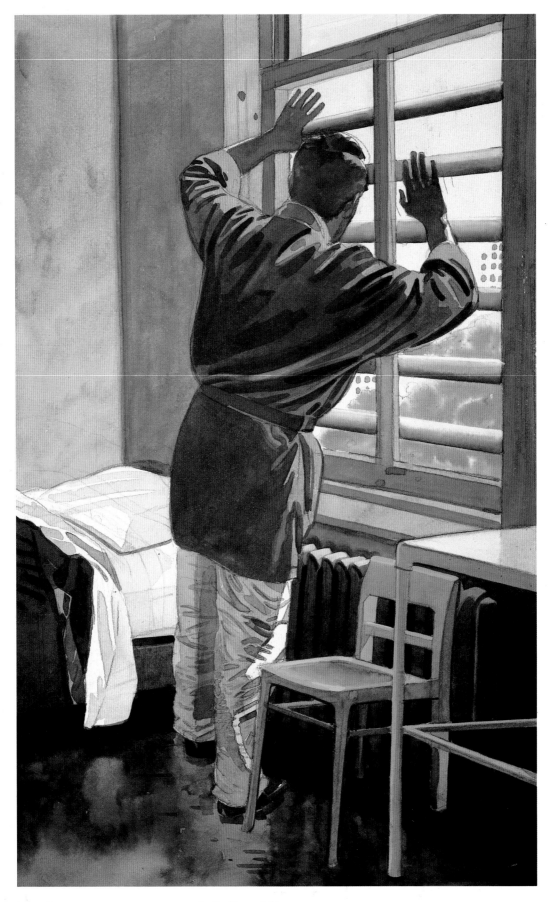

ART DIRECTOR
Roger Black

PUBLICATION
Newsweek, August 11, 1986

PUBLISHING COMPANY
Newsweek, Inc.

WRITER
Joyce Barnathan

Julian Allen

Newsweek's Moscow correspondent had slipped into a Soviet mental hospital where dissidents were held as "patients." Since photographs could not be taken, Julian Allen re-created scenes from the article, "Inside a Mind Jail," working from descriptions relayed to him by telephone from the U.S.S.R.

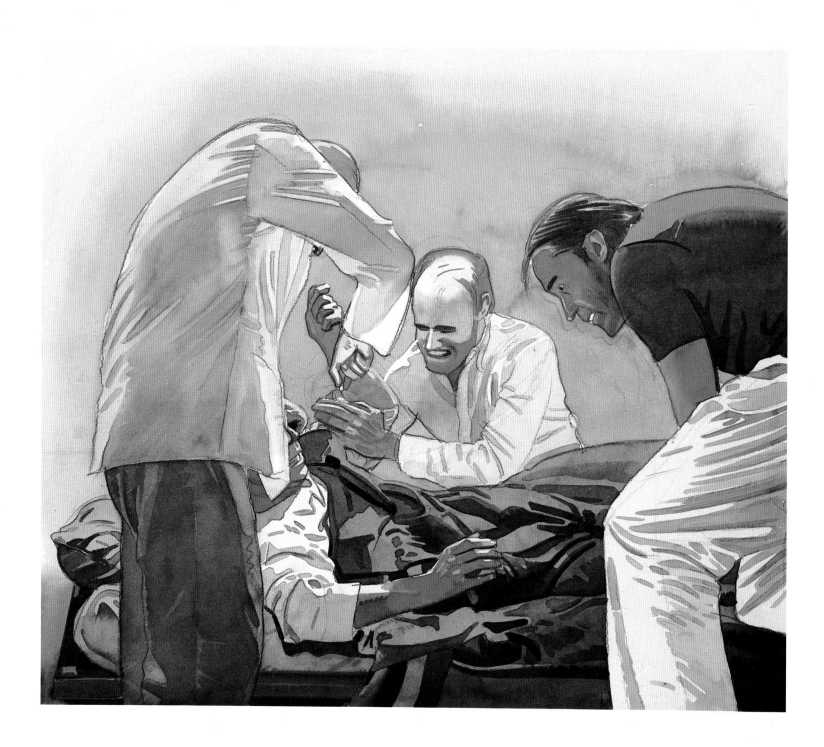

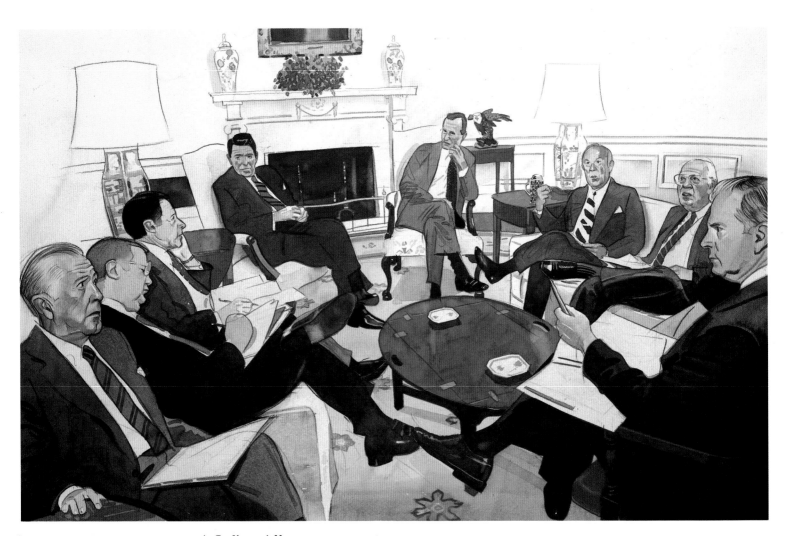

ART DIRECTOR
Roger Black
PUBLICATION
Newsweek, December 8, 1986
PUBLISHING COMPANY
Newsweek, Inc.
WRITER
Tom Morganthau

Julian Allen

In the midst of the Iran-Contra scandal, the magazine learned that a meeting was to be held at the White House; all the key players were to be present; since no photographs were available, Newsweek called on Julian Allen to reconstruct the event in his illustration for "Who Knew?" Medium: Watercolor.

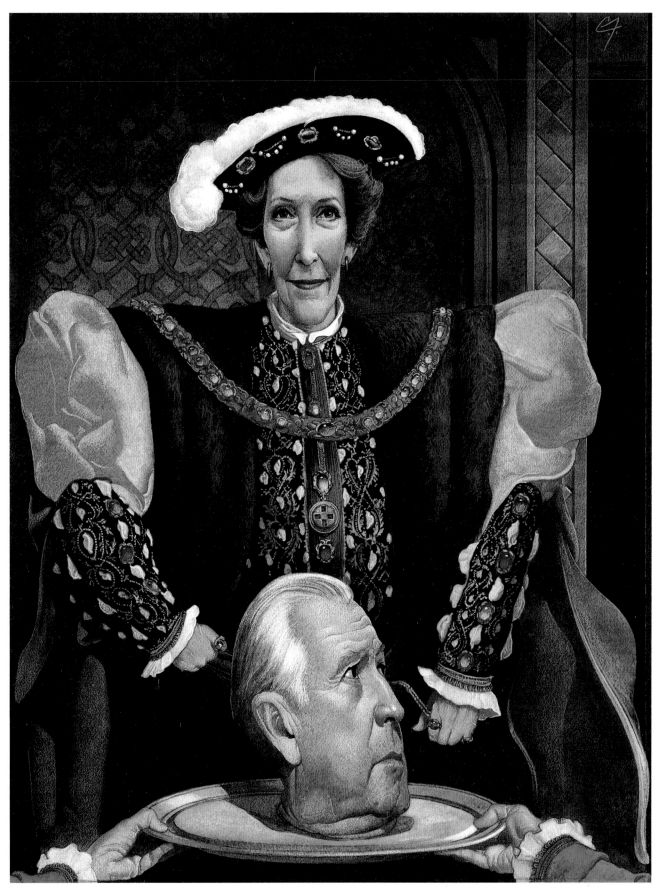

ART DIRECTOR
Fred Woodward

DESIGNER
Jolene Cuyler

PUBLICATION
Regardie's, April 1987

PUBLISHING COMPANY
Regardie's Magazine, Inc.

C.F. Payne

Nancy Reagan, as Henry VIII, posing in front of John the Baptist as played by former White House chief of staff Donald Regan: C.F. Payne's "Altered Egos" illustrate an article on the First Lady's role in the Reagan administration. Medium: Oil.

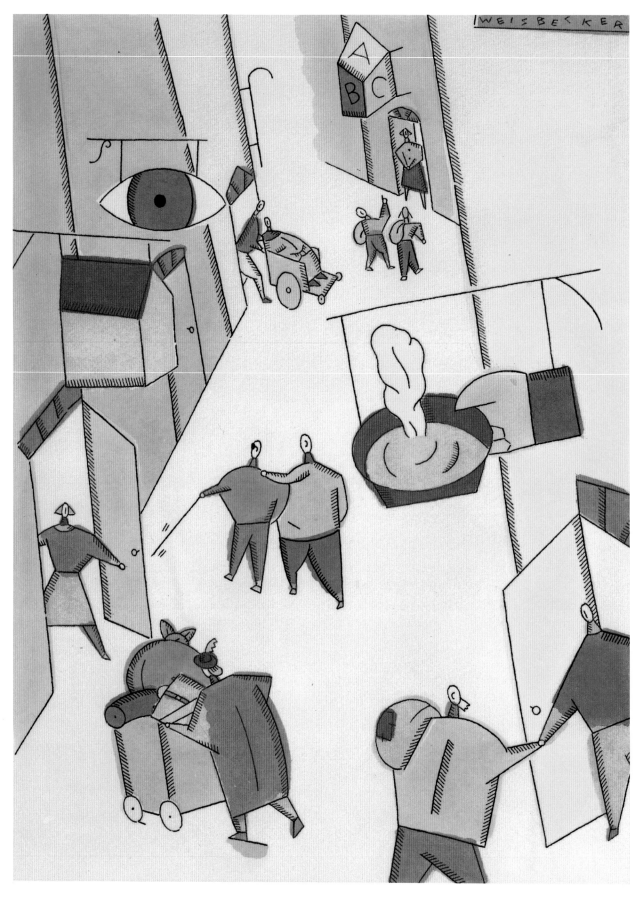

ART DIRECTOR
Josh Gosfield

DESIGNER
Robert Best

PUBLICATION
New York, October 13, 1986

PUBLISHING COMPANY
Murdoch Magazines

WRITER
Ava Plakins

Philippe Weisbecker

Philippe Weisbecker's street scene, populated with stylized figures representing people helping people, illustrated, "How to Help," an article that described local social-welfare agencies and advised readers on how to volunteer. Medium: Pen, ink and watercolor.

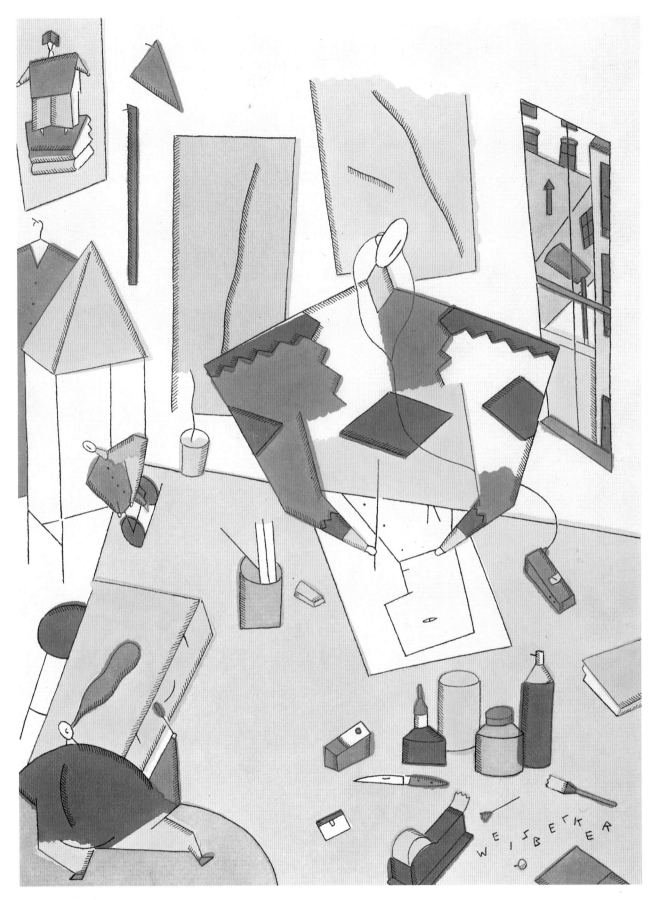

DESIGNER
Andrew P. Kner
PUBLICATION
Print, January/February 1987
PUBLISHING COMPANY
RC Publications

Philippe Weisbecker

Philippe Weisbecker's cover illustration for the graphic-design magazine shows himself at work. Medium: Ink and watercolor.

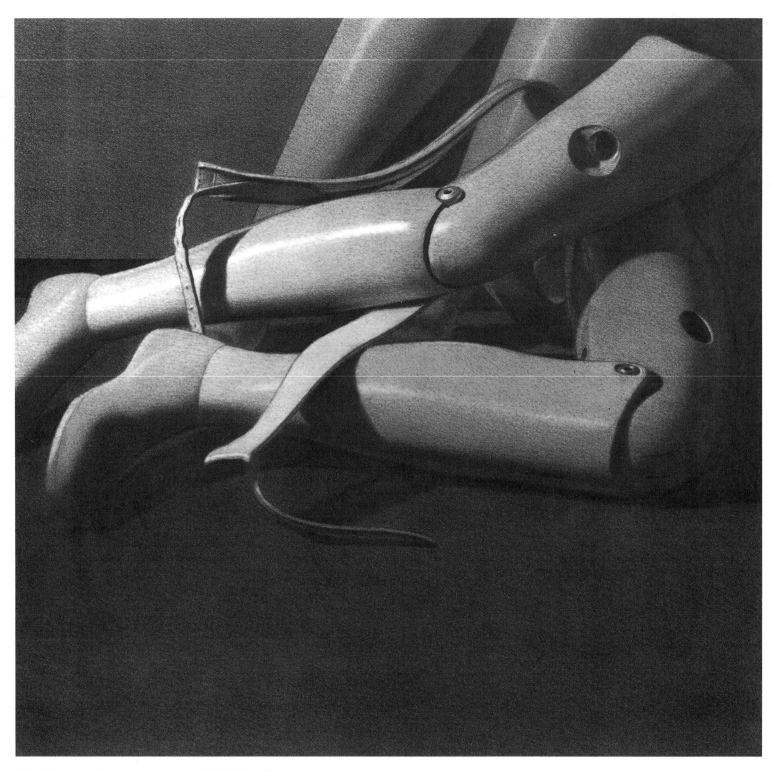

ART DIRECTOR/DESIGNER
Judy Garlan

PUBLICATION
The Atlantic Monthly, October 1986

PUBLISHING COMPANY
The Atlantic Monthly Company

WRITER
William Hoffman

Ralph Giguere

To illustrate a short story, "Night Sport," about a deranged Vietnam veteran who lost both legs in the war and who takes his revenge on a young man who breaks into his house, Ralph Giguere focuses on the artificial legs of the protagonist. Medium: Pencil.

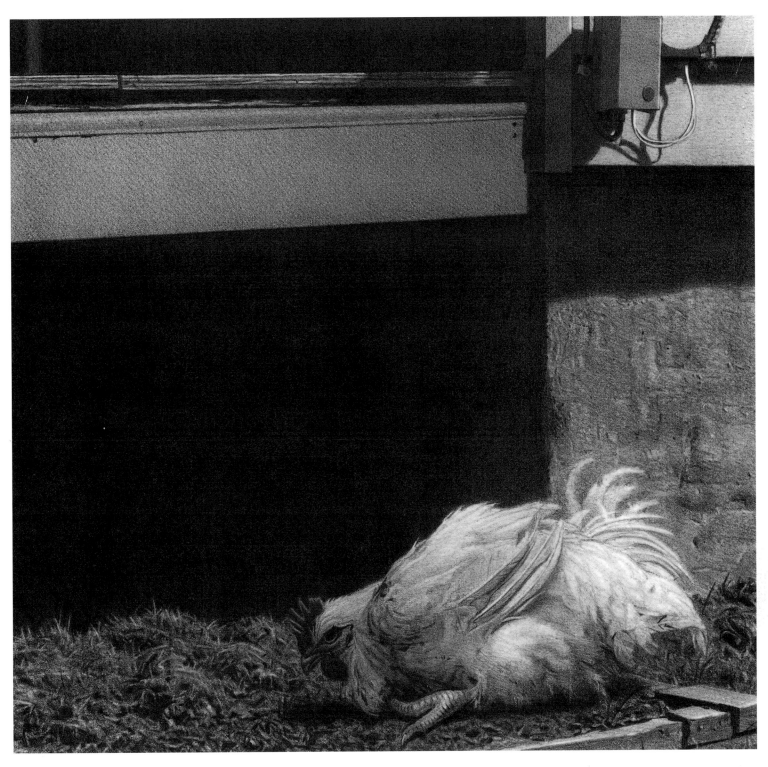

ART DIRECTOR
Judy Garlan
PUBLICATION
The Atlantic Monthly, May 1986
PUBLISHING COMPANY
The Atlantic Monthly Company
WRITER
Robert Bausch

Ralph Giguere

In the short story "The White Rooster" this drawing of a wounded rooster which has crawled under the house, perhaps to die, becomes a symbol for the uncomfortable and worsening relationship between a father and son. Medium: Pencil.

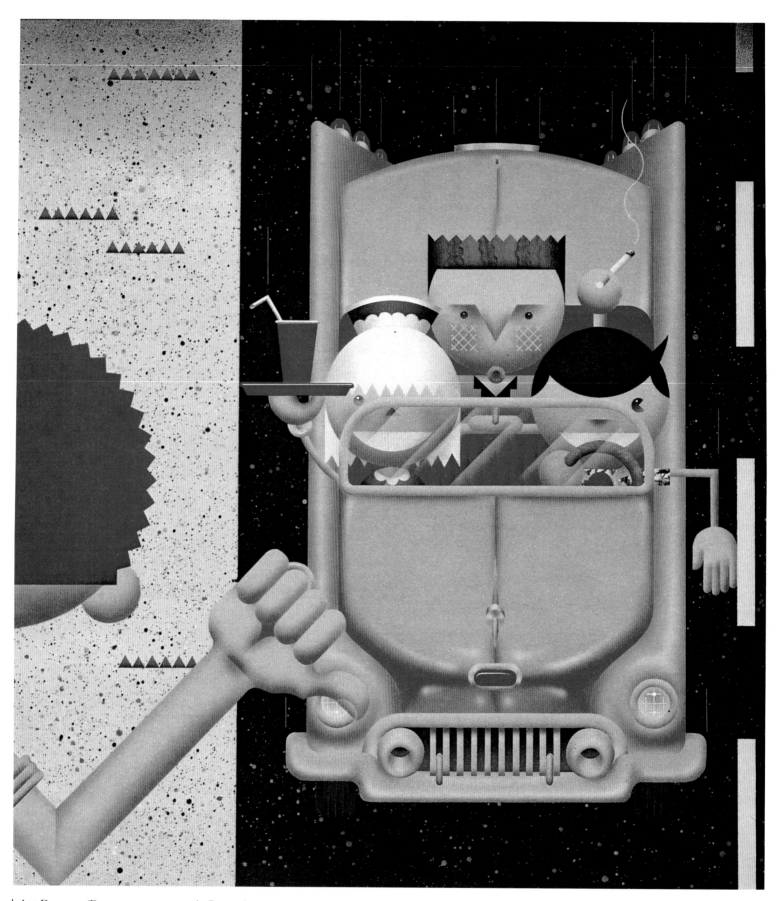

ART DIRECTOR/DESIGNER
Bambi Nicklen
PUBLICATION
West, September 7, 1986
PUBLISHING COMPANY
San Jose Mercury News
WRITER
Steve Chapple

José Cruz

Sharp angles feature prominently in José Cruz's illustration of a car ("Chrome Sweet Chrome") and a hitchhiker for an article on classic cars in a California magazine. Medium: Airbrush.

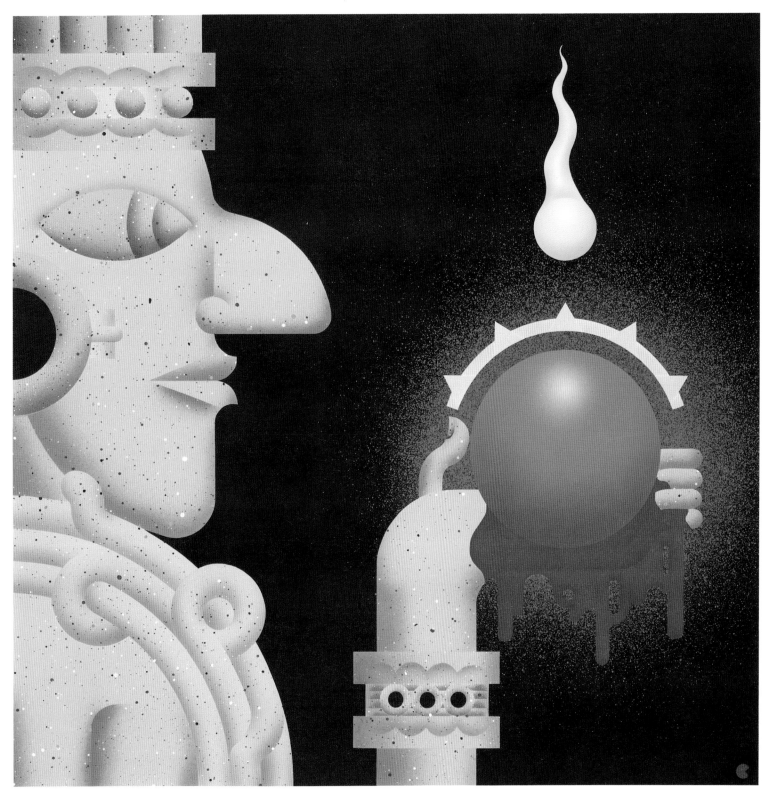

ART DIRECTOR
Hans Georg Pospischil

PUBLICATION
Frankfurter Allgemeine Magazine,
June 13, 1986

PUBLISHING COMPANY
Frankfurter Allgemeine Zeitung

WRITER
Michael Schwarz

José Cruz

This cover illustration by José Cruz portrays an ancient Aztec god holding the Mexican symbols of power and life. Medium: Acrylic.

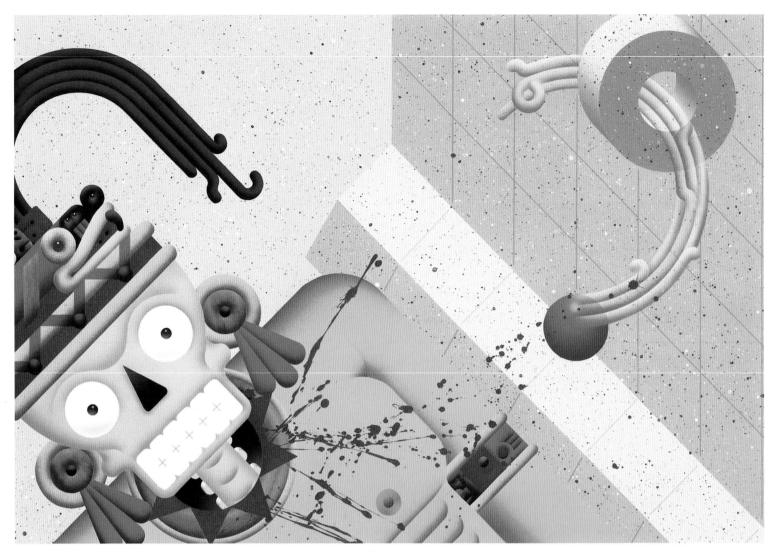

ART DIRECTOR
Hans Georg Pospischil
PUBLICATION
*Frankfurter Allgemeine Magazine,
June 13, 1986*
PUBLISHING COMPANY
Frankfurter Allgemeine Zeitung
WRITER
Michael Schwarz

José Cruz

José Cruz's harsh geometric style illuminates "*Spiele in Mexiko*" a very graphic article on the relationship between violence, Aztecs, wrestling and homosexuality in Mexico. Medium: Acrylic.

ART DIRECTOR
Derek Ungless

DESIGNER
Angelo Savaides

PUBLICATION
Rolling Stone, September 25, 1986

PUBLISHING COMPANY
Straight Arrow Publishers, Inc.

WRITER
Jimmy Guterman

José Cruz

To do a portrait of "Cyndi's New Shades" in the "Geometrix" style that he developed, José Cruz studied magazine pictures of Lauper and did several small sketches. He then took compass, t-square, templates, and ruler, and made a final drawing which was then airbrushed. Medium: Acrylic/airbrush.

ART DIRECTOR
Tina Adamek

PUBLICATION
Postgraduate Medicine, July 1986

PUBLISHING COMPANY
McGraw-Hill, Inc.

WRITER
Francis G. Mackey, M.D.

Mel Odom

Mel Odom uses arrows to express the anxiety felt by heart attack and bypass patients as they contemplate a return to normal sexual activity, for "Sexuality in Coronary Artery Disease." Medium: Pencil, dyes and gouache.

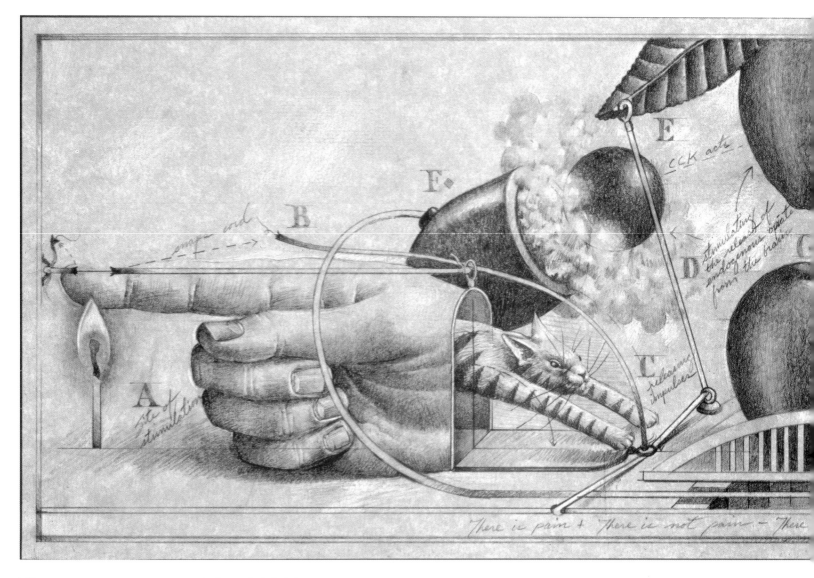

DESIGNER
Scott Wright

PUBLICATION
Research in Action, Winter '86/'87

PUBLISHING COMPANY
Virginia Commonwealth University

WRITER
William Van Pelt

Scott Wright

In this article about "Solving the Problem of Pain," Scott Wright uses a visual metaphor of the chemical process that occurs in the nervous system which enables pain to be communicated to the brain. Medium: Pencil.

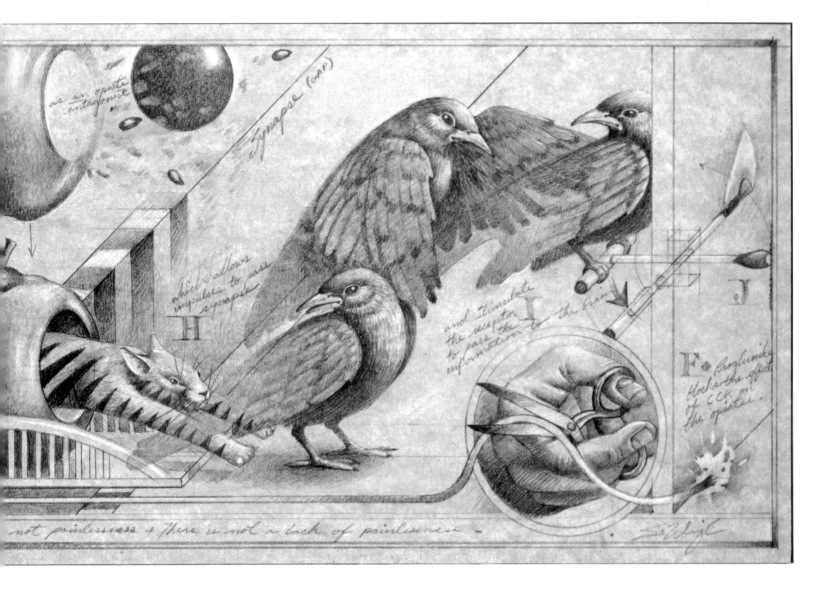

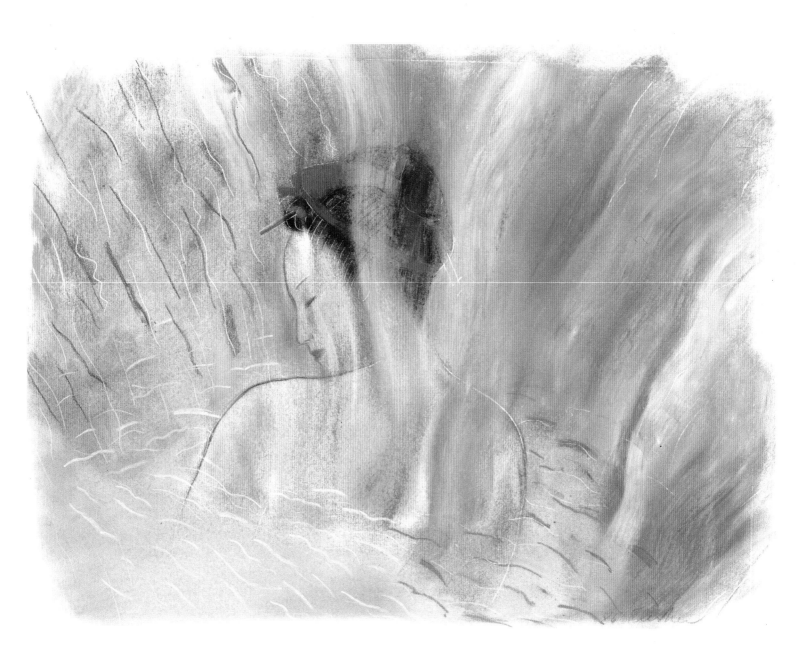

ART DIRECTOR/DESIGNER
Ronn Campisi

PUBLICATION
The Boston Globe Travel Section
March 16, 1986

PUBLISHING COMPANY
Affiliated Publications, Inc.

WRITER
Tom Ashbrook

Vivienne Flesher

Steam partly obscures a young Japanese woman in
Vivienne Flesher's pastel drawing for "The Serenity
of the Japanese bath." Medium: Pastel.

ART DIRECTOR/DESIGNER
Lynn Staley

PUBLICATION
The Boston Globe
September 28, 1986

PUBLISHING COMPANY
Affiliated Publications, Inc.

WRITER
Ann Beattie

Vivienne Flesher

For a short story by Ann Beattie called "In Amalfi,"
Vivienne Flesher's pastel drawing conveys the
isolation felt by a woman who finds herself spending
her days sitting alone on a terrace overlooking the
glamourous resort town of Amalfi. Medium: Pastel.

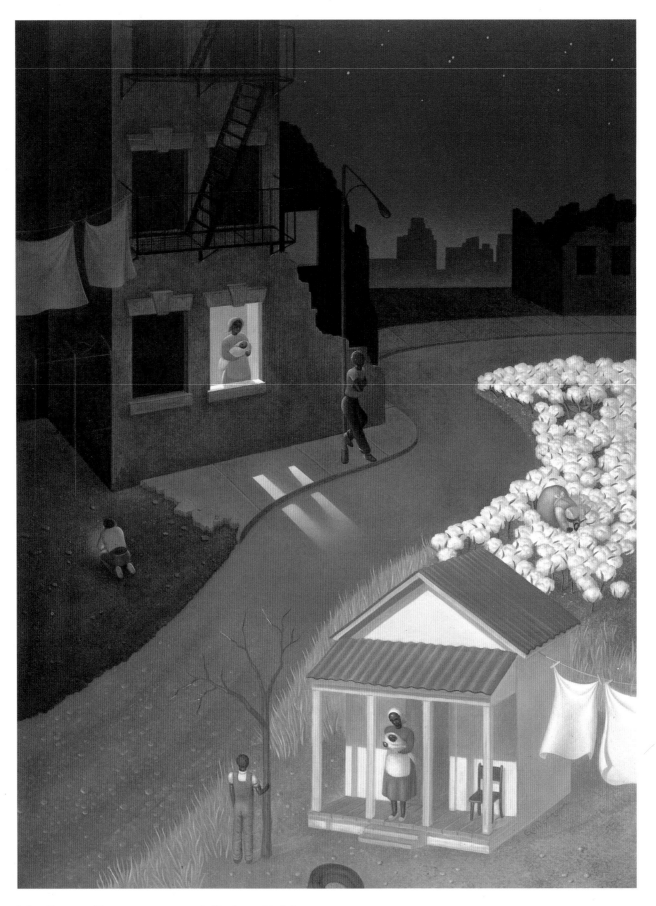

ART DIRECTOR/DESIGNER
Judy Garlan

PUBLICATION
The Atlantic Monthly, June 1986

PUBLISHING COMPANY
The Atlantic Monthly Company

WRITER
Nicholas Lemann

Robert Goldstrom

Robert Goldstrom evokes the spirit of American regionalist art in this cover illustration highlighting an article ("The Origins of the Underclass") on problems that plague the black underclass in northern ghettos. Medium: Oil.

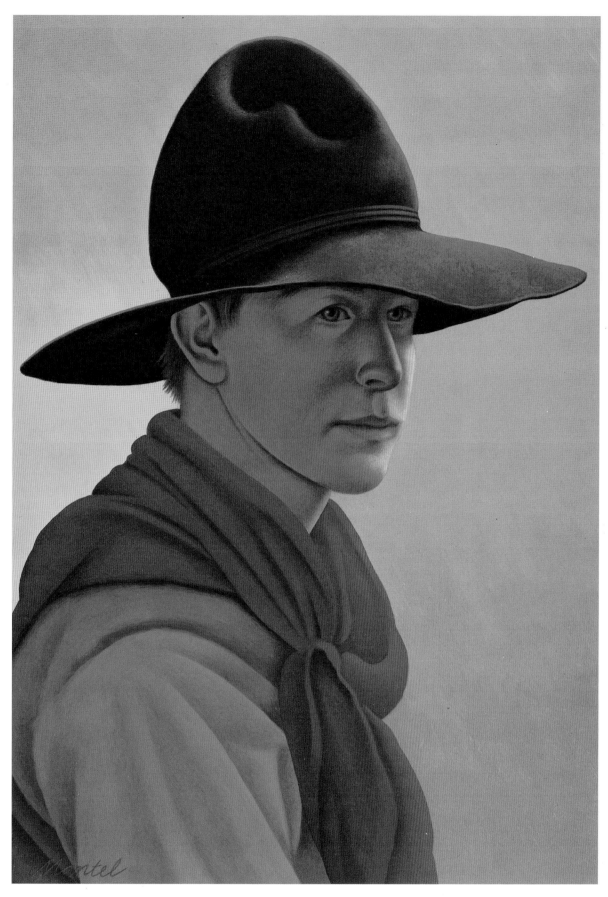

ART DIRECTOR
Fred Woodward
PUBLICATION
Texas Monthly, April 1987
PUBLISHING COMPANY
Texas Monthly, Inc.

Richard Mantel

A 19th-century cowboy song, "Little Joe the
Wrangler," inspired both the article and this painting
evocative of the Old West. Medium: Acrylic.

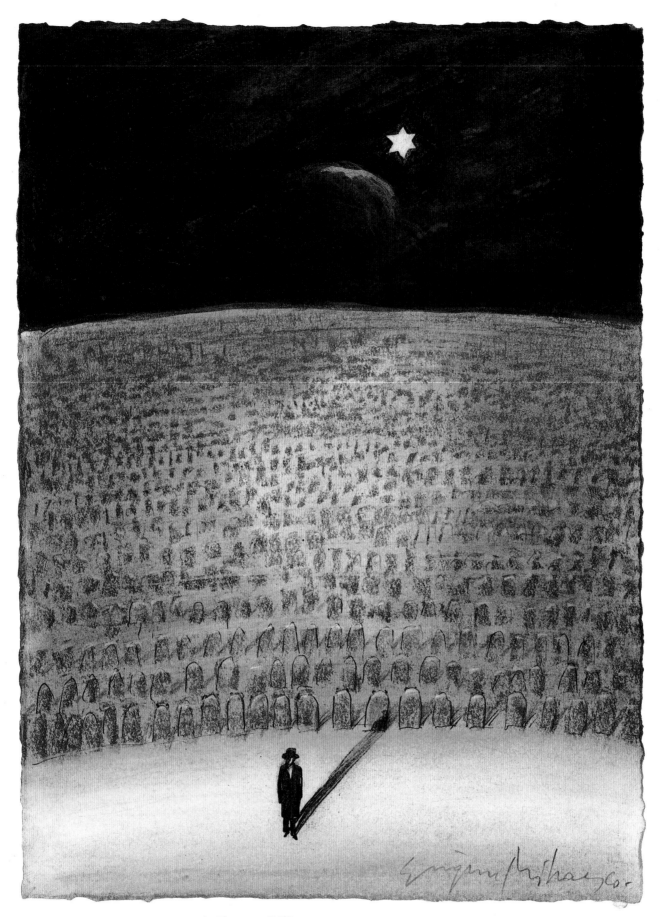

ART DIRECTOR
Robert Post

DESIGNER
Cynthia Hoffman

PUBLICATION
Chicago, October 1986

PUBLISHING COMPANY
Metropolitan Communications, Inc.

WRITER
Stanley Elkin

Eugene Mihaesco

A lonely soul standing before rows of gravestones is Eugene Mihaesco's representation of Stanley Elkin's story about "The Rabbi of Lud," who had no congregation and who served in an area known for its cemeteries. Medium: Watercolor.

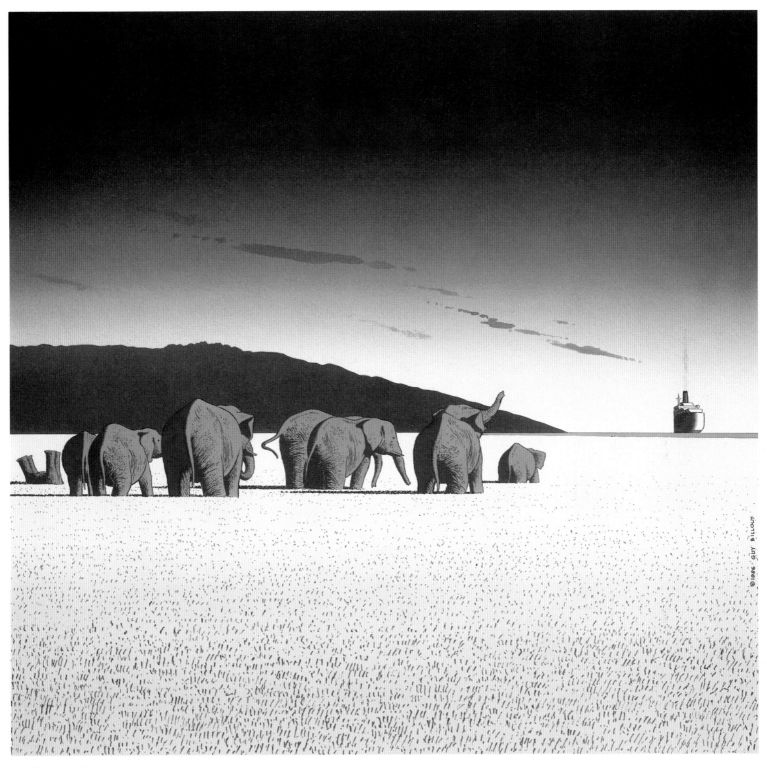

ART DIRECTOR/DESIGNER
Michael B. Marcum

PUBLICATION
Campus Voice, April/May 1986

PUBLISHING COMPANY
Whittle Communications

WRITER
Steve Chapple

Guy Billout

Guy Billout's watercolor illustrates "Culture Shock on the High Seas," an article describing a "semester at sea" program in which college students study aboard an ocean liner. Medium: Watercolor.

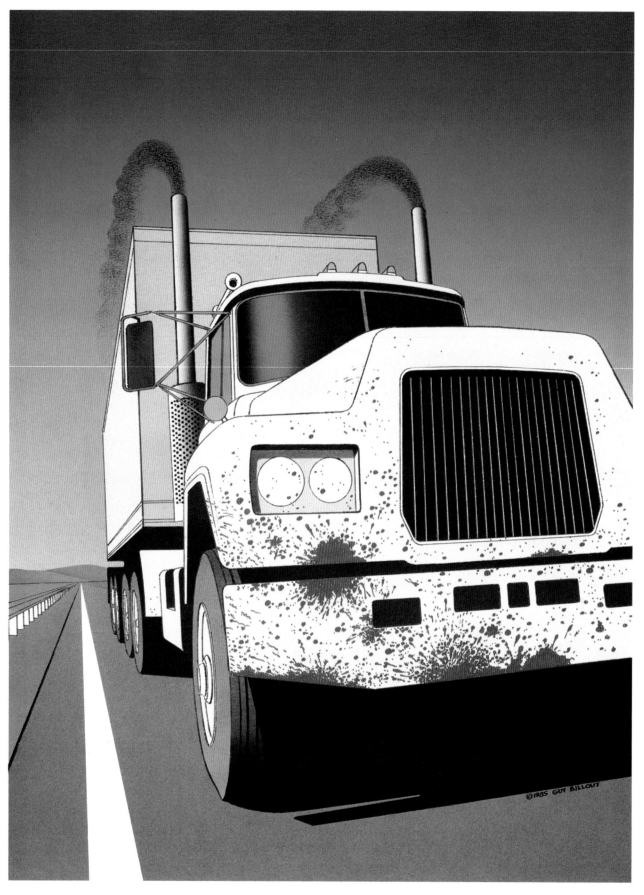

©1985 GUY BILLOUT

ART DIRECTORS
Walter Bernard and Milton Glaser
DESIGNER
Colleen McCudden
PUBLICATION
Insurance Review, June 1986
PUBLISHING COMPANY
Insurance Information Institute

Guy Billout

Guy Billout's watercolor image of a truck was used as the cover illustration for "The Toll Trucks Take," a piece about trucks and the danger they cause on American highways. Medium: Watercolor and airbrush.

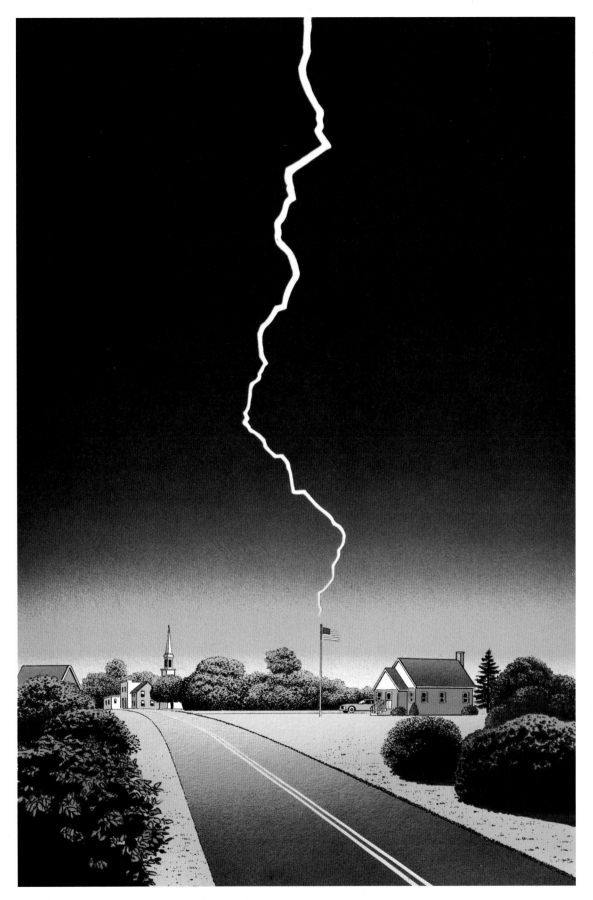

ART DIRECTOR
Rudy Hoglund

PUBLICATION
Time, March 24, 1986

PUBLISHING COMPANY
Time Inc.

WRITER
George J. Church

Guy Billout

The rising rates of insurance in the United States was the basis for this cover story, "Sorry, Your Policy is Canceled." Guy Billout submitted a peaceful suburban scene helpless in the face of disaster. Medium: Gouache.

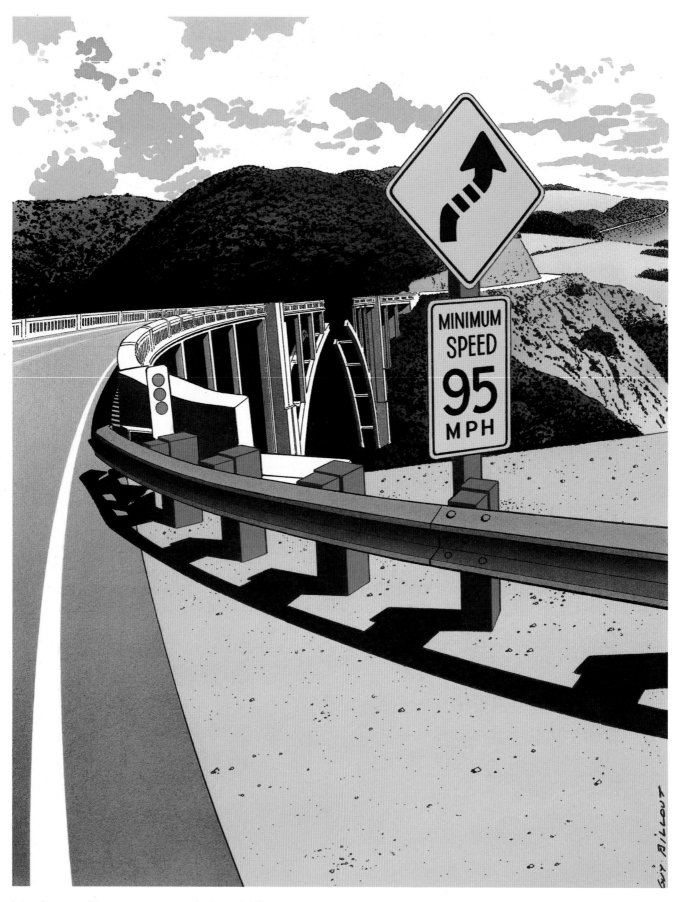

ART DIRECTOR/DESIGNER
Judy Garlan
PUBLICATION
The Atlantic Monthly, April 1986
PUBLISHING COMPANY
The Atlantic Monthly Company

Guy Billout

Guy Billout has a bimonthly page in the magazine wherein he makes a statement, the subject of which is of his own choosing: here, "Ballistics," his comment on a California bridge. Medium: Brush and airbrush, watercolor.

ART DIRECTOR/DESIGNER
Judy Garlan

PUBLICATION
The Atlantic Monthly, December 1986

PUBLISHING COMPANY
The Atlantic Monthly Company

Guy Billout

In one ("Prop") of his full-page bimonthly features for the magazine, Guy Billout draws on his memories of a visit to St. Peter's in Rome as a 12 year old. Medium: Brush and airbrush, watercolor.

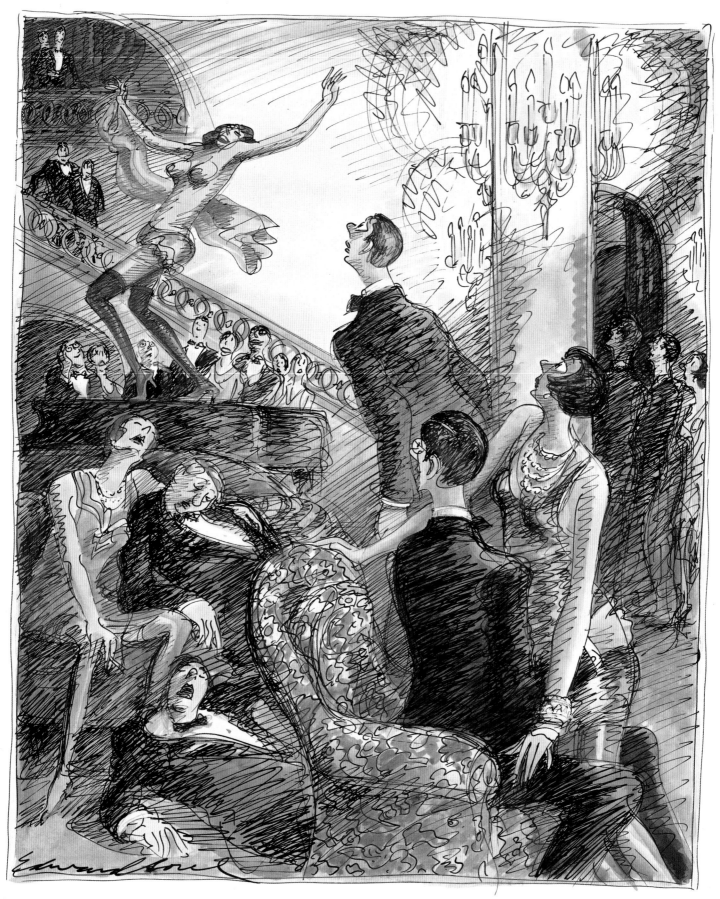

ART DIRECTOR
Everett Halvorsen
DESIGNER
Ronda Kass
PUBLICATION
Forbes, October 27, 1986
PUBLISHING COMPANY
Forbes, Inc.
WRITER
Edward Sorel

Edward Sorel

One of a series of illustrations for an article on "Marrying Rich," this depicts the wedding of a Reynolds tobacco heir to Libby Holman. The party to introduce her to his socialite friends degenerated into a drunken orgy, with "The Unblushing Bride" performing a strip-tease for the guests. Medium: Pen, ink and watercolor.

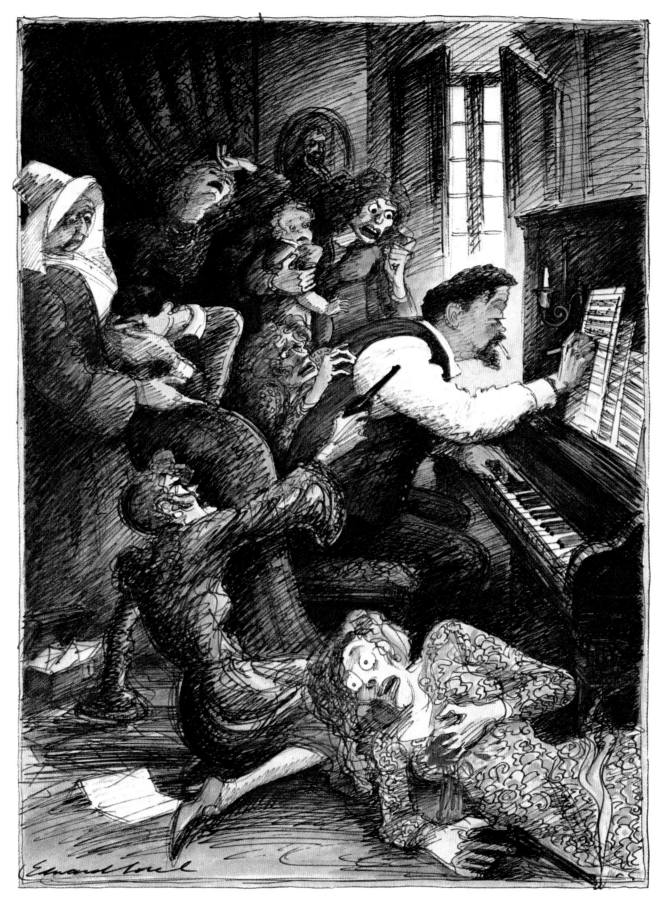

ART DIRECTOR
Mary Shanahan
PUBLICATION
Gentlemen's Quarterly, June 1986
PUBLISHING COMPANY
Condé Nast Publications, Inc.
WRITER
Nancy Caldwell Sorel

Edward Sorel

Edward Sorel's portrait of composer Claude Debussy was done for an article on some of history's greatest cads, "Scoundrel Time." Medium: Watercolor, pen and ink.

ART DIRECTOR
Christopher Burg

PUBLICATION
MACWORLD, March 1986

PUBLISHING COMPANY
PCW Communications, Inc.

WRITER
Erfert Nielson

John Hersey

This computer-generated image by John Hersey illustrates "April Foolery," about the many new things that can be done on computers.
Medium: Computer.

ART DIRECTOR
Christopher Burg

DESIGNER
Christina Chase

PUBLICATION
MACWORLD, September 1986

PUBLISHING COMPANY
PCW Communications, Inc.

WRITER
Reese M. Jones

John Hersey

John Hersey used the computer to generate an overlay for his illustration on "Mac Modeling," the use of the Macintosh computer for theoreotical modeling. Medium: Macintosh computer, Macpaint software.

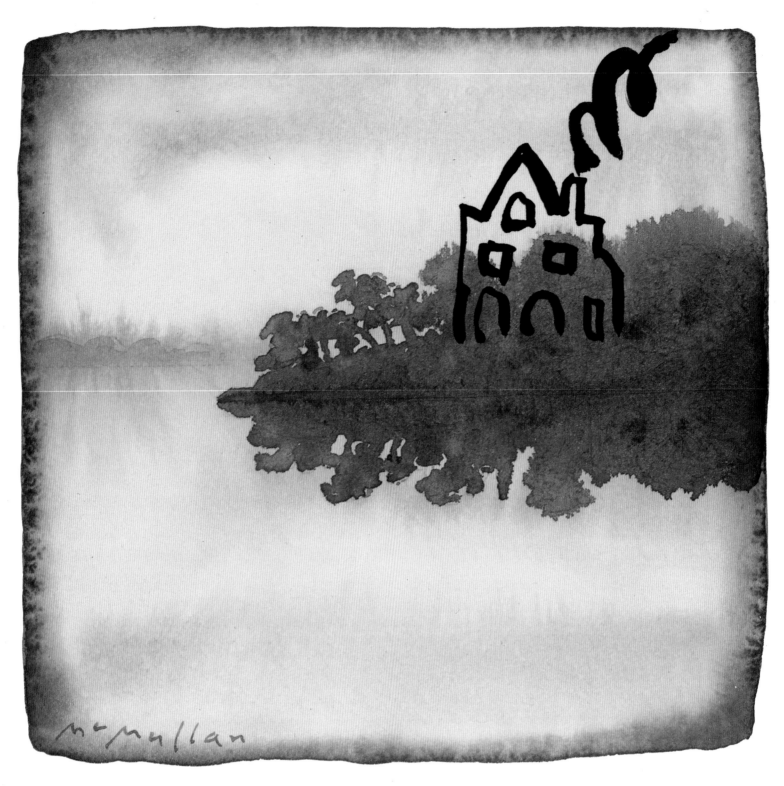

ART DIRECTOR
Wendall K. Harrington
DESIGNER
John Bark
PUBLICATION
Esquire, February 1987
PUBLISHING COMPANY
Hearst Corporation
WRITER
John Barth

James McMullan

Violating the purity of a watercolor scene with a graffiti-like house suggests the turmoil in John Barth's story ("The Point") of a fight between families over a piece of land. Medium: Watercolor.

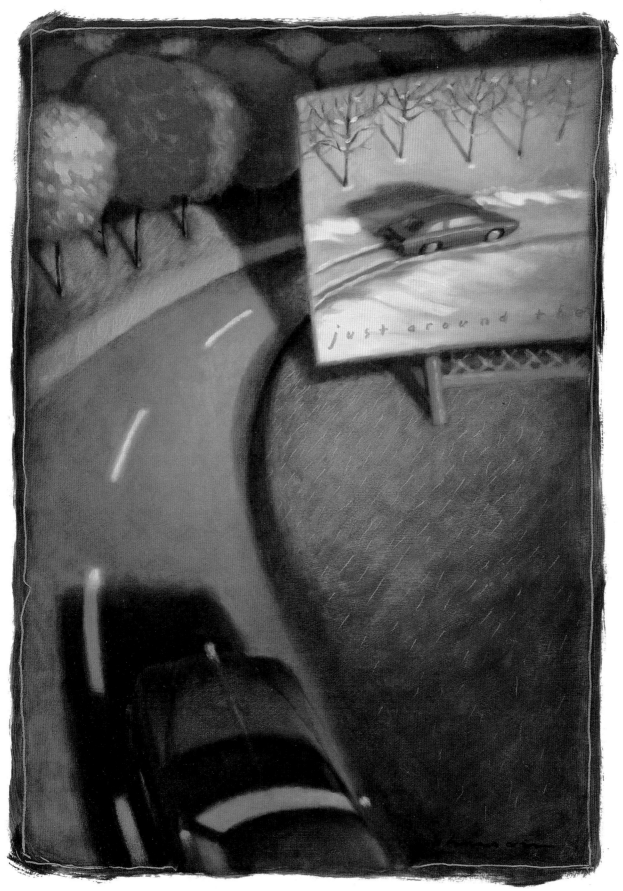

ART DIRECTOR
Judy Sell

PUBLICATION
Minnesota Guide, October 15, 1986

PUBLISHING COMPANY
Minneapolis Star and Tribune

WRITER
Harvey Meyer

Steve Johnson

The popular Road Runner and Wily Coyote cartoons served as Steve Johnson's inspiration in his cover illustration for a newspaper supplement, "Fall Car Care," on the maintenance of cars in cold weather. Medium: Oil.

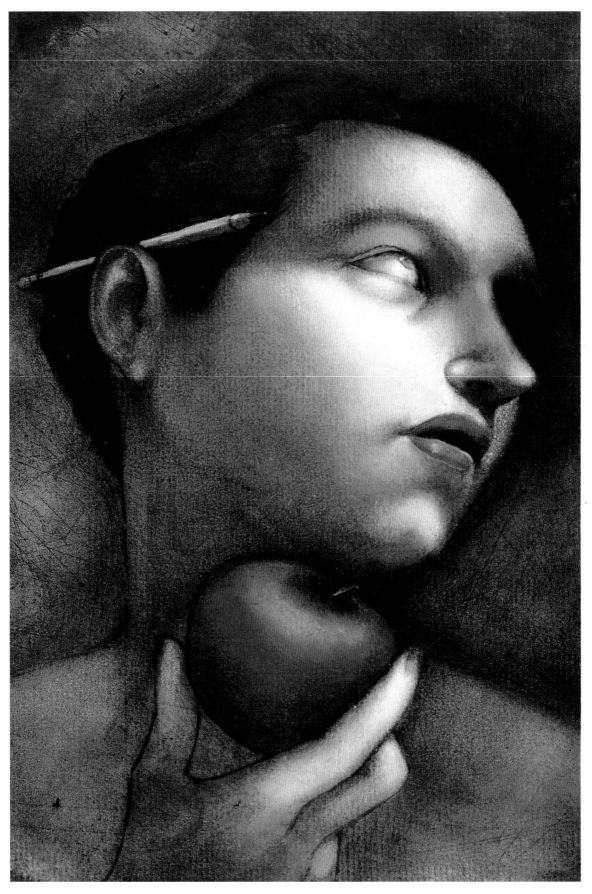

ART DIRECTOR
Rebecca Bernstein

PUBLICATION
The Reporter, September 4, 1986

PUBLISHING COMPANY
University of Buffalo Publications

WRITER
Shawn Carey

Joel Peter Johnson

"I decided on an image inspired by a Renaissance portrait," says Joel Peter Johnson. "I wanted to evoke the idea of the emotional quality of the relationship that exists between the student and the teacher. Ideally it is one of inspiration." The painting was done for an article on "10 Commandments of Effective Teaching." Medium: Oil and colored pencil.

ART DIRECTOR/DESIGNER
Rip Georges
PUBLICATION
L.A. Style, August 1986
PUBLISHING COMPANY
L.A. Style, Inc.

Barbara Nessim

Barbara Nessim's whimsical cover illustration of a woman wearing a dish hat defined the tag line "The Los Angeles Dining Experience," for a piece called "Supper in the City." Medium: Gouache and pastel.

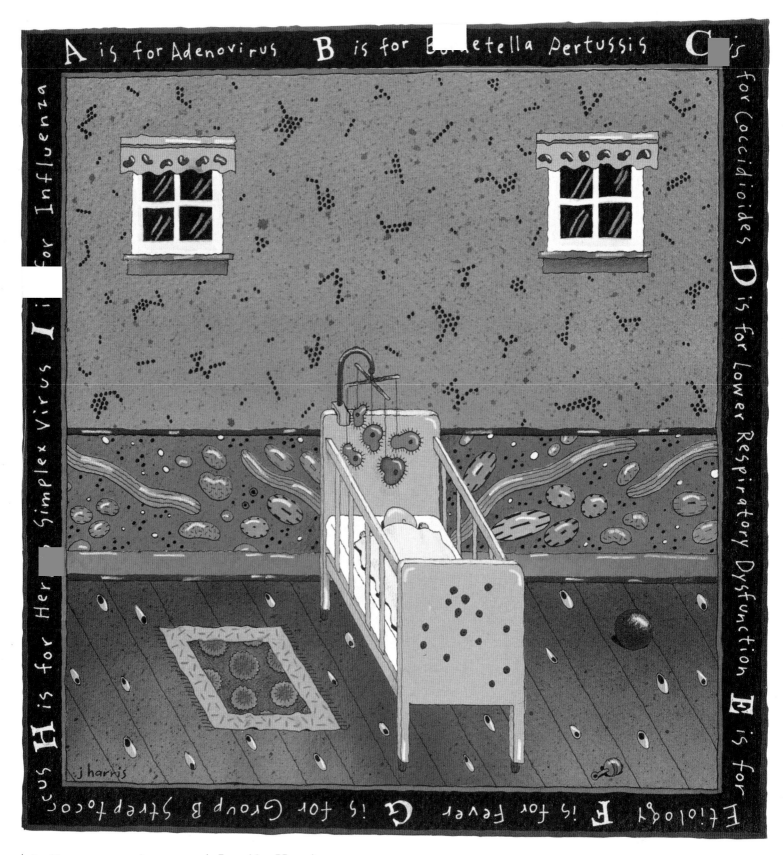

The illustration border reads: A is for Adenovirus · B is for Bordetella Pertussis · C is for Coccidioides · D is for Lower Respiratory Dysfunction · E is for Etiology · F is for Fever · G is for Group B Streptococcus · H is for Herpes Simplex Virus · I is for Influenza

ART DIRECTOR
Tina Adamek

PUBLICATION
*Postgraduate Medicine,
February 1986*

PUBLISHING COMPANY
McGraw-Hill, Inc.

WRITER
Charles V. Sanders, M.D.

Jennifer Harris

A sleeping baby is assailed by bacteria and viruses in Jennifer Harris's illustration for "Common Bacterial Pneumonitis in Infants," an article about organisms that cause various types of infant pneumonia.
Medium: Dyes and Ink.

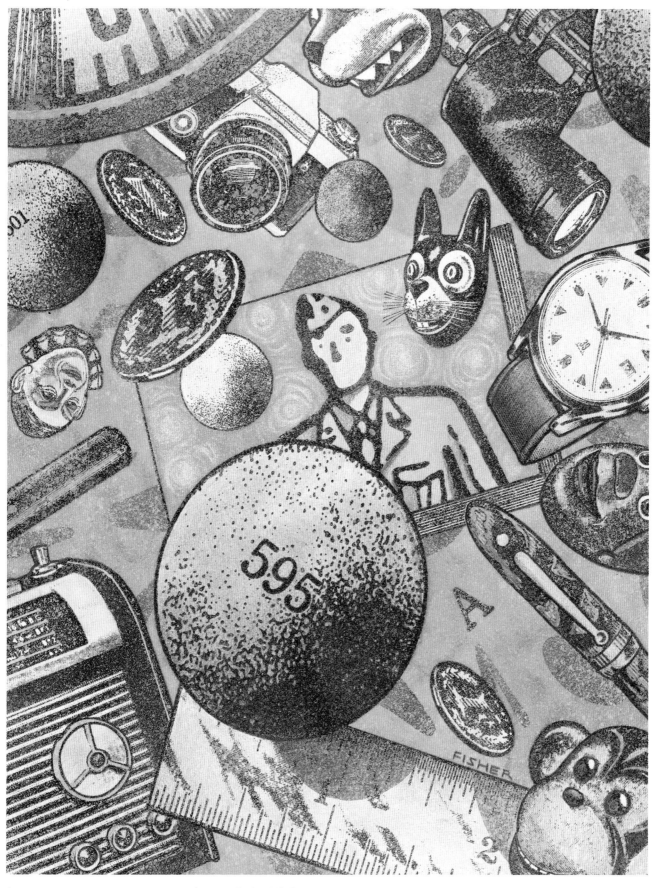

ART DIRECTOR
Robert Post
DESIGNER
Cynthia Hoffman
PUBLICATION
Chicago, June 1986
PUBLISHING COMPANY
Metropolitan Communications, Inc.
WRITER
Stanley Elkin

Mark S. Fisher

Mark S. Fisher depicts a series of impressions about an evening at the Virginia State Fair in 1956, while the writer was in the Army, for "Summer: A True Confession." Medium: Xerox and watercolor.

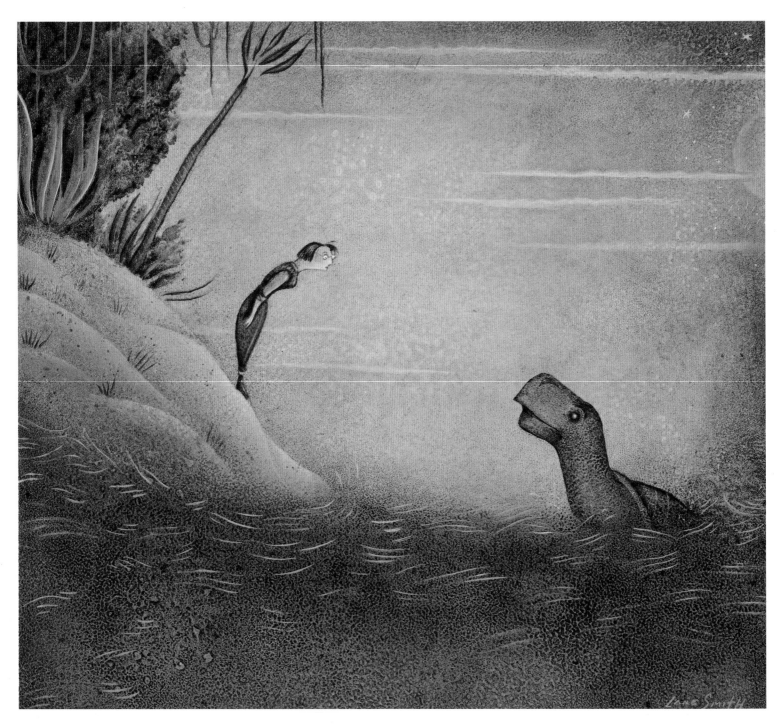

ART DIRECTOR
Joan Ferrell

PUBLICATION
Travel & Leisure, April 1986

PUBLISHING COMPANY
American Express Publishing Corporation

WRITER
Patti Hagan

Lane Smith

Lane Smith's whimsical and inventive treatment of "Land of the Giant Green Turtles," about turtle watching in a rain forest in Costa Rica. Medium: Gouache and oil.

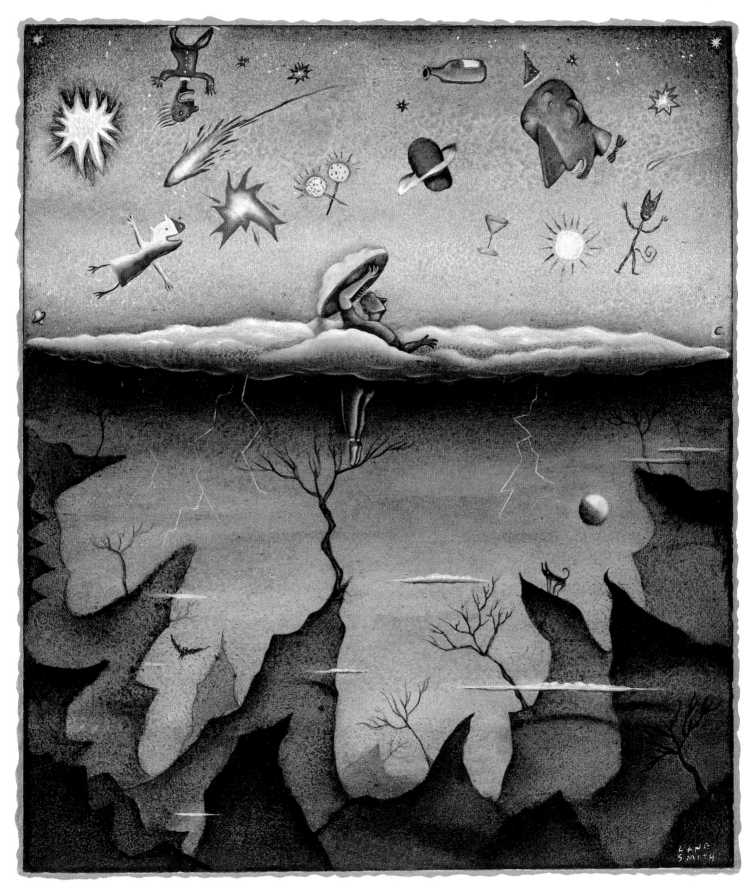

ART DIRECTOR/DESIGNER
Lynn Staley

PUBLICATION
The Boston Globe, January 4, 1987

PUBLISHING COMPANY
Affiliated Publications, Inc.

WRITERS
Patricia Harris and David Lyon

Lane Smith

In a painting commissioned for a New Year's article
on the future, ("Search for Tomorrow"), Lane
Smith's stylized our eternal preoccupation with
predictions. Medium: Oil.

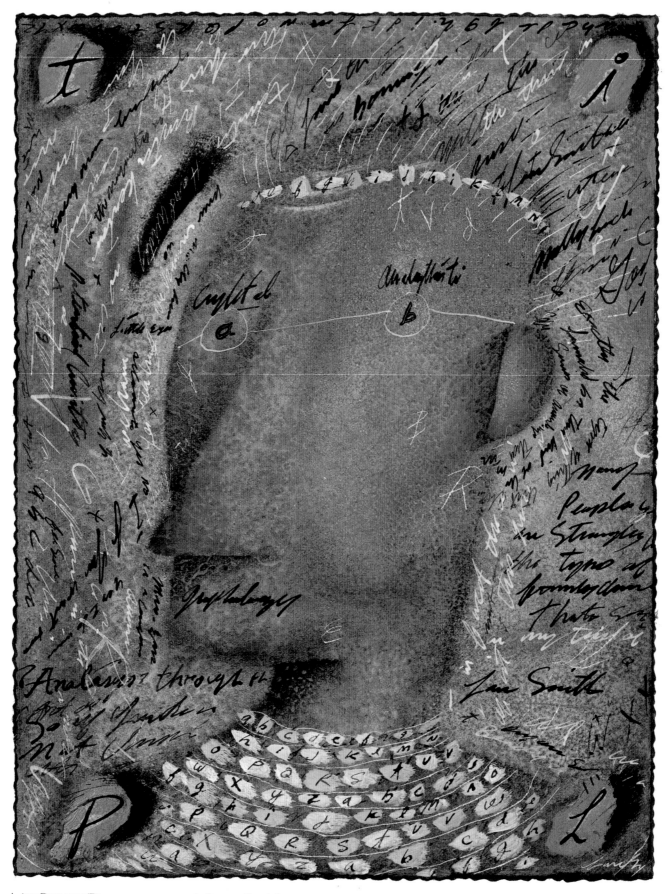

ART DIRECTOR/DESIGNER
Greg Paul

PUBLICATION
Boston Woman, March 1987

PUBLISHER
Alexander Teperman

WRITER
Ed Rader

Lane Smith

To illustrate an article on hiring employees based on their handwriting ("Hire-O-Glyphics"), Lane Smith tried to approach the subject less literally and exploit the graphic possibilities of handwriting. Medium: Oil and ink.

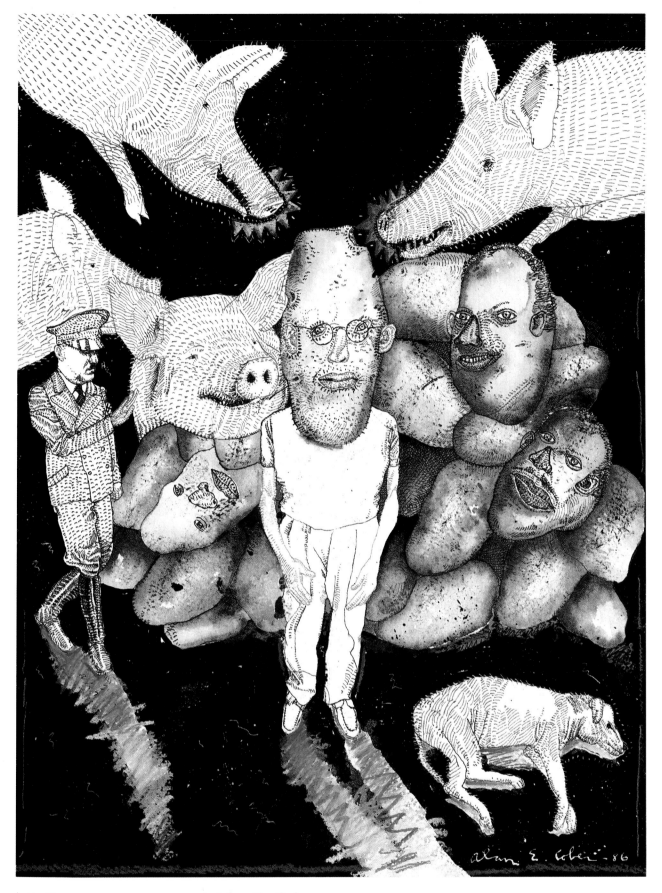

ART DIRECTOR
Jeff Stanton
PUBLICATION
Southern, November 1986
PUBLISHING COMPANY
Southern Writers Project Inc.
WRITER
Barry Hannah

Alan E. Cober

A Hitler-like figure, pigs with lupine traits, floating faces, a dog supine: Alan E. Cober's imaginative rendering of Barry Hannah's article, "Dead Horse Gets Up and Beats You." Medium: Ink, watercolor, prismacolor.

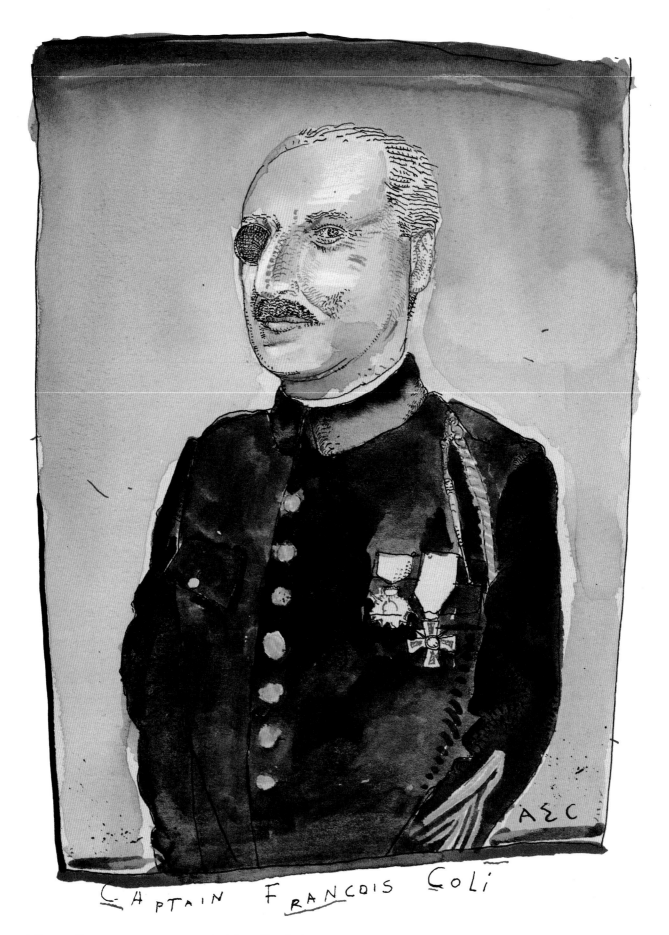

CAPTAIN FRANCOIS COLI

PICTURE EDITOR
Lee Battaglia

DESIGNER
Phil Jordan

PUBLICATION
Air & Space, February/March 1987

PUBLISHING COMPANY
Smithsonian Institution

WRITER
Stephan Wilkinson

Alan E. Cober

Alan E. Cober's four images, recall the 60-year-old mystery ("The Search for L'Oiseau Blanc") of the disappearance of two French aviators who may have made the first nonstop transatlantic air crossing between the United States and Europe. Medium: Watercolor, ink, prismacolor.

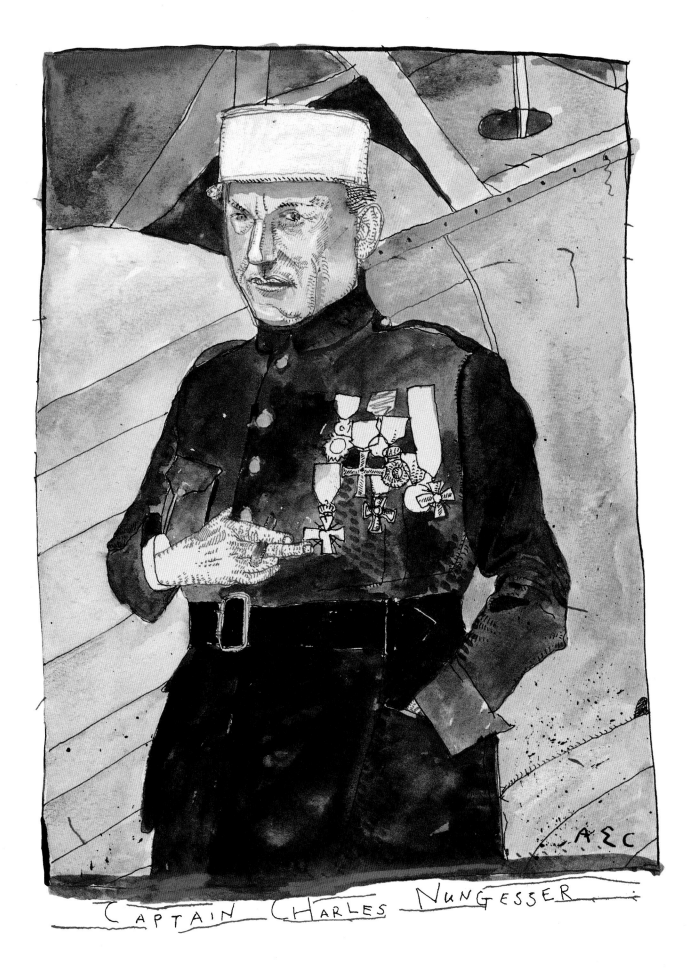

CAPTAIN CHARLES NUNGESSER

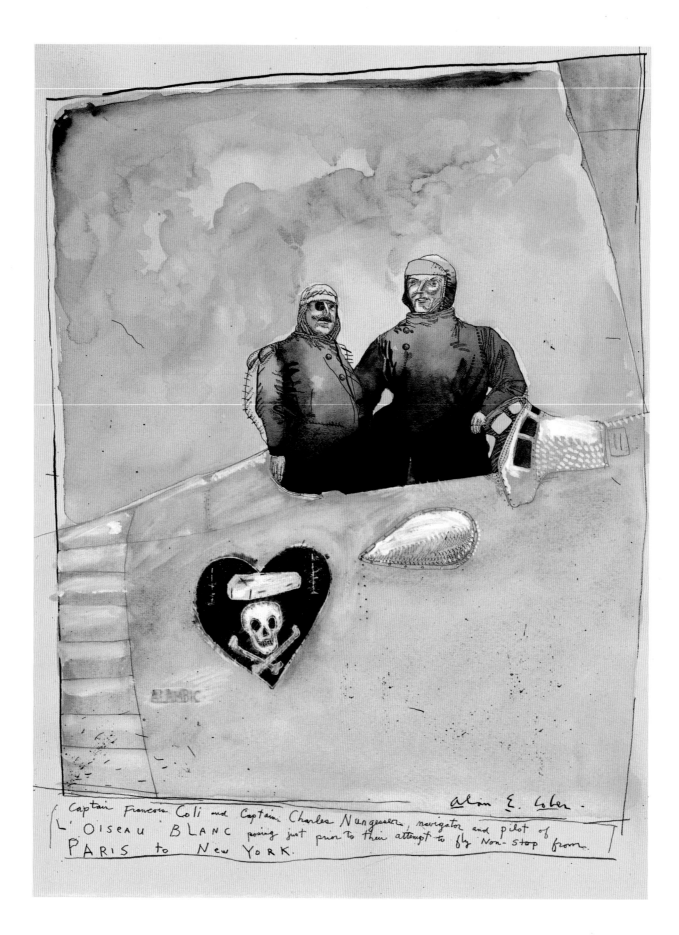

Captain Francois Coli and Captain Charles Nungesser, navigator and pilot of
L'OISEAU BLANC posing just prior to their attempt to fly Non-stop from
PARIS to New York.

Alan E. Cober.

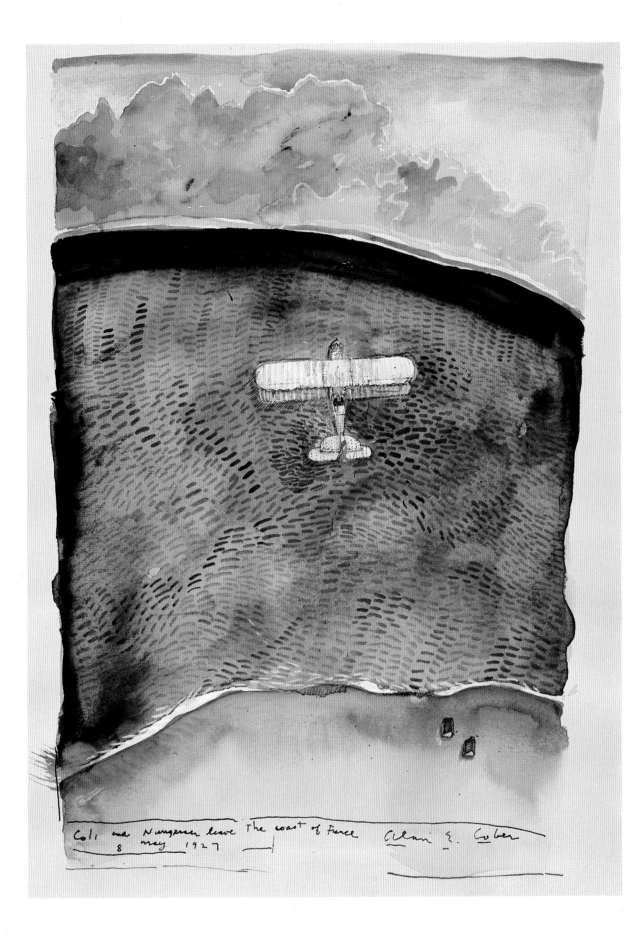

Coli and Nungesser leave The coast of France
8 may 1927

Alan E. Cober

ART DIRECTOR
Bruce Charonnat

DESIGNER
Leslie Barton

PUBLICATION
MACWORLD, January 1986

PUBLISHING COMPANY
PCW Communications, Inc.

WRITER
Gordon McComb

Mick Wiggins

Mick Wiggins's computer-generated image illustrated "A Clipboard Collage," on a Macintosh computer's ability to transfer images and information from one file to another. Medium: Macintosh computer, Macpaint.

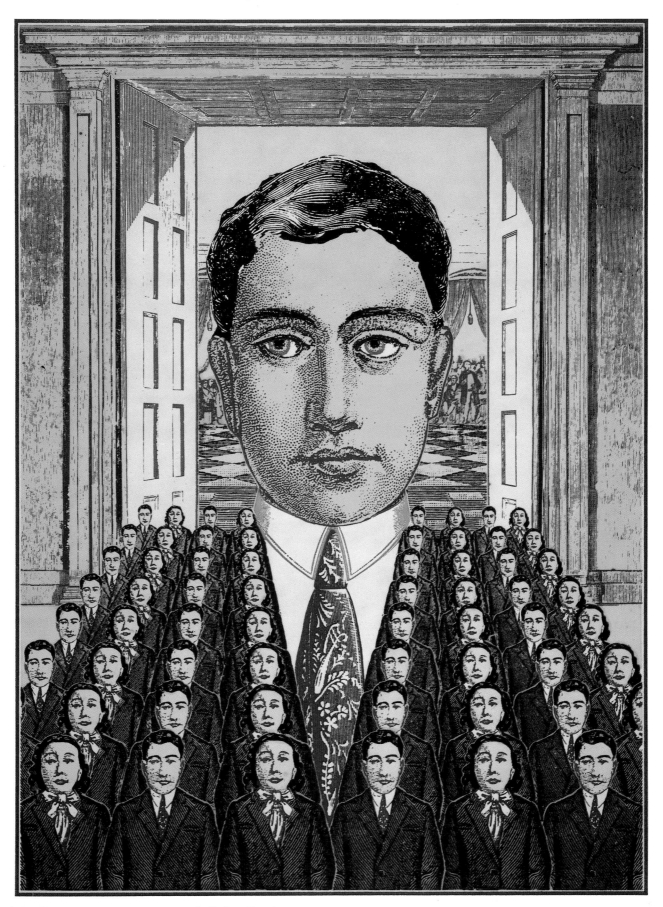

ART DIRECTOR
Barbara Groenteman
DESIGNER
Doris Kogan
PUBLICATION
*Meetings & Conventions,
January 1987*
PUBLISHING COMPANY
Murdoch Magazines
WRITER
Julie Moline

John Craig

John Craig's collage grouped business men and
women into one large central figure to represent the
formation of corporate culture and identity, for
"Marching to the Corporate Drum." Medium:
Collage and overlays.

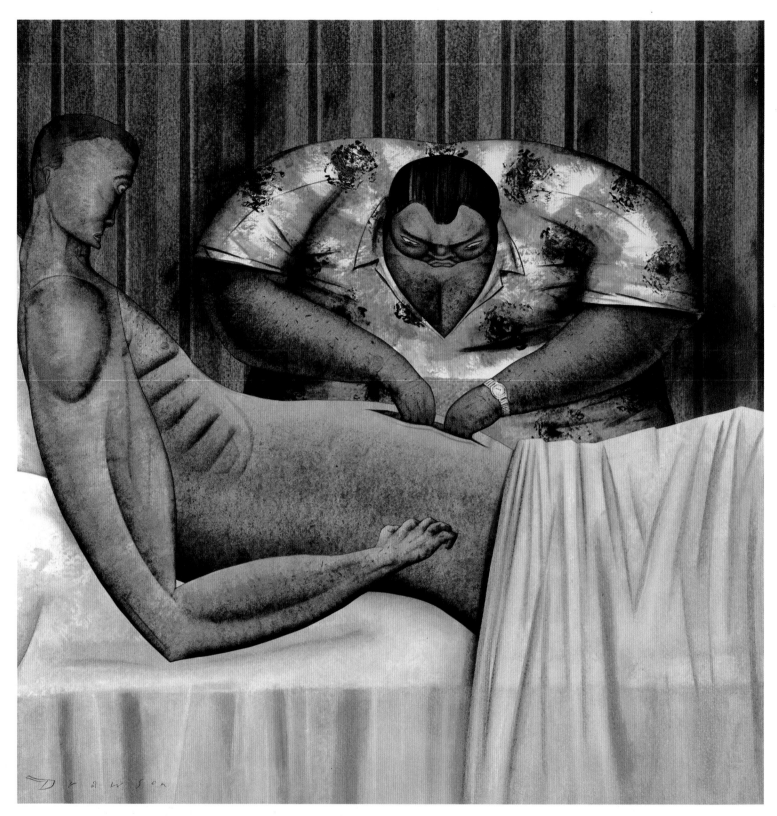

ART DIRECTOR
Nancy E. McMillen

DESIGNER
Fred Woodward

PUBLICATION
Texas Monthly, December 1986

PUBLISHING COMPANY
Texas Monthly, Inc.

WRITER
Gary Cartwright

Blair Drawson

Gary Cartwright's article on psychic surgery is illustrated with a vivid scene in the piece ("Touch Me, Feel Me, Heal Me"), when the so-called healer reaches into the patient's stomach. Medium: Mixed.

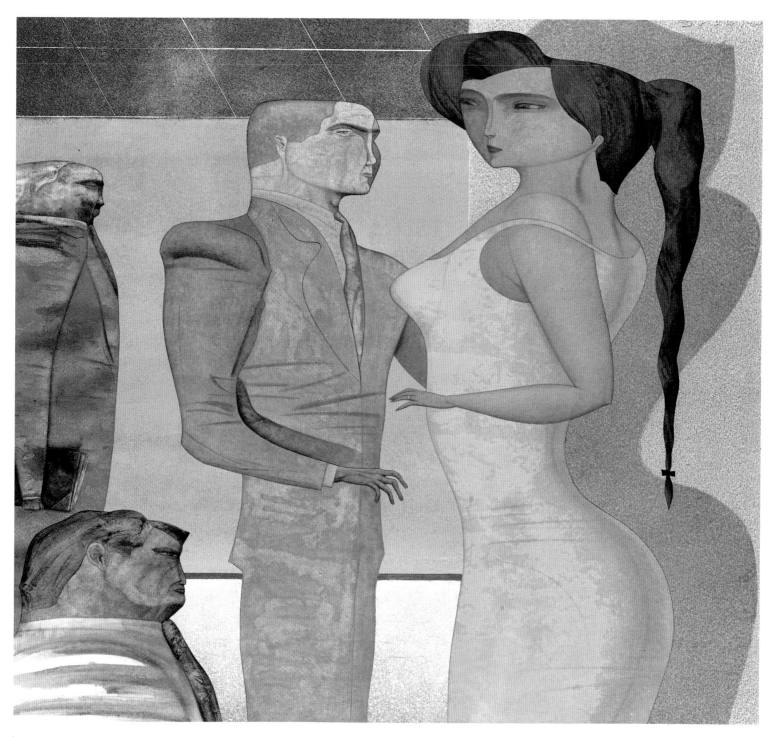

ART DIRECTOR
Tom Staebler

DESIGNER
Kerig Pope

PUBLICATION
Playboy, December 1986

PUBLISHING COMPANY
Playboy Enterprises, Inc.

WRITER
Thomas McGuane

Blair Drawson

The woman, the husband, the lover: Blair Drawson's rendering of the protagonists in Thomas McGuane's "Partners," a story of a love triangle. Medium: Mixed.

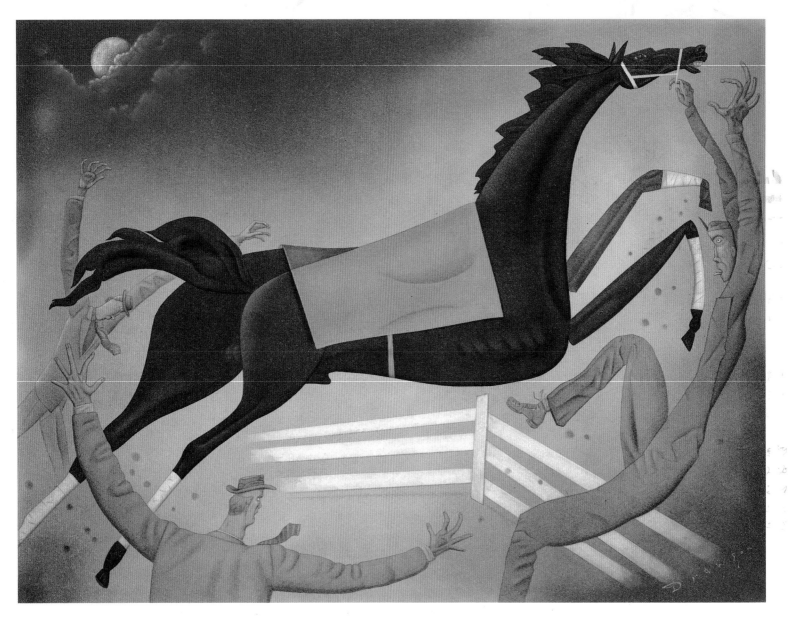

ART DIRECTOR
Tom Staebler

DESIGNER
Kerig Pope

PUBLICATION
Playboy, June 1986

PUBLISHING COMPANY
Playboy Enterprises, Inc.

WRITER
Donald E. Westlake

Blair Drawson

By making the animal the central figure in this illustration of a crucial scene drawn from Donald Westlake's "Horse Laugh," Blair Drawson emphasized the difficulty of trying to steal a horse in the dark. Medium: Watercolor.

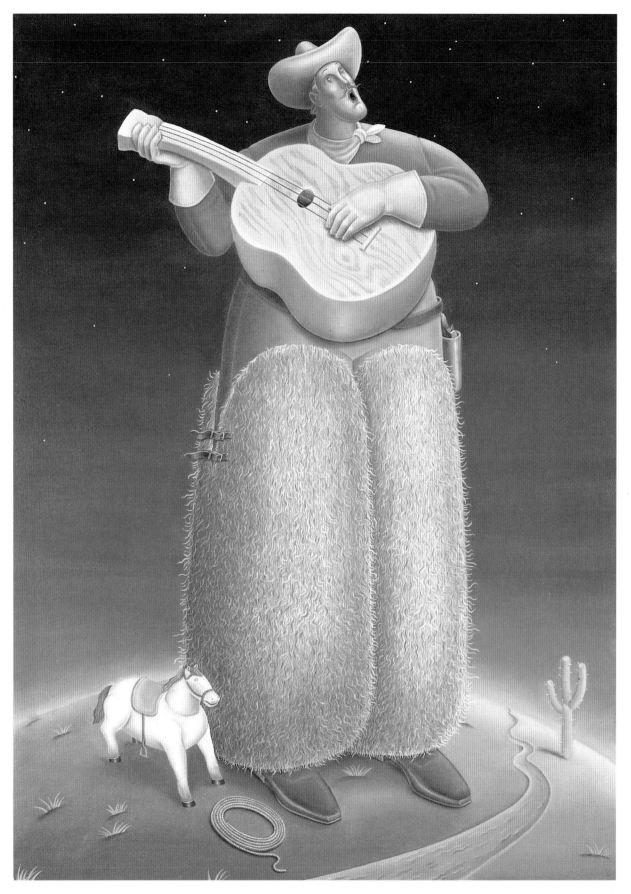

ART DIRECTOR
Fred Woodward

PUBLICATION
Texas Monthly, October 1986

PUBLISHING COMPANY
Texas Monthly, Inc.

Sandra Hendler

Sandra Hendler decided to paint a legendary larger than lifesize cowboy for her contribution to the magazine's regular feature on "Western Art." Medium: Oil.

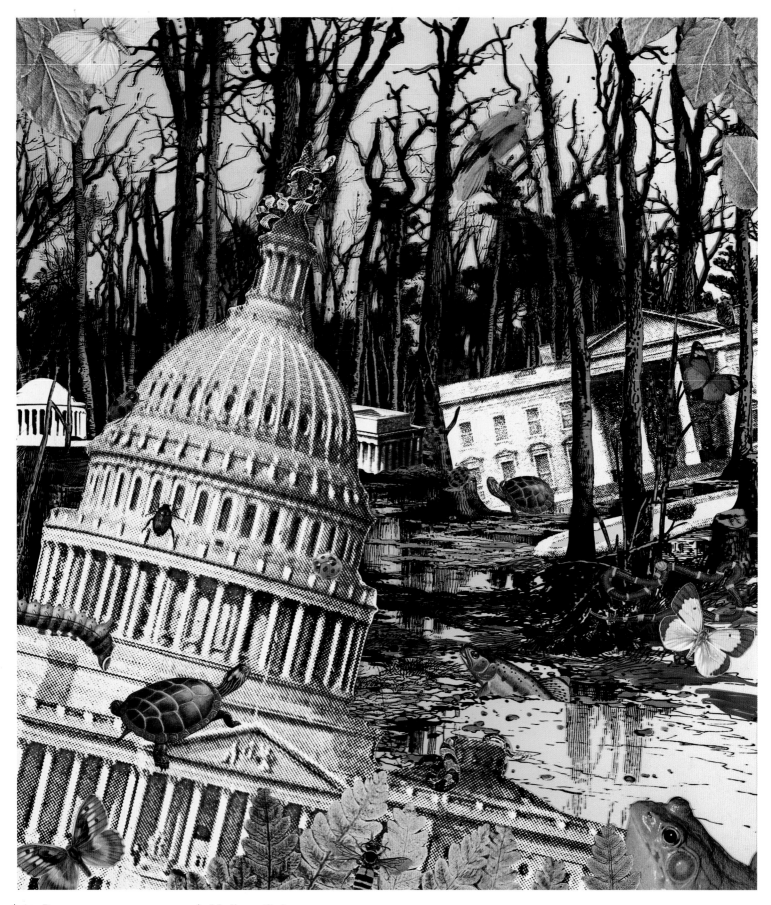

ART DIRECTOR
Brian Noyes

DESIGNER
Jann Alexander

PUBLICATION
The Washington Post Magazine
June 15, 1986

PUBLISHING COMPANY
The Washington Post

WRITER
Bob Arnebeck

Melissa Grimes

Melissa Grime's illustration of Washington, DC ran
with an article, "*What* Swamp?" debunking the myth
that the U.S. capital was built on a swamp. Medium:
Collage and mixed media.

ART DIRECTOR/DESIGNER
Su Pogany

PUBLICATION
Campus Voice, Spring 1987

PUBLISHING COMPANY
Whittle Communications

WRITER
Ed Ward

Melissa Grimes

"Wild Wild Life," about the writer's experience working as an extra in a marching band in the movie "True Stories" is depicted by a mix of an empty, vast Texas landscape and bizarre images from the movie. Medium: Xerox, collage and colored paper.

ART DIRECTOR
Tina Adamek

PUBLICATION
Postgraduate Medicine
December 1986

PUBLISHING COMPANY
McGraw-Hill, Inc.

WRITER
Perry S. Tepperman, M.D.

Gwyn M. Stramler

The long road back to recover from a devastating
stroke is emphasized in Gwyn M. Stramler's
illustration for an article called "Rehabilitation
Medicine." Medium: Watercolor and acrylic.

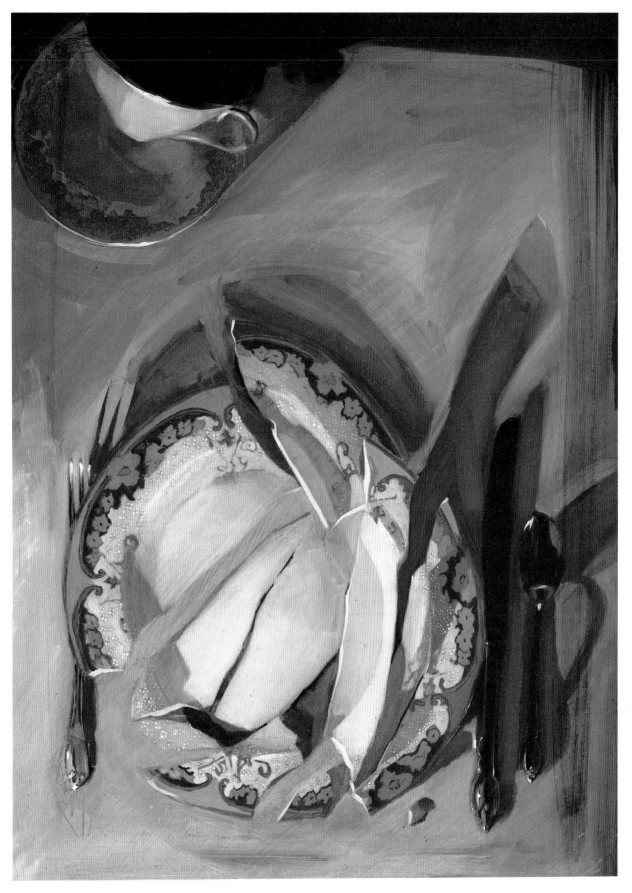

ART DIRECTOR/DESIGNER
Emily Borden
PUBLICATION
Valley, March 1986
PUBLISHING COMPANY
World of Communications
WRITER
Mike Nelson

Gwyn M. Stramler

A broken dish depicts the "Shattered Lives" of those afflicted with eating disorders. Medium: Watercolor and acrylic.

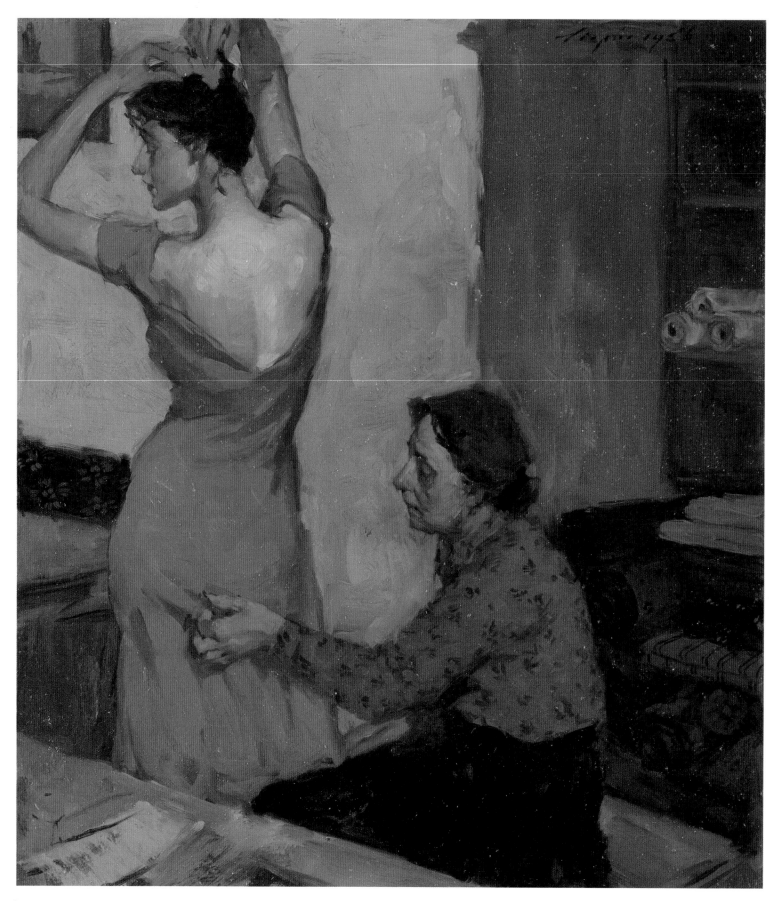

Art Director
Karen Price

Designer
Malcolm T. Liepke

Publication
Women's Monthly, February 15, 1986

Publishing Company
Hartwell Press

Writer
Barb Simpson

Malcolm T. Liepke

Malcolm Liepke's painting of a woman being fitted for a dress demonstrated the gist of an article on women's concerns about fashion and "Looking Good." Medium: Oil.

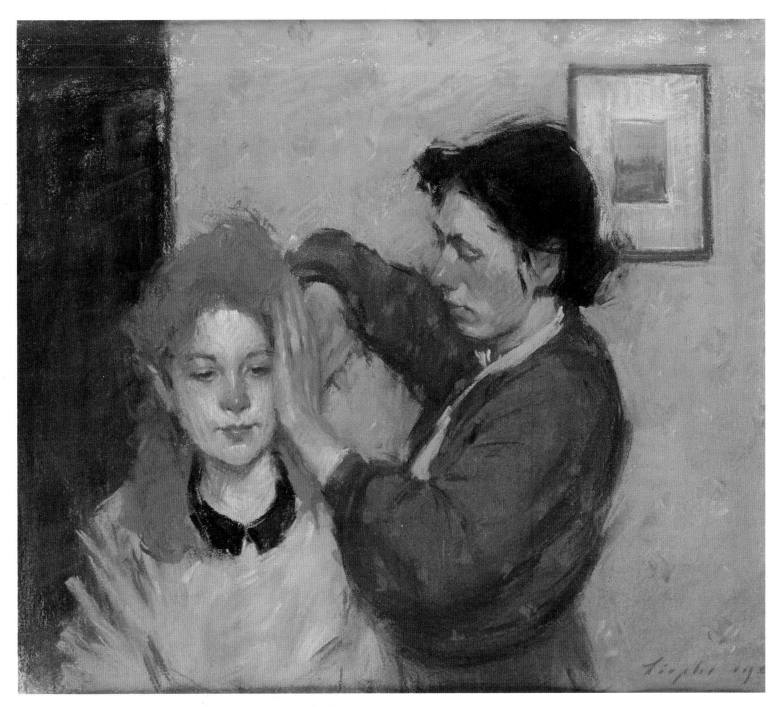

ART DIRECTOR
Craig Bowman

DESIGNER
Malcolm T. Liepke

PUBLICATION
Today's Family, March 1, 1986

PUBLISHING COMPANY
S & L Publishing Inc.

WRITER
Janet Marks

Malcolm T. Liepke

The love and caring evident in this painting served as a depiction of the article, "Your Daughter," dealing with the relationship between a mother and daughter. Medium: Pastel.

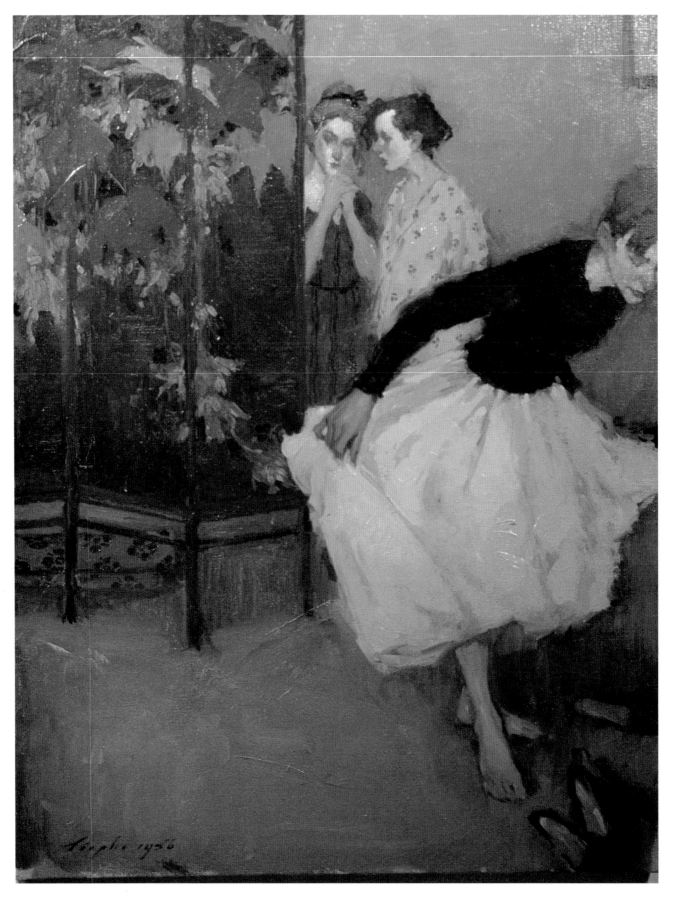

ART DIRECTOR
Karen Price
DESIGNER
Malcolm T. Liepke
PUBLICATION
Women's Monthly, June 1, 1986
PUBLISHING COMPANY
Hartwell Press
WRITER
Jan Colbert

Malcolm T. Liepke

Malcolm T. Liepke's behind-the-scenes look at a fashion show, for "A Look at Fashion," recalls the Impressionist images of Degas's dancers. Medium: Oil.

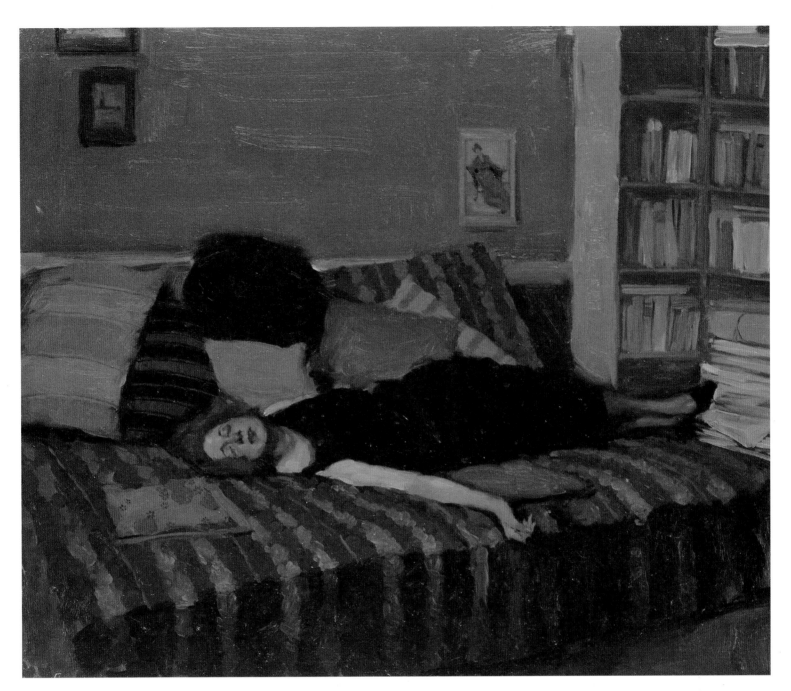

ART DIRECTOR
Karen Price

DESIGNER
Malcolm T. Liepke

PUBLICATION
Women's Monthly
September 15, 1986

PUBLISHING COMPANY
Hartwell Press

WRITER
Sonia Marks

Malcolm T. Liepke

Malcolm T. Liepke used a painting of a sleeping
woman to focus on the hectic lives of today's career
women ("On a Treadmill?") and their need for
relaxation. Medium: Oil.

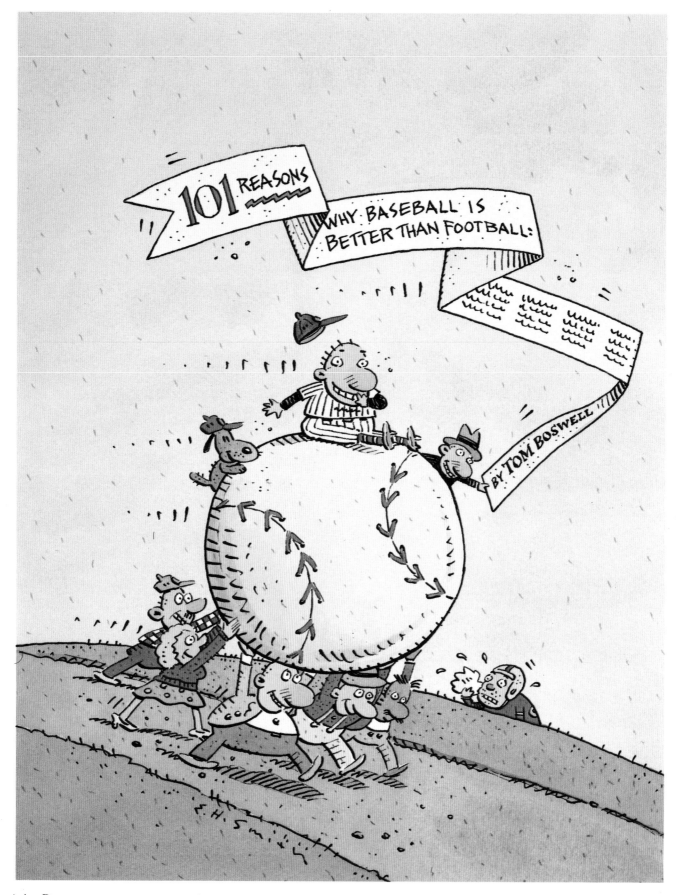

ART DIRECTOR
Michael Walsh

PUBLICATION
The Washington Post Magazine
January 18, 1987

PUBLISHING COMPANY
The Washington Post

WRITER
Thomas Boswell

Elwood H. Smith

Elwood Smith was given full reign in designing these illustrations for "99 Reasons Why Baseball is Better Than Football." The cover was assigned prior to the article's completion and enabled Elwood to consult with the writer about the story's humorous slant.
Medium: Watercolor and india ink.

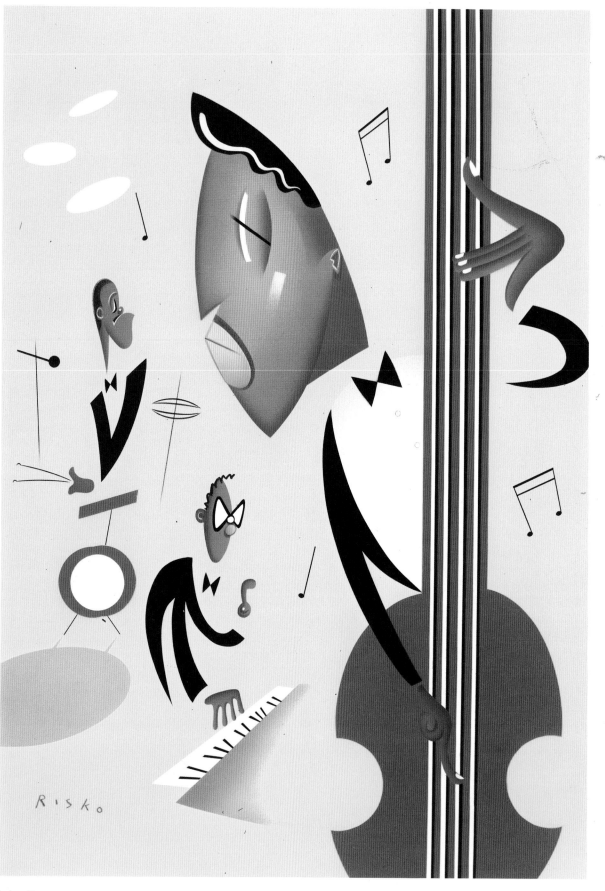

ART DIRECTOR
Derek Ungless
PUBLICATION
Rolling Stone, February 12, 1987
PUBLISHING COMPANY
Straight Arrow Publishers, Inc.
WRITER
David Fricke

Robert Risko

Sketch pad in hand, Robert Risko sat down and listened to Atlantic Records' "Classic Jazz and Blues LPs," and documented his mood. Medium: Gouache, airbrush.

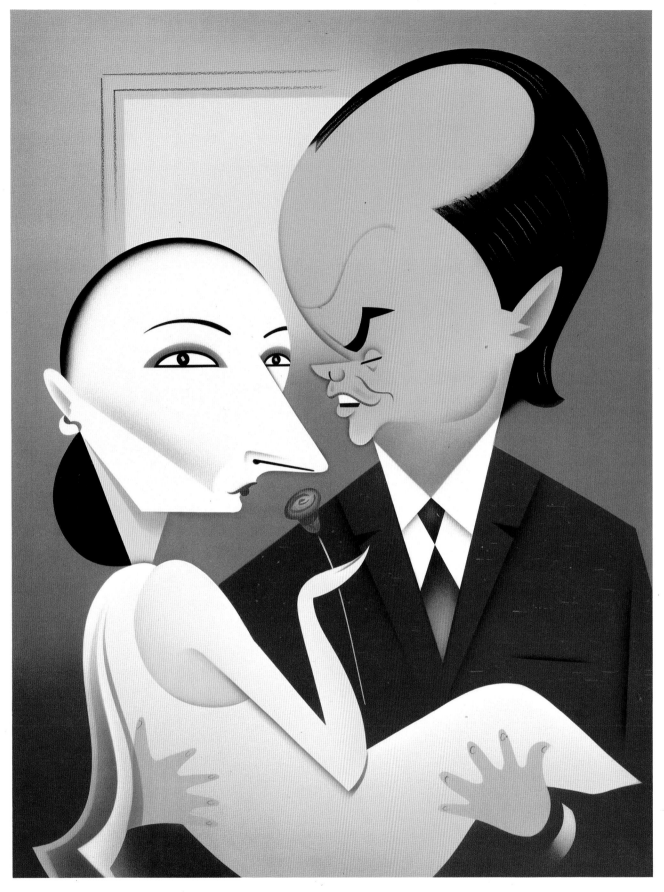

ART DIRECTOR
Tom Staebler
DESIGNER
Kerig Pope
PUBLICATION
Playboy, September 1986
PUBLISHING COMPANY
Playboy Enterprises, Inc.
WRITER
Richard Condon

Robert Risko

Robert Risko executed a caricature of Jack Nicholson carrying Anjelica Huston over the threshold in a scene from "Prizzi's Family," the prequel to "Prizzi's Honor." Medium: Airbrush with designer's gouache.

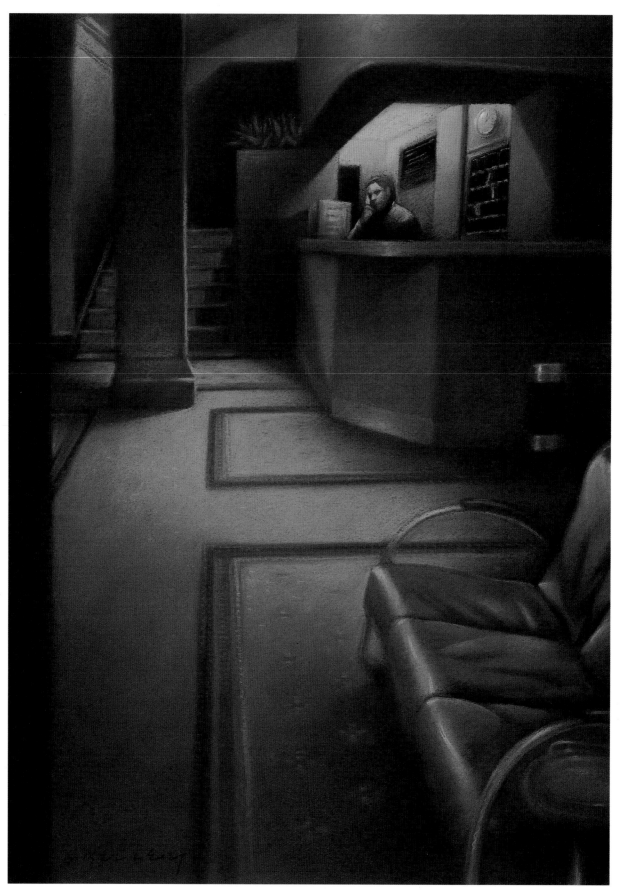

ART DIRECTOR
Rip Georges
PUBLICATION
L.A. Style, March 1987
PUBLISHING COMPANY
L.A. Style, Inc.
WRITER
Michael Fessier Jr.

Gary Kelley

A quiet moment in an old hotel: Gary Kelley's
illustration for a story, "Tell 420 I'm Sorry," pictures
a desk clerk talking on the telephone. Medium: Pastel.

ART DIRECTORS
Anna Janes and Jim Ireland
DESIGNERS
Jim Ireland and Anna Janes
PUBLICATION
*Canadian Radio Guide
February 1987*
PUBLISHING COMPANY
Publishing Services
WRITER
Diane Turbide

Joseph Salina

Murder and mayhem feature in Joseph Salina's cover illustration for "Murder Most Appealing," an article on a radio mystery series. Medium: Acrylic and oil glazes.

ART DIRECTOR
Gianni Caccia
PUBLICATION
Vice-Versa, May August 1986
PUBLISHING COMPANY
Les Editions Vice-Versa

Normand Cousineau

Normand Cousineau reveals the forbidden and seductive pleasures of eating in this cover illustration for a literary magazine's special on food, *"Plaisirs et Fantasmes de la Table."* Medium: Gouache, ink, colored pencil.

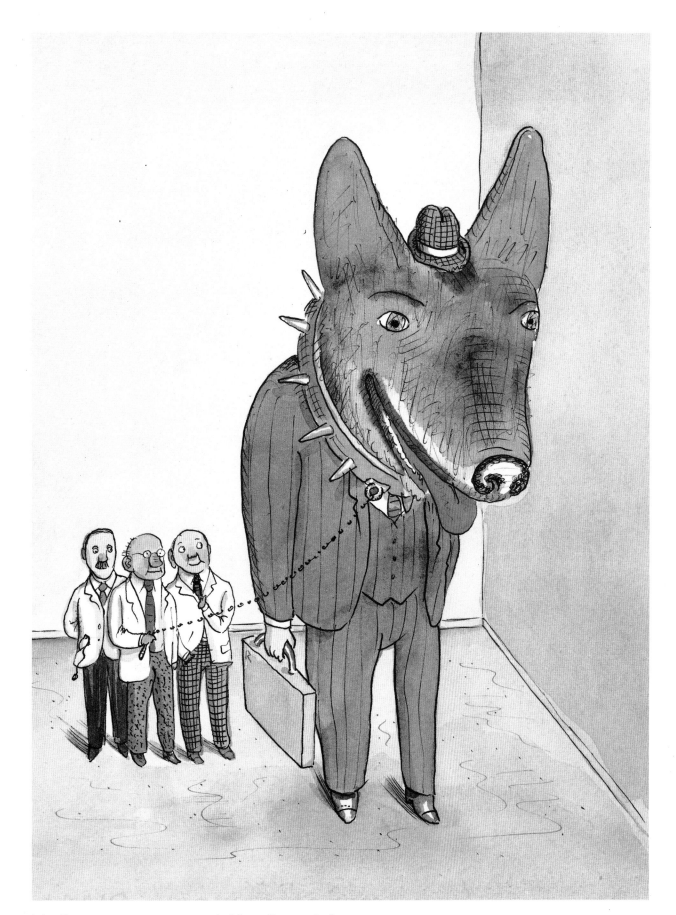

ART DIRECTOR
Roger Dowd
PUBLICATION
Medical Economics
October 20, 1986
PUBLISHING COMPANY
Medical Economics Company, Inc.
WRITER
James Lewis Griffith, J.D.

Marc Rosenthal

To portray the concept of lawyers as protectors for staff doctors, Marc Rosenthal combined the images of watchdog and lawyer into one formidable figure, for an article called "Why Your Medical Staff Needs Its Own Lawyer." Medium: Watercolor.

ART DIRECTOR
Harry Knox

DESIGNER
Jeff Dever

PUBLICATION
Liberty, July 1986

PUBLISHING COMPANY
*The General Conference of
Seventh-day Adventists*

WRITER
Joseph L. Conn

Bryan Leister

Bryan Leister's piece was created for
"Desanctification," an article on how Catholic
schools are changing in order to receive government
funds. Medium: Oil.

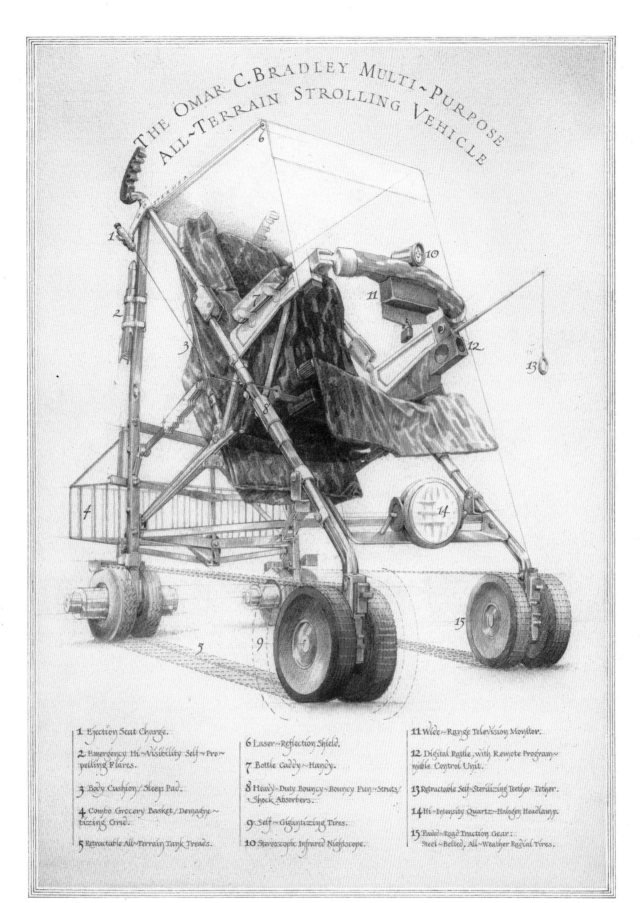

ART DIRECTOR
Veronique Vienne
PUBLICATION
Parenting, April 1987
PUBLISHING COMPANY
Parenting Magazine Partners
WRITER
Ellis Weiner

Dugald Stermer

To illustrate the writer's description of what might happen when "The Pentagon Designs a Stroller," Dugald Stermer played up the notorious inefficiency of so-called experts. Medium: Pencil and watercolor.

ART DIRECTOR
Elliott Negin

PUBLICATION
Public Citizen, October 1986

PUBLISHING COMPANY
Public Citizen, Inc.

WRITERS
John Shepard and Ian Gilbert

David Street

David Street was inspired by the socialist posters of the 1920s in his illustration for an article dealing with the Reagan administration's attempt to eradicate existing federal regulations on health and safety ("Reagan to Workers: Drop Dead"). Medium: Linocut with watercolor.

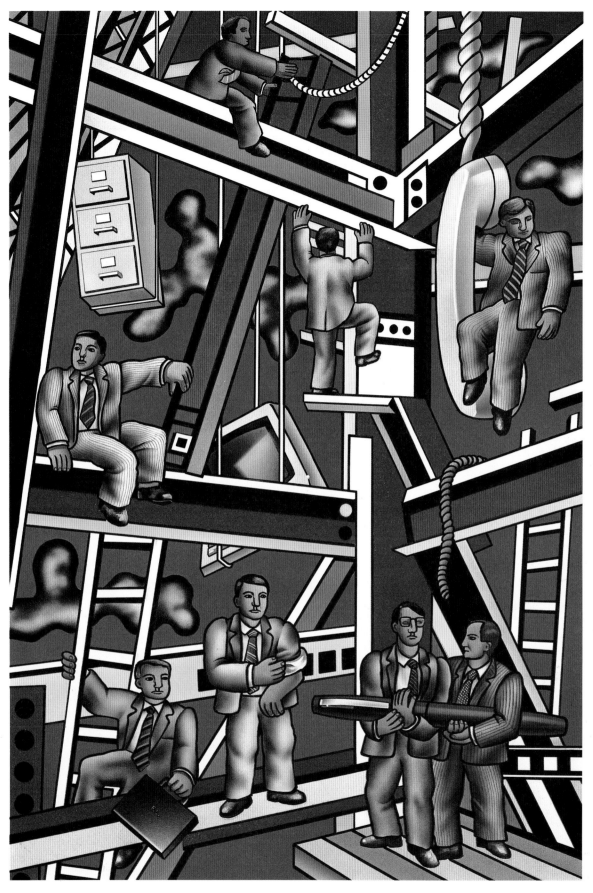

ART DIRECTOR
Cate Cochran

PUBLICATION
Canadian Business, July 1986

PUBLISHING COMPANY
C.B. Media Ltd.

WRITER
*Kathleen Fyfe and
Vivian Kanargelidis*

Mike Esk

Fernand Léger's painting "The Builders" provided the basis for this illustration of an article ("Changing the Mix") dealing with the expansion of Canada's 50 fastest-growing companies. Medium: Watercolor and gouache.

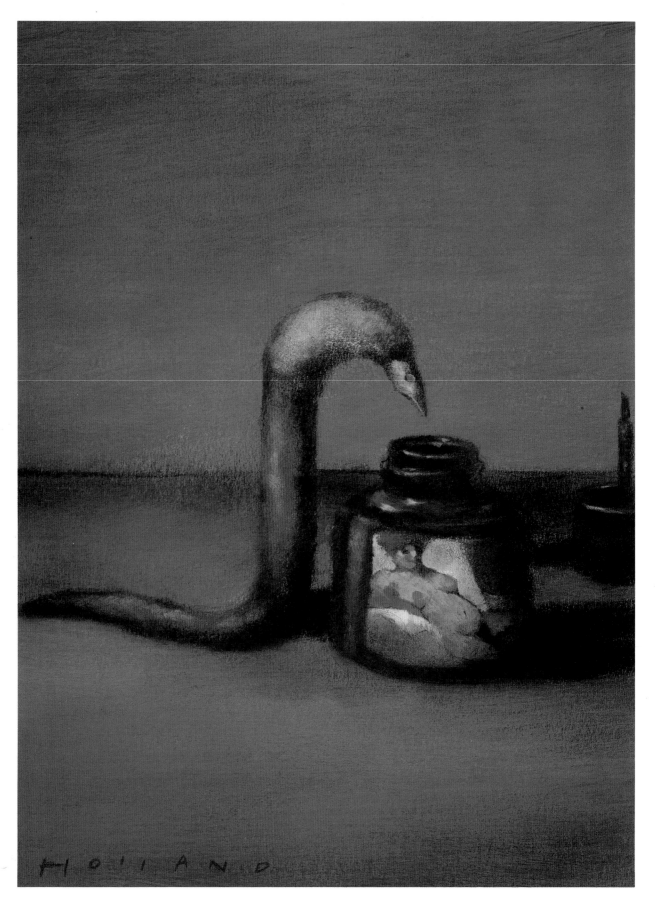

ART DIRECTOR
Tom Staebler/Kerig Pope
PUBLICATION
Playboy, May 1986
PUBLISHING COMPANY
Playboy Enterprises, Inc.
WRITER
Larry Tritten

Brad Holland

Brad Holland's pen & inkwell were portrayed as the tools of a fictional erotic writer for "The Notebooks of Gatling Wessex." Medium: Acrylic.

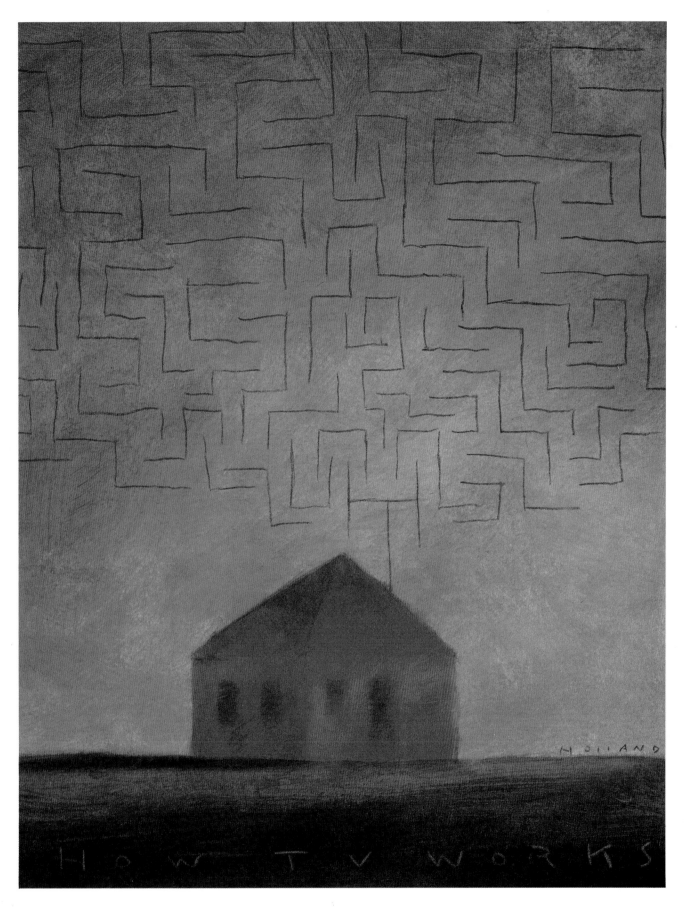

PUBLICATION
Print, May/June 1986
PUBLISHING COMPANY
RC Publications

Brad Holland

Brad Holland's house with a television antenna that
grows, and grows, and grows . . . for an article called
"Visual Commentary." Medium: Acrylic.

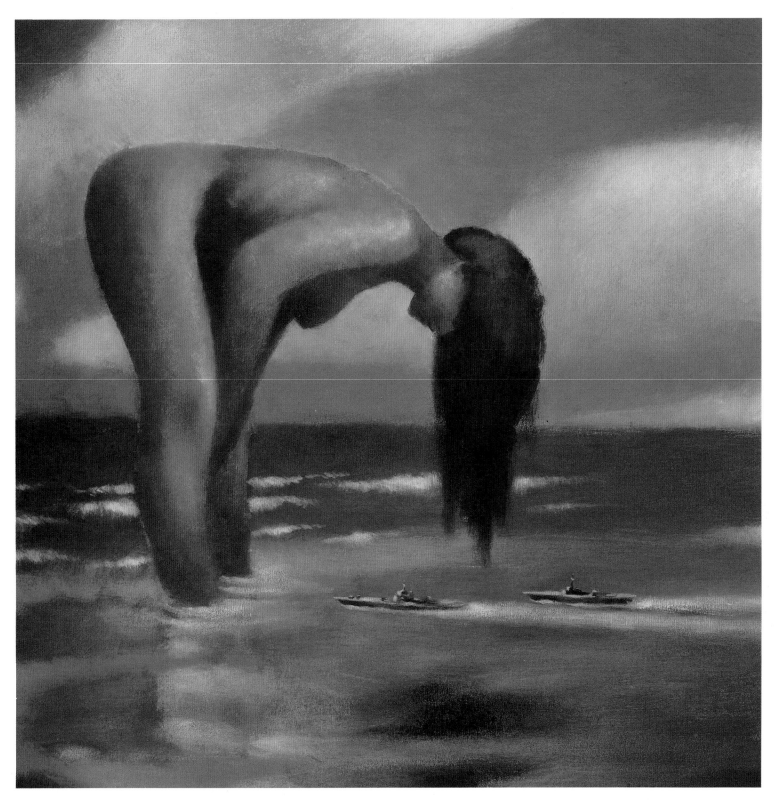

ART DIRECTOR
Tom Staebler

DESIGNER
Theo Kouvatsos

PUBLICATION
Playboy, September 1986

PUBLISHING COMPANY
Playboy Enterprises, Inc.

WRITER
P.F. Kluge

Brad Holland

Brad Holland's drawing of a Philippine woman ran with an article "Why They *Love* Us in the Philippines," on a country beset by political problems. Medium: Acrylic.

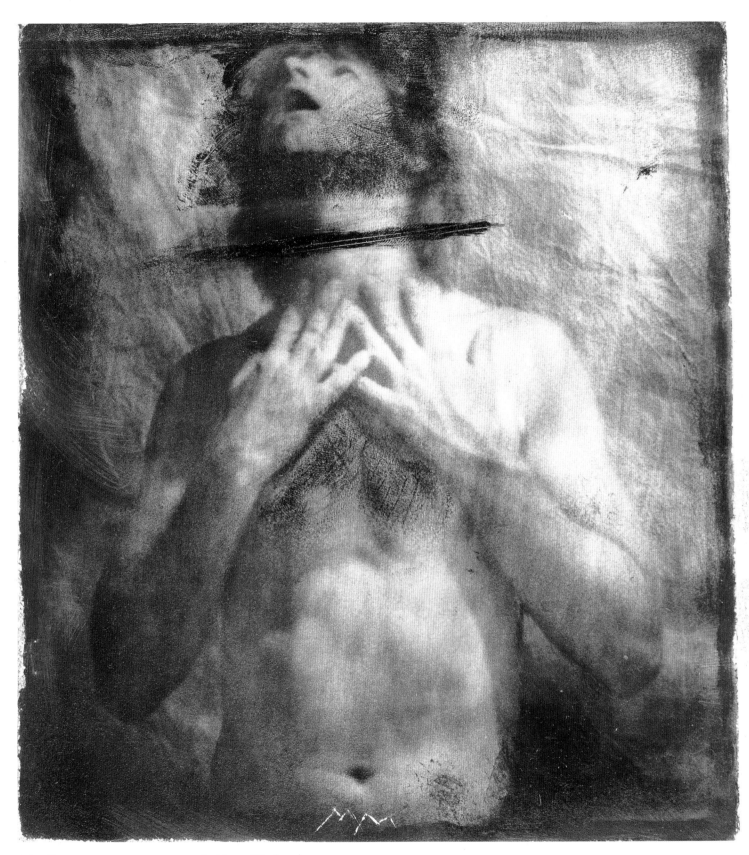

ART DIRECTOR
Tina Adamek

PUBLICATION
Postgraduate Medicine,
August 1986

PUBLISHING COMPANY
McGraw-Hill, Inc.

WRITER
Thomas L. Petty, M.D.

Matt Mahurin

Matt Mahurin's illustration for an article ("Pharmacotherapy for Chronic Obstructive Pulmonary Disease") on drug therapy for those afflicted with chronic obstructive pulmonary disease shows a man with a black slash across his neck to depict an obstruction of airflow. Medium: Photograph & Oil.

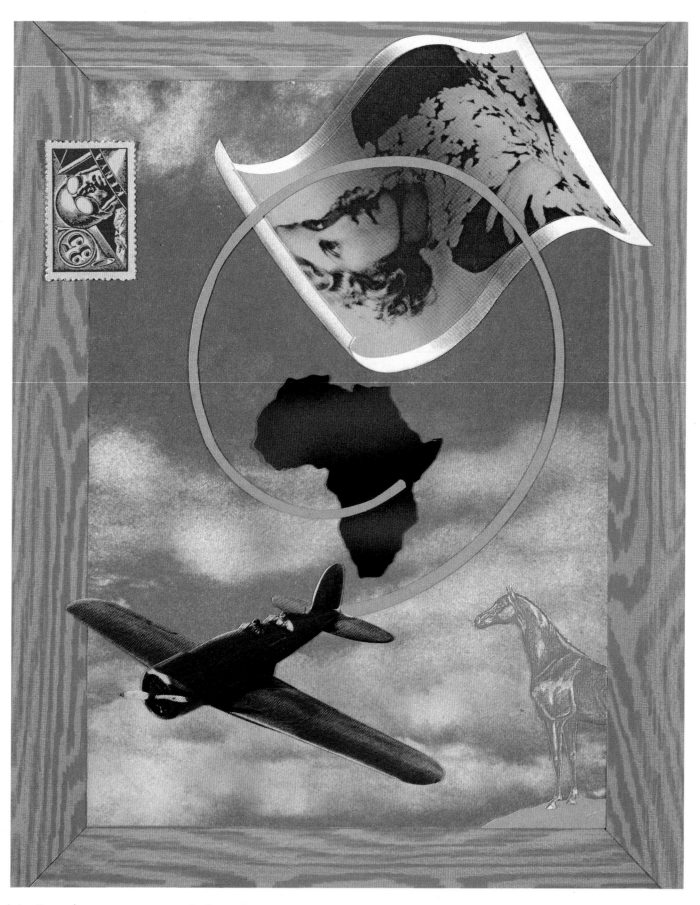

ART DIRECTOR
Lynn Staley

PUBLICATION
The Boston Globe, December 7, 1986

PUBLISHING COMPANY
Affiliated Publications, Inc.

WRITERS
Barry Shlachter with Amrita Shlachter

Gene Greif

Beryl Markham, the noted horsetrainer who pioneered aviation while living in Kenya in the 1930s, inspired Gene Greif's collage for "The Lady and The Legend." Medium: Collage.

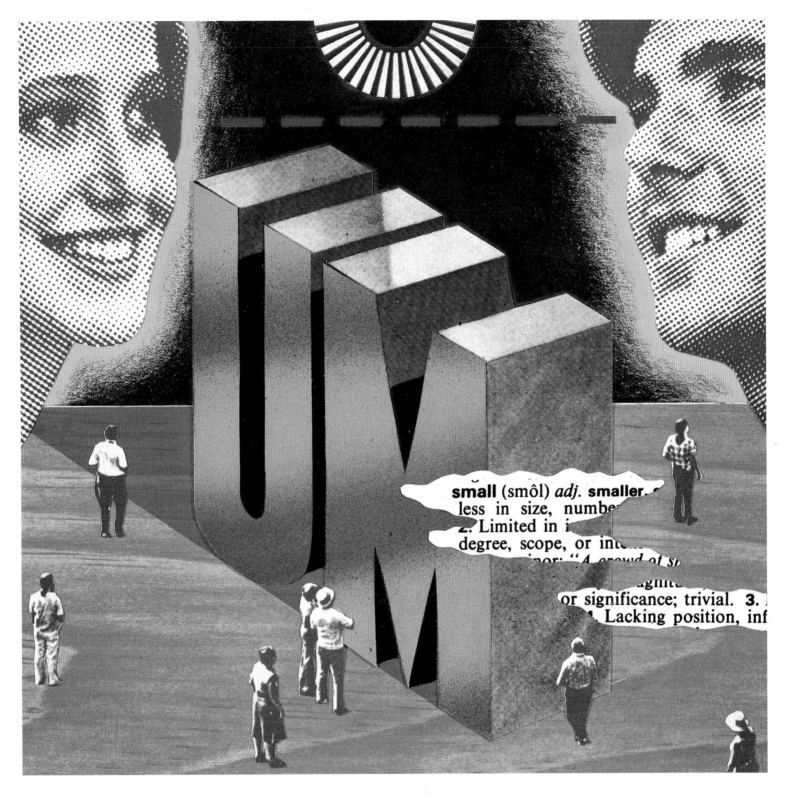

ART DIRECTOR
Melissa Warner

DESIGNER
Dania Martinez

PUBLICATION
Seventeen, January 1986

PUBLISHING COMPANY
Triangle Communications Inc.

WRITERS
*Joyce Anisman-Saltman with
Dan Carlinsky*

Gene Greif

The word "Um" is a symbol of the inability of some
to communicate with new acquaintances, and takes
on monumental proportions ("When Small Talk's a
Big Deal"), in Gene Greif's illustration. Medium:
Collage.

ART DIRECTOR
Nancy Butkus

DESIGNER
Gina Davis

PUBLICATION
Manhattan, inc., April 1986

PUBLISHING COMPANY
Metrocorp

WRITER
Adrienne Simmons

Dave Calver

To enliven and article that concerned itself with the statistics of the messenger business, "Street Fleet," Dave Calver showed a cityscape filled with messengers drawn in a humorous vein. Medium: Colored pencil.

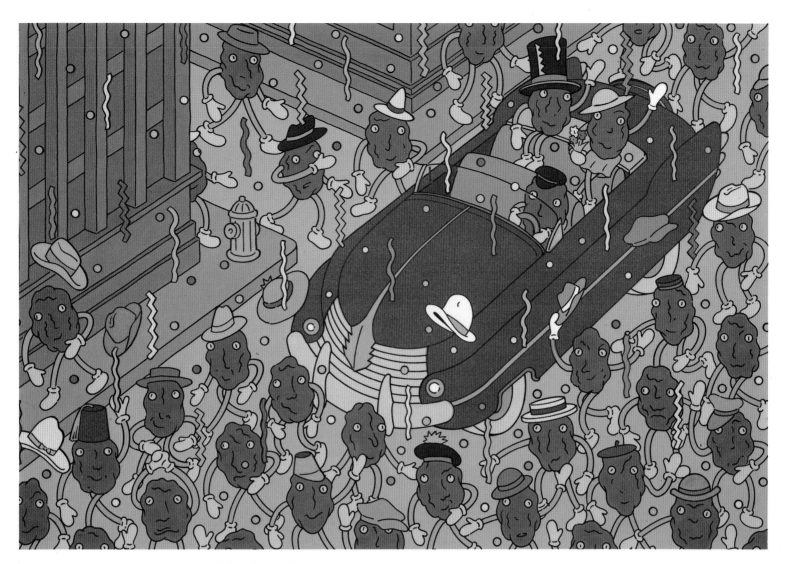

ART DIRECTOR
Robin Jefferies

DESIGNER
Dick Daniels

PUBLICATION
Kansas City Star, February 28, 1987

PUBLISHING COMPANY
Kansas City Star

WRITER
Charlyne Varkonyi

Dick Daniels

The resurgence of the raisin, popularized in a recent series of successful television commercials, was the subject of Dick Daniels's painting for a food-supplement article, "Raisin' a Little Respect."
Medium: Acrylic on acetate.

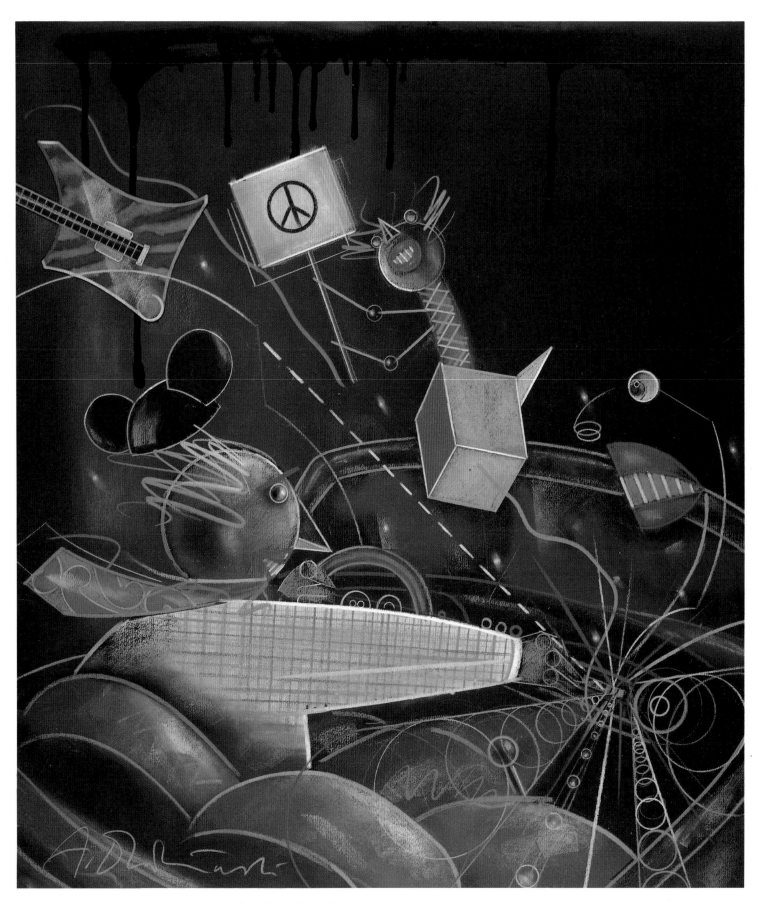

ART DIRECTOR/DESIGNER
Bambi Nicklen
PUBLICATION
West, April 27, 1986
PUBLISHING COMPANY
San Jose Mercury News
WRITER
Edward O. Welles

Andrzej Dudzinski

Rock and roll blares out of Andrzej Dudzinski's cover illustration for a feature on FM stations, "It's Only Rock 'n Roll." Medium: Pastel.

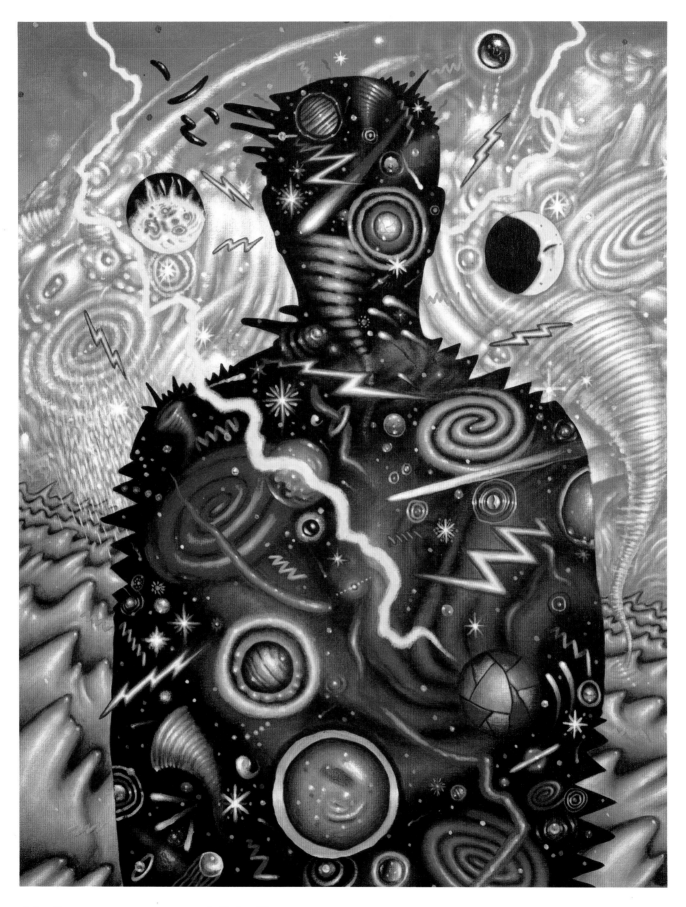

ART DIRECTOR
Cynthia Hoffman
PUBLICATION
Chicago, May 1986
PUBLISHING COMPANY
Metropolitan Communications, Inc.
WRITER
James Krohe Jr.

John Kurtz

Lightning, tornadoes and rain assault a human image in John Kurtz's illustration for "The Weather and Us," an article on the effect of weather on people. Medium: Oil.

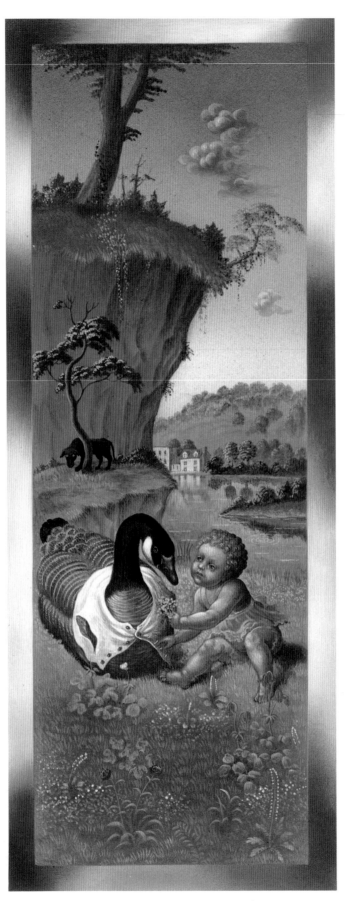

ART DIRECTOR/DESIGNER
Alice Degenhardt
PUBLICATION
Creative Living, Winter 1987
PUBLISHING COMPANY
*Northwestern Mutual Life
Insurance*
WRITER
David McKelvey

Kinuko Y. Craft

Creative interaction between humans and animals is subtly conveyed in this illustration by Kinuko Y. Craft for an article called "Learning of Ourselves From Llamas, Leopards and Leaping Lizards." Medium: Egg tempera.

CREATIVE DIRECTOR
Will Kefauver
DESIGNER
Sandra Mayer
PUBLICATION
Literary Cavalcade, March 1987
PUBLISHING COMPANY
Scholastic Inc.
WRITER
F. Scott Fitzgerald

Douglas Fraser

Needing to set a serious tone for F. Scott Fitzgerald's story, "The Baby Party," Doug Fraser decided to crop in close on the children, carefully controlling the flow of movement and light. Medium: Oil on paper.

ART DIRECTOR/DESIGNER
Cynthia Hoffman
PUBLICATION
Chicago, March 1987
PUBLISHING COMPANY
Metropolitan Communications, Inc.
WRITER
Laurence Gonzales

Jeffrey Smith

Jeffrey Smith's illustration is one of a series he created for "No Escape," an article that featured the conversations and experiences of four patients who live in a state mental hospital. Medium: Watercolor.

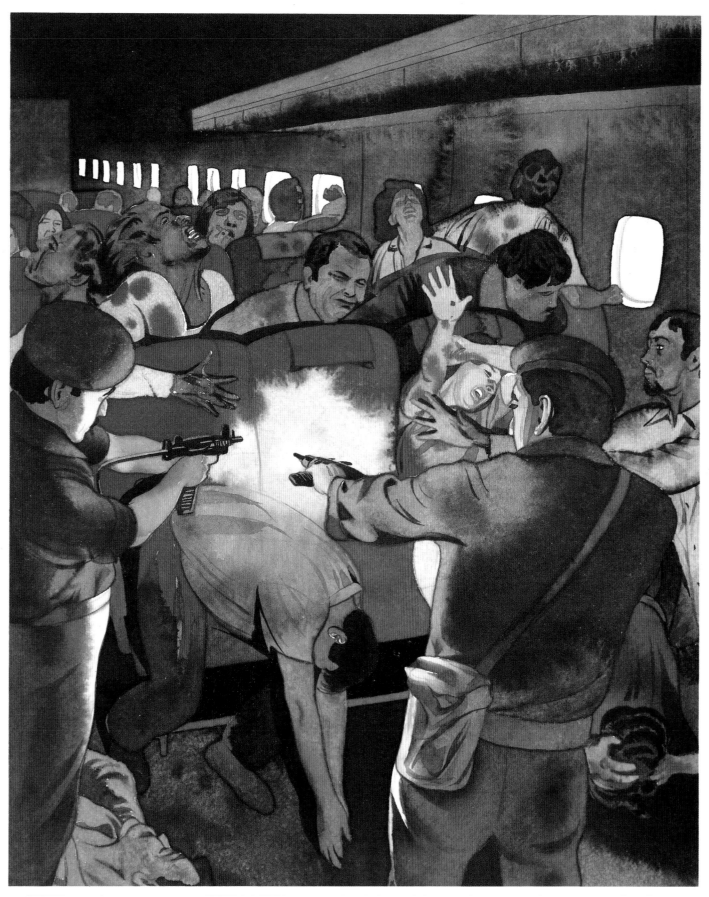

ART DIRECTOR
Patricia von Brachel

DESIGNER
Roger Black

PUBLICATION
Newsweek, September 15, 1986

PUBLISHING COMPANY
Newsweek, Inc.

WRITER
Harry Anderson et. al.

Jeffrey Smith

A violent scene during a 16-hour ordeal ("The Agony of Pan Am Flight 73") undergone by hostages of terrorists who had hijacked an airplane, as recreated by Jeffrey Smith. Medium: Watercolor.

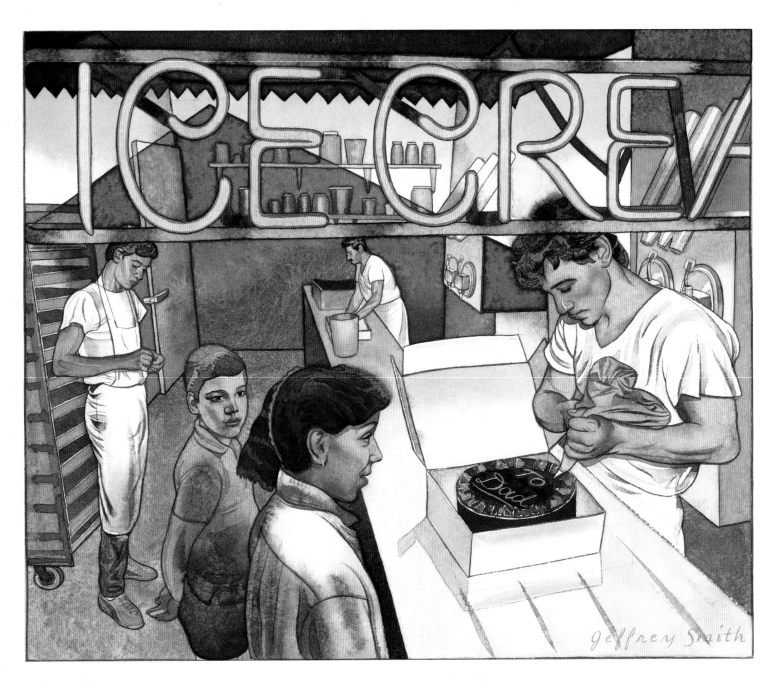

ART DIRECTOR
Diana LaGuardia
DESIGNER
Audrey Razgaitas
PUBLICATION
*The New York Times Magazine
September 14, 1986*
PUBISHING COMPANY
The New York Times
WRITER
Peter C. Canning

Jeffrey Smith

Jeffrey Smith's illustration, set in a bakery, pictures an event from an article called ''Family Ties,'' about the effects of divorce on children. Medium: Watercolor.

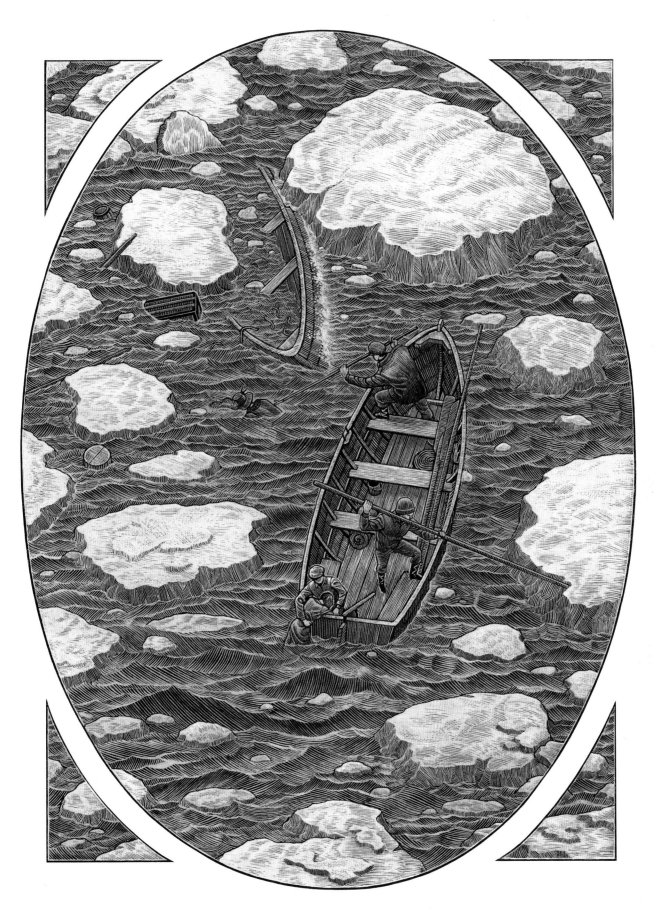

ART DIRECTOR
Wendall K. Harrington

DESIGNER
Scott Yardley

PUBLICATION
Esquire, November 1986

PUBLISHING COMPANY
Hearst Corporation

WRITER
William Kennedy

Douglas Smith

Cold colors depict a winter scene in a short story, "A Cataclysm of Love," set in Albany in the 1880s, relating the rescue of the survivor of a river skiff capsized by ice floes. Medium: Watercolor and scratchboard.

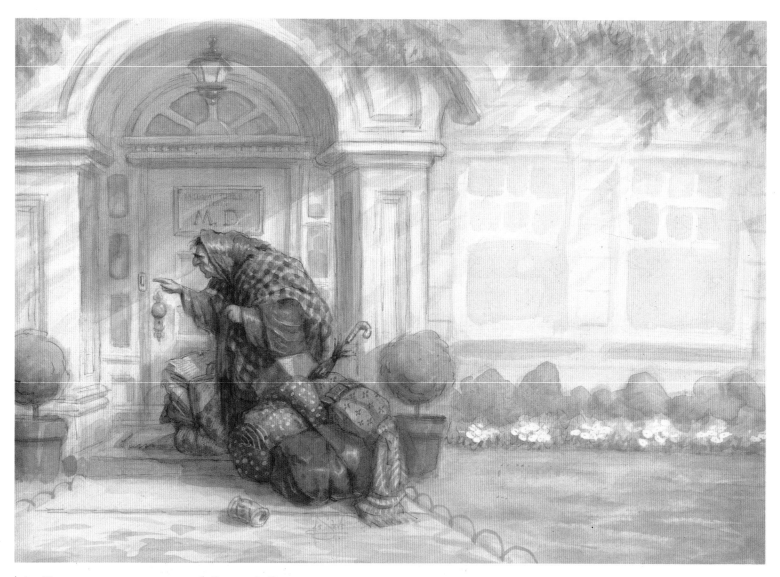

ART DIRECTOR
Lois Erlacher

DESIGNER
Marlene Goldman

PUBLICATION
Emergency Medicine
October 15, 1986

PUBLISHING COMPANY
Cahners Publishing Company

WRITER
Alan Fitch

Peter de Sève

Peter de Sève used the contrast between the images of a clean and proper suburban doctor's office and a shopping-bag lady dressed in rags to illustrate "With Neither Home Nor Health," an article on the plight of the homeless and ailing. Medium: Watercolor.

ART DIRECTOR
Esther Coit
PUBLICATION
San Diego, October 1986
PUBLISHING COMPANY
R.R. Donnelley & Sons
WRITER
Martin Hill

Everett Peck

Martin Hill's account of "The Prisoners of Lindbergh Field," about the poor location of an airport and the various proposals submitted to remedy the situation, are depicted in Everett Peck's drawing. Medium: Pen and ink with wash.

ART DIRECTOR
Fabien Baron

DESIGNER
Anne Kwong

PUBLICATION
New York Woman, November 1986

PUBLISHING COMPANY
American Express Publishing Corporation

Karen Barbour

Karen Barbour's image of a man in an urban setting illustrated an article detailing the most passionate moments, such as "Desire under the El," experienced by various well-known personalities in New York City. Medium: Gouache.

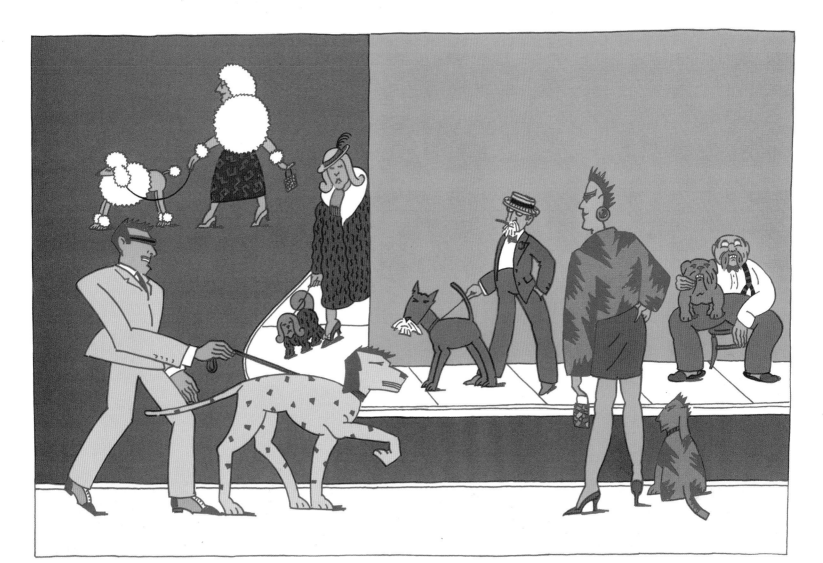

ART DIRECTOR
Hans Georg Pospischil

DESIGNER
Seymour Chwast

PUBLICATION
*Frankfurter Allgemeine
October 1986*

PUBLISHING COMPANY
Frankfurter Allgemeine Zeitung

WRITER
Von Michael Freitag

Seymour Chwast

Part of a cover and two-page spread for "The Dog I Am," this playful street scene showing people who look like their pet dogs was conceived and illustrated by Seymour Chwast. Medium: Color overlay.

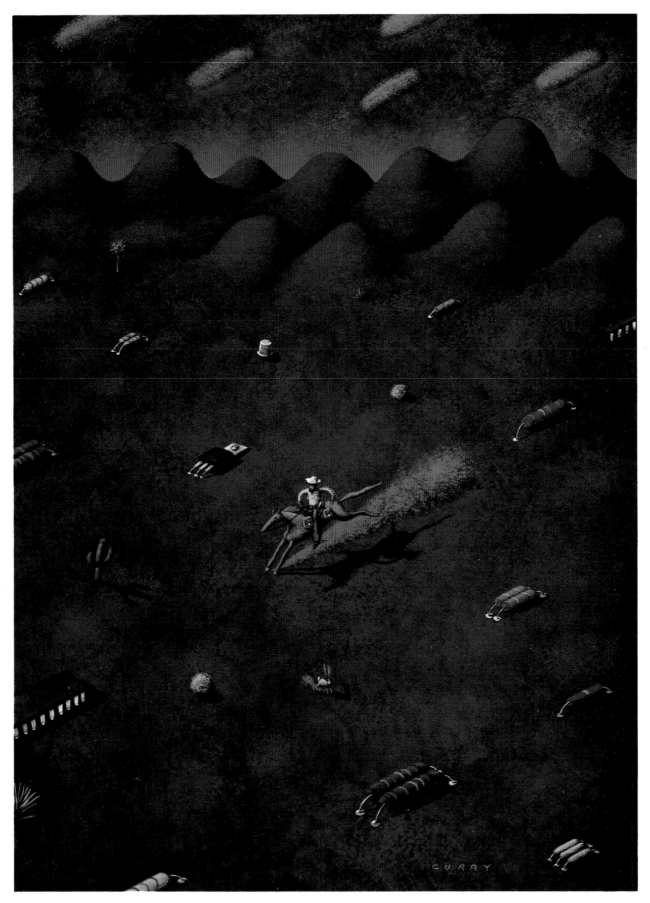

ART DIRECTOR
Deborah Flynn Hanrahan
PUBLICATION
Lotus, July 1986
PUBLISHING COMPANY
Lotus Publishing Corporation
WRITER
Jack Coppley

Tom Curry

Tom Curry puts a pony-express rider in a silicone prairie environment to suggest the speed of electronic mail in this computer magazine cover story, "Symphonic Mail, Part I." Medium: Acrylic.

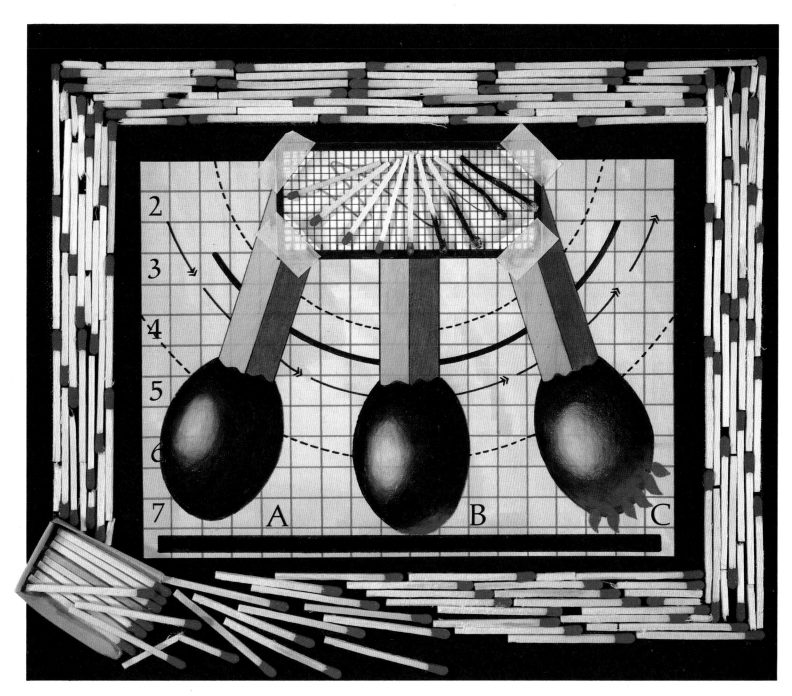

ART DIRECTOR/DESIGNER
Philip Brooker
PUBLICATION
The Miami Herald, May 4, 1986
PUBLISHING COMPANY
The Miami Herald

Philip Brooker

Philip Brooker used girds, arrows, press type, and real matches to create this illustration for a humorous primer called "How Things Work." Medium: India ink, pencil, gouache, matches.

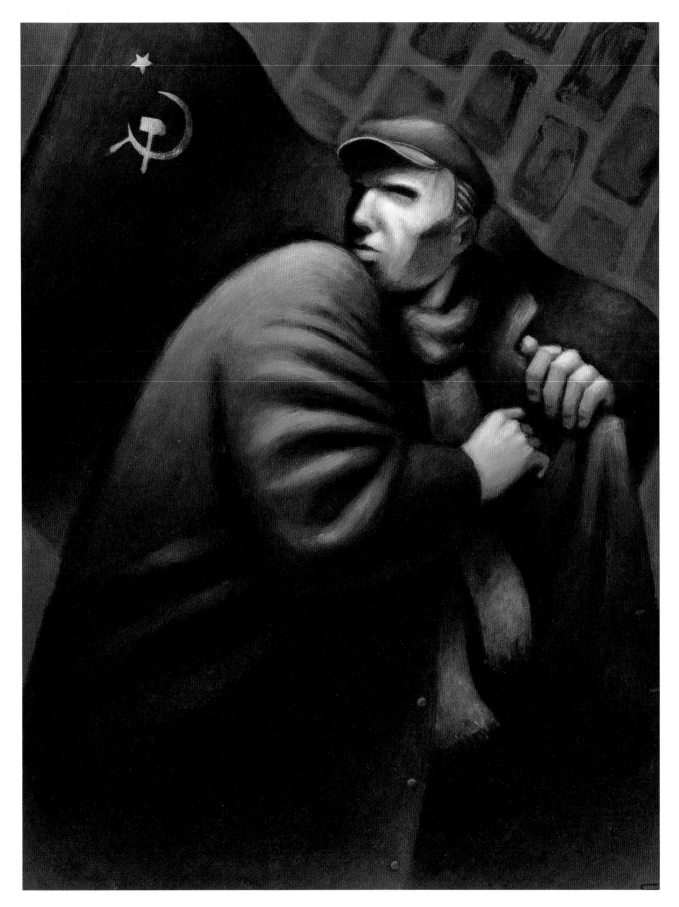

ART DIRECTOR
Fred Woodward
DESIGNER
Jolene Coyler
PUBLICATION
Regardie's, March 1987
PUBLISHING COMPANY
Regardie's Magazine, Inc.
WRITER
A. Craig Copetas

David Shannon

To illustrate "Notes From the Underground," on the thriving black-market economy in the U.S.S.R., David Shannon presented a poster employing a figure of heroic proportions prevalent in Soviet propaganda pieces. Medium: Acrylic.

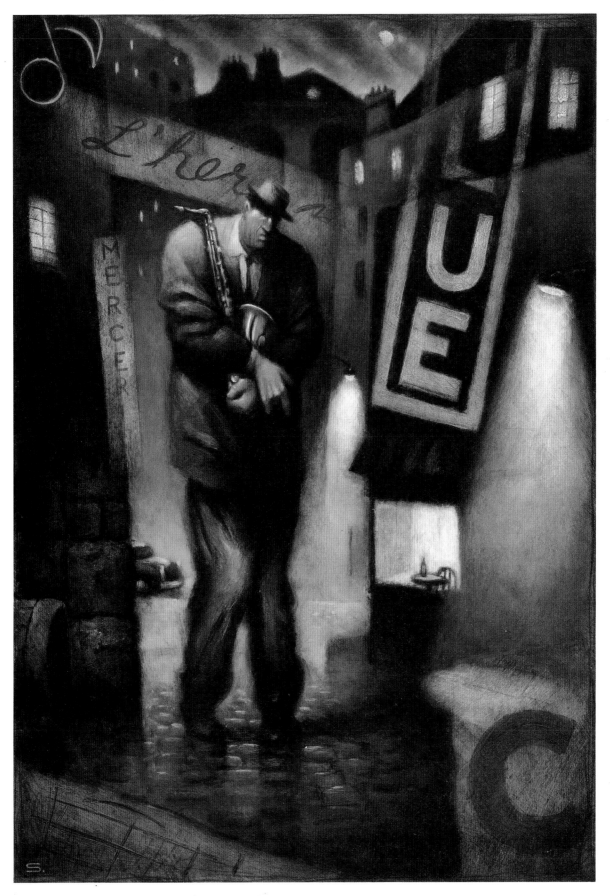

ART DIRECTOR
Michael Walsh

PUBLICATION
The Washington Post Magazine
November 16, 1986

PUBLISHING COMPANY
The Washington Post

WRITER
Irene Kubota

David Shannon

A street scene at night shows a lone figure clutching a musical instrument in David Shannon's drawing for "Some Liked It Hot," an article on Dexter Gordon, star of the movie "Round Midnight," about the jazz era in Paris. Medium: Acrylic.

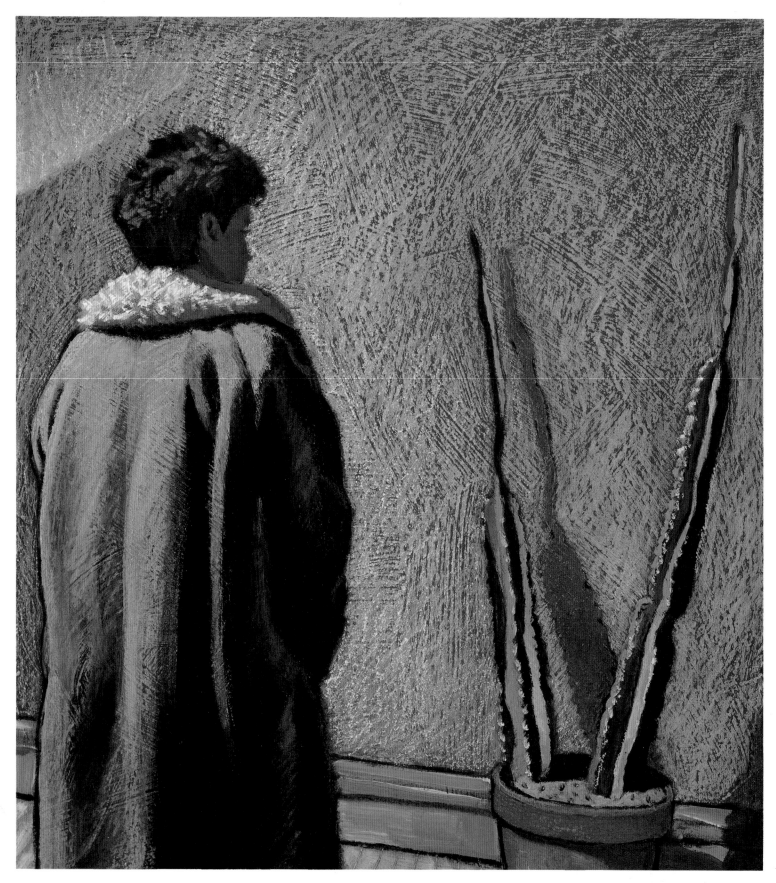

ART DIRECTOR
Bill Gaspard

DESIGNER
Linden Wilson

PUBLICATION
Kansas City Star Magazine
December 21, 1986

PUBLISHING COMPANY
Kansas City Star

WRITER
Helen Carper

Linden Wilson

A cactus, a woman in a winter coat, bright sunshine streaming on both: Linden Wilson's images for a Christmas story ("Baubles and Spice") on a woman's inability to adapt to the warm weather when her family moves to the Rio Grande Valley of Texas. Medium: Alkyd and oil pastel.

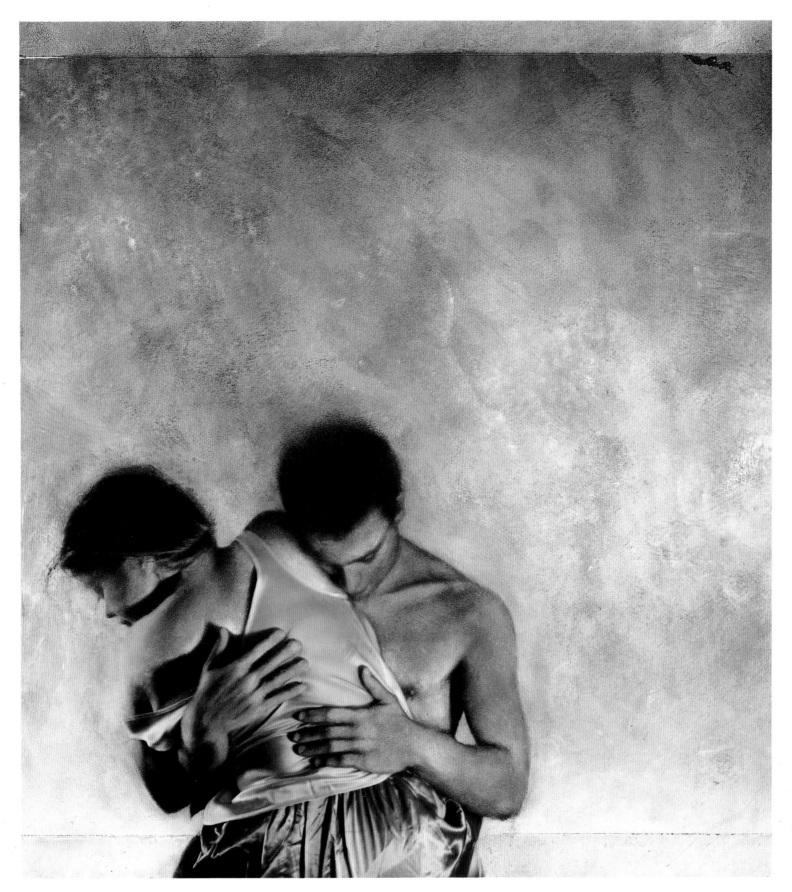

ART DIRECTOR/DESIGNER
Ken Palumbo

PUBLICATION
Playgirl, March 1987

PUBLISHING COMPANY
Playgirl Inc.

WRITER
Sara Nelson

Joanie Schwarz

The end of a love affair may not be the end of the relationship, observes Joanie Schwarz in her illustration for "Happily Not Ever After." Medium: Oil.

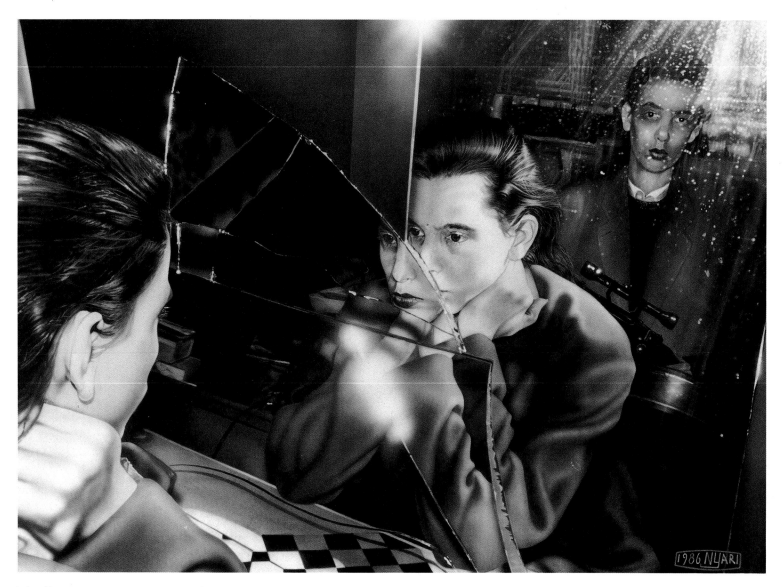

ART DIRECTOR
Derek Ungless

DESIGNER
Raul Martinez

PUBLICATION
Rolling Stone
July 17/31, 1986

PUBLISHING COMPANY
Straight Arrow Publishers, Inc.

WRITER
Frederick Exley

Istvan Nyari

By using stark black-and-white, 'film noir' style
drawing and employing images such as the borken
mirror, Istvan Nyari suggests the sexual tension
between the two main characters in this short story,
"Brother in Arms." Medium: Gouache.

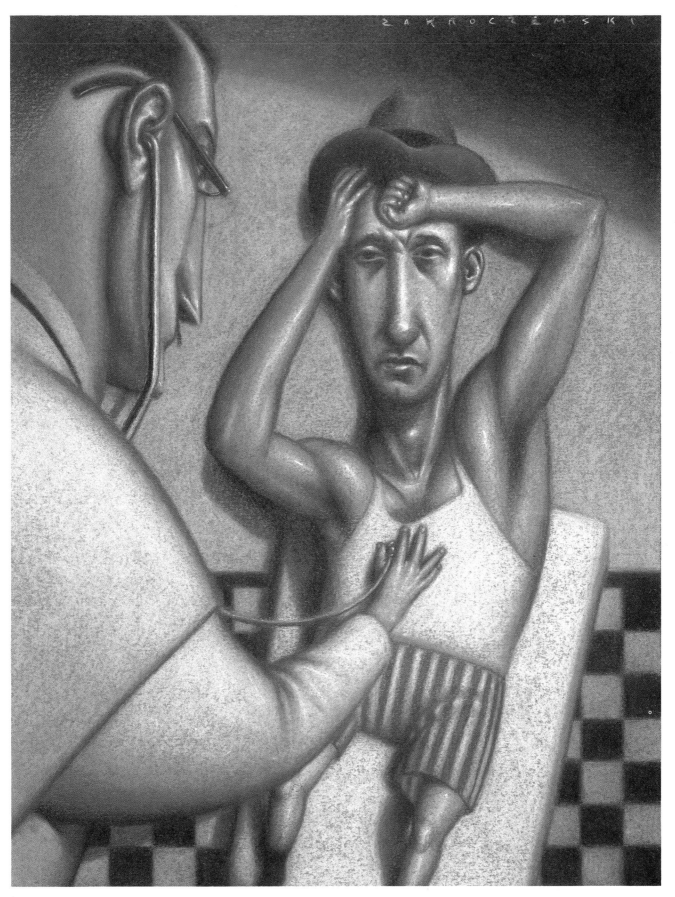

ART DIRECTOR
Allan Kegler
PUBLICATION
Buffalo Physician, September 1986
PUBLISHING COMPANY
University of Buffalo, Publications
WRITER
Guy A. Taylor

Daniel Zakroczemski

A physician examining an ailing man illustrates a medical article on "Differential Diagnosis of Common Complaints." Medium: Pastel pencils.

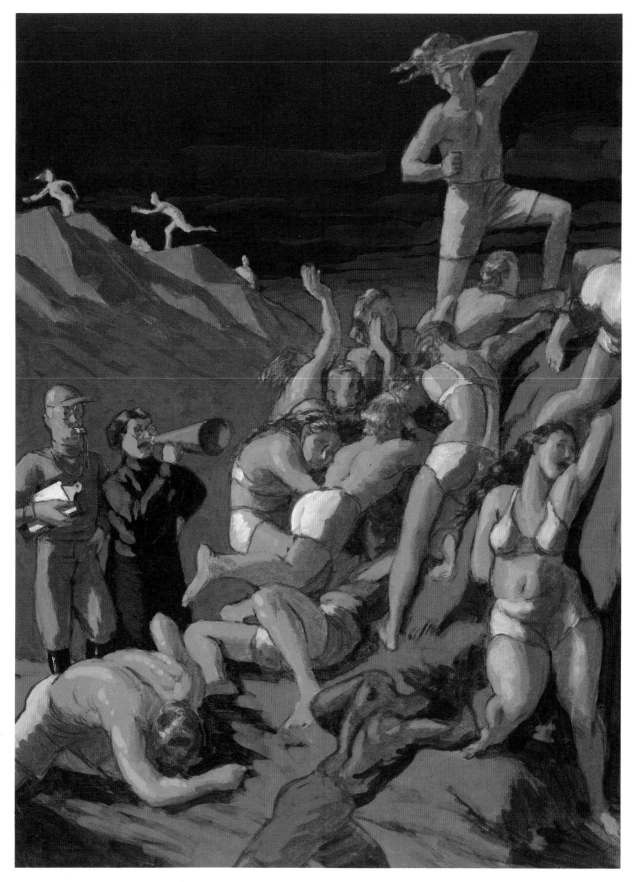

ART DIRECTOR
Nancy E. McMillen

DESIGNER
David Kampa

PUBLICATION
Texas Monthly, February 1986

PUBLISHING COMPANY
Texas Monthly, Inc.

WRITER
Kathy Lowry

Barry Root

The abuse and degradation suffered by the writer on her weeklong initiation into ONE, the controversial Texas-based human-potential program, is depicted in a hellish scene from the article, "One Flew Over the Cuckoo's Nest." Medium: Watercolor and gouache.

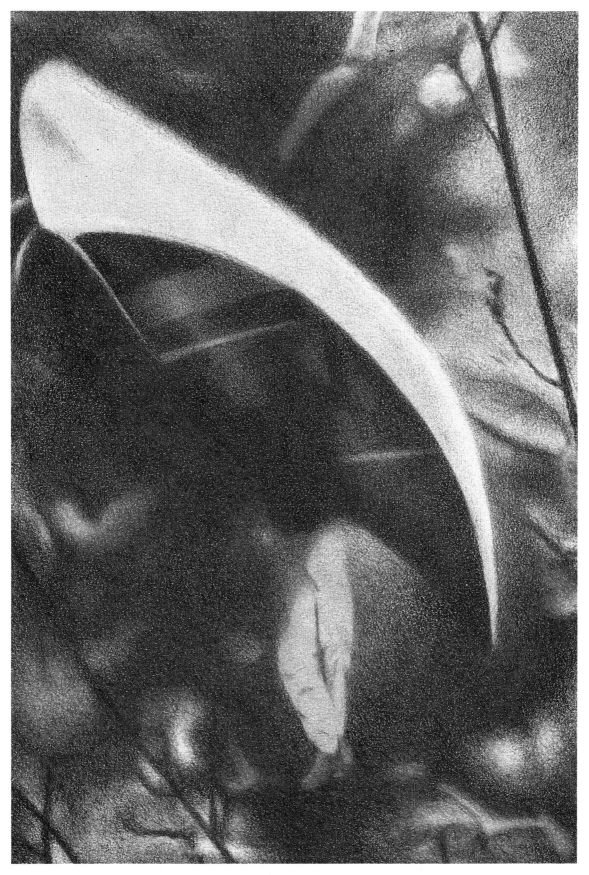

ART DIRECTOR
Barbara Solowan
DESIGNER
Mark Danzig
PUBLICATION
Toronto, July 1986
PUBLISHING COMPANY
The Globe and Mail
WRITER
Jay Teitel

Christine Bunn

A writer's reminiscences of portaging inspired the serious tone in Christine Bunn's drawing for "Rhapsody in Canoe." Medium: Colored pencil.

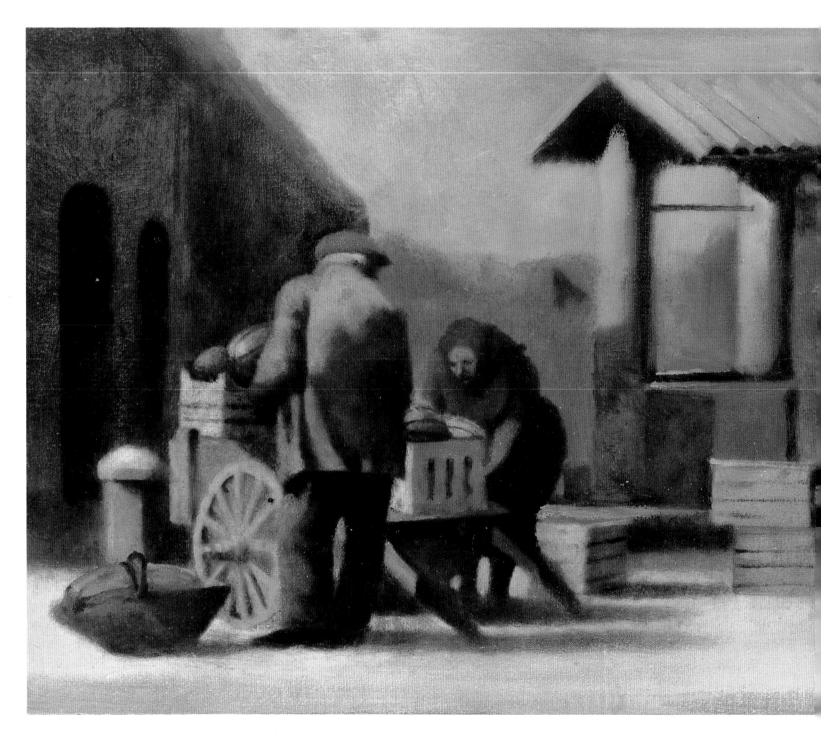

ART DIRECTOR
Bob Ciano

DESIGNER
Ken Kleppert

PUBLICATION
Travel & Leisure, April 1987

PUBLISHING COMPANY
*American Express Publishing
Corporation*

WRITER
Richard Covington

Paola Piglia

Paola Piglia, a native Italian, worked from memory to recreate the serenity of village life in Tuscany for "A Villa of Your Very Own." Medium: Oil.

ART DIRECTOR/DESIGNER
Stephen Hoffman

PUBLICATION
Sports Illustrated, January 1987

PUBLISHING COMPANY
Time Inc.

WRITER
Gary Smith

Paola Piglia

"An Andean town in which there aren't even dreams to be broken": Paola Piglia's two illustrations for "A Letter From South America" convey the contrast in the perception of sports between an impoverished South American country and the United States. Medium: Oil.

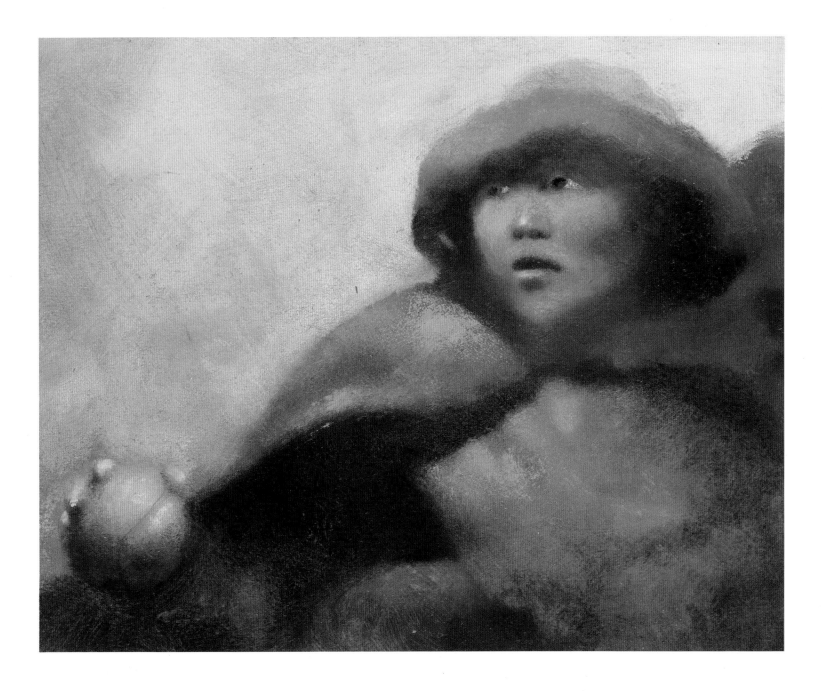

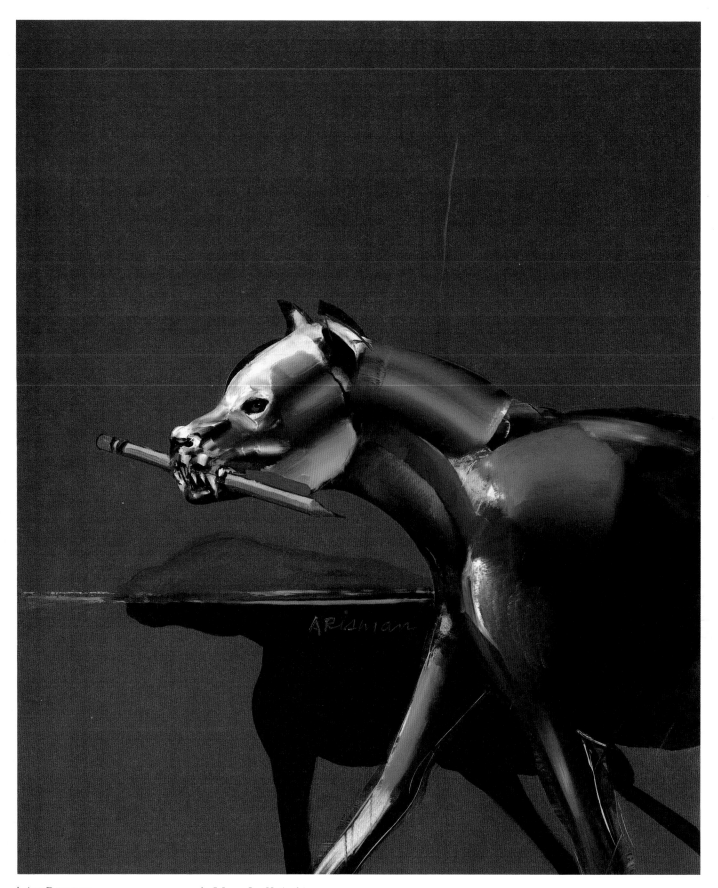

ART DIRECTOR
Walter Herdeg

PUBLICATION
Graphis 243, 1986

PUBLISHING COMPANY
Graphis Press

WRITER
Steven Heller

Marshall Arisman

For a cover story on the artist, Marshall Arisman painted himself as a hyena looking for something to record. Medium: Oil.

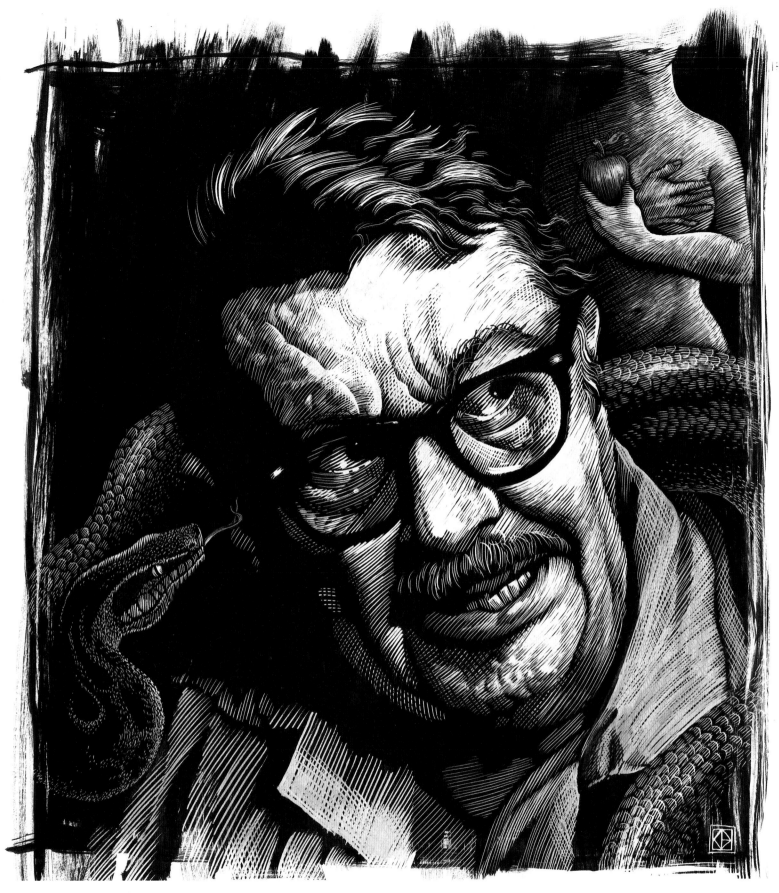

ART DIRECTOR/DESIGNER
Kent H. Barton

PUBLICATION
Sunshine, June 22, 1986

PUBLISHING COMPANY
The News and Sun-Sentinel Company

WRITERS
John DeGroot and Linda Marx

Kent H. Barton

Eve, the snake, the apple: Kent H. Barton's illustration takes on a Biblical twist. For "The Way of All Flesh," an article about a religious cult leader who had sex charges brought against him, Kent Barton chose to use symbols of temptation and original sin. Medium: Scratchboard and color dyes.

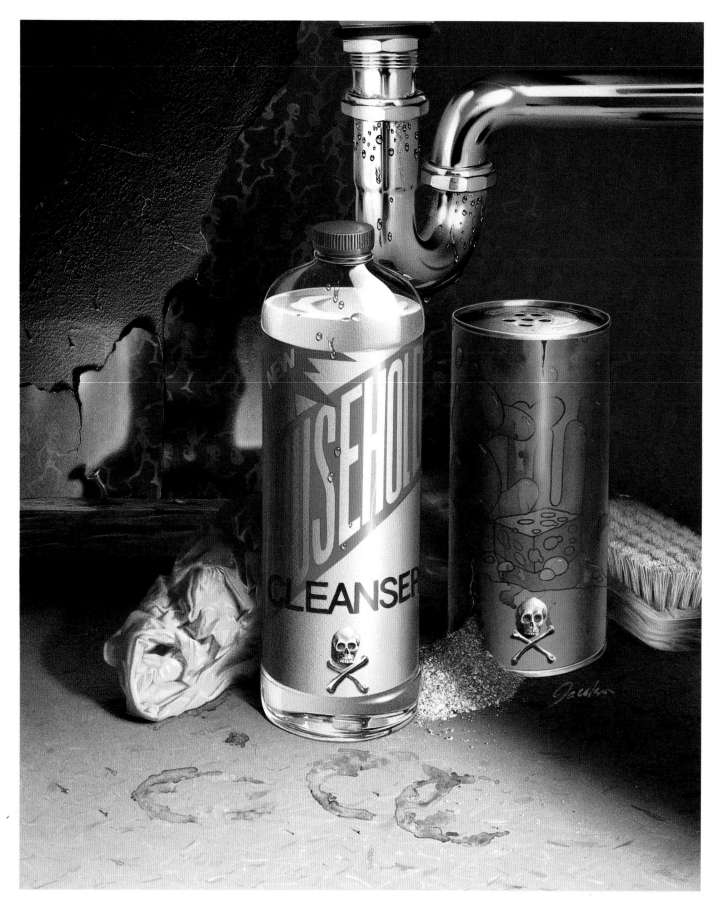

ART DIRECTOR
James Lawrence
DESIGNER
Rick Jacobson
PUBLICATION
Harrowsmith
PUBLISHING COMPANY
Camden House Publishing, Inc.

Rick Jacobson

Rick Jacobson's straightforward illustration of consumer products stored under a sink hints at the dangers of corrosive and toxic household cleaners. Medium: Gouache and acrylic.

ART DIRECTOR/DESIGNER
Bill Powers
PUBLICATION
Time, February 16, 1987
PUBLISHING COMPANY
Time Inc.
WRITER
Martha Smilgis

Peter Sis

Peter Sis's small delicate paintings were used to highlight this sensitive article ("Big Chill") on heterosexuals contracting AIDS from other heterosexuals. Medium: Oil.

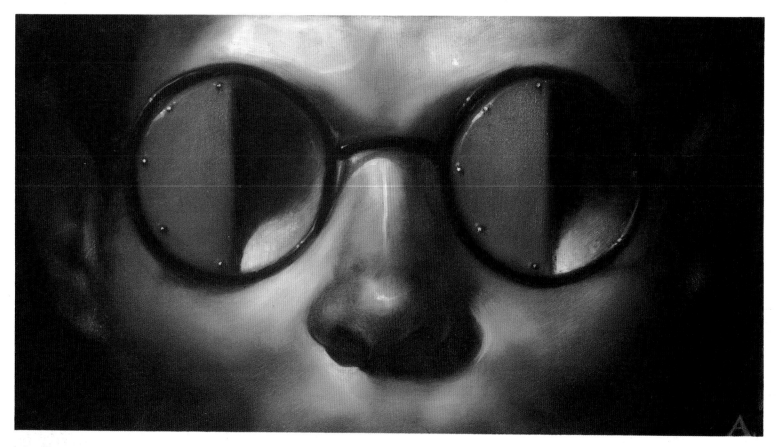

ART DIRECTOR
Jerelle Kraus

PUBLICATION
The New York Times
October 17, 1986

PUBLISHING COMPANY
The New York Times

WRITER
Barnett R. Rubin

Daniel Adel

Half-covered eyeglasses symbolize the op-ed columnist's contention that media attention on the problems of South Africa have diverted the public's attention away from "The Overlooked War in Afghanistan." Medium: Oil.

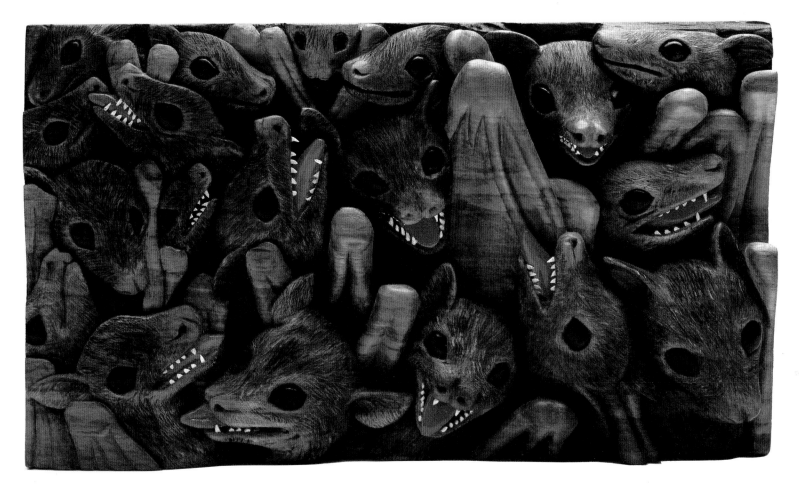

ART DIRECTOR
Lori Wendin
PUBLICATION
Connecticut, October 1986
PUBLISHING COMPANY
Communications International
WRITER
Jean Kinney

Nancy Blowers

A piece from Nancy Blower's private collection was selected to illustrate "Going Batty," an article on bats. Medium: Wood, wood stain, acrylic, polyurethane.

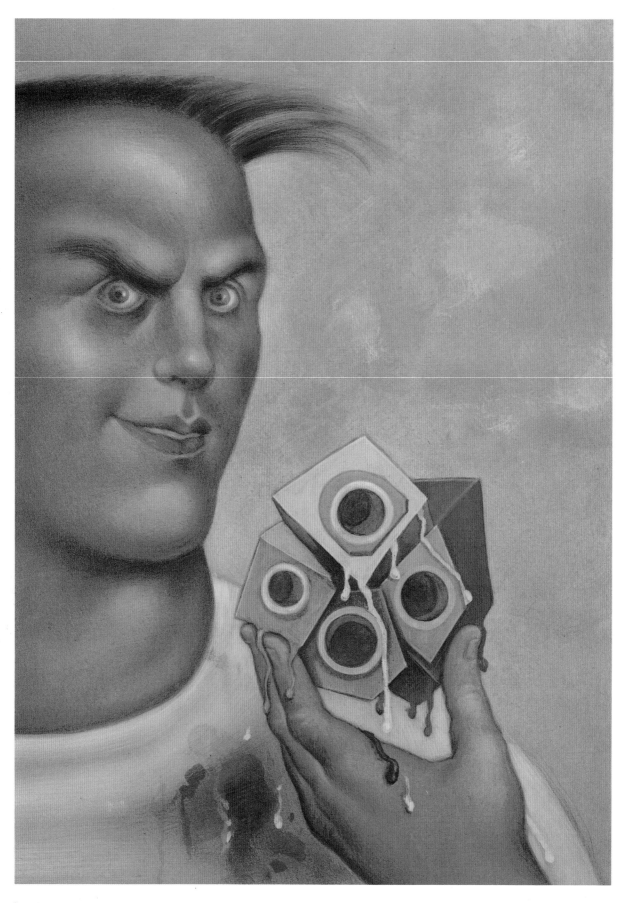

ART DIRECTOR/DESIGNER
Kerig Pope
PUBLICATION
Playboy, April 1986
PUBLISHING COMPANY
Playboy Enterprises, Inc.
WRITER
Laurence Gonzales

Anita Kunz

The developer of the artificial heart apparently has two very different aspects to his personality: scientific genius and punk creator. Anita Kunz reveals "The Rock 'N' Roll Heart of Robert Jarvik," in her portrait for a piece on the well-known physician. Medium: Watercolor and gouache.

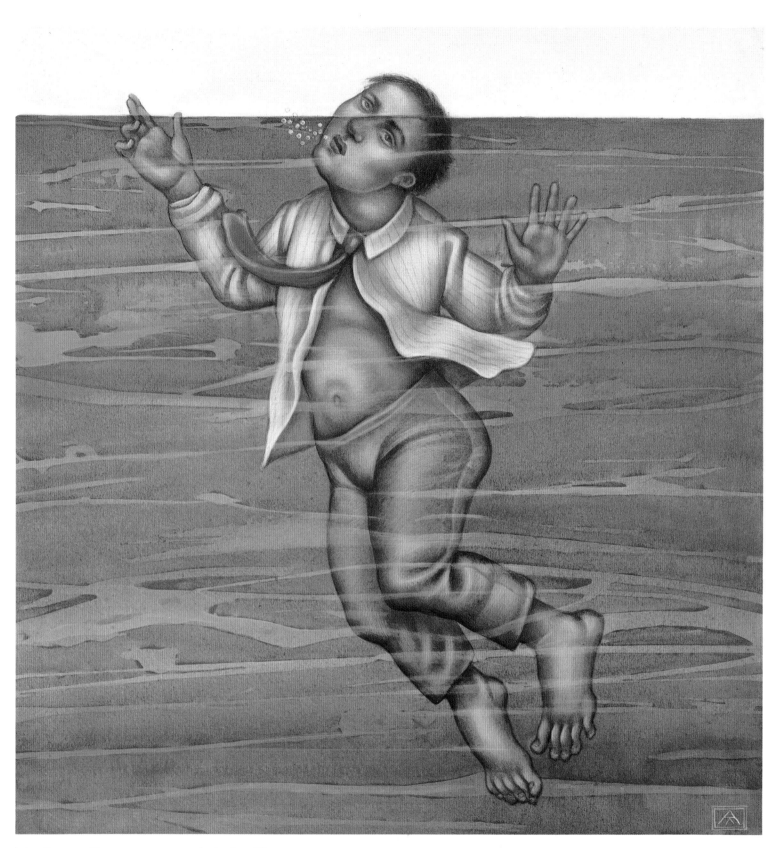

ART DIRECTOR/DESIGNER
Kent H. Barton

PUBLICATION
Sunshine, November 30, 1986

PUBLISHING COMPANY
*The News and Sun—
Sentinel Company*

WRITER
John DeGroot

Anita Kunz

Anita Kunz's illustration emphasized the rigors of
"Getting Dry," the recovery from alcoholism.
Medium: Watercolor and gouache.

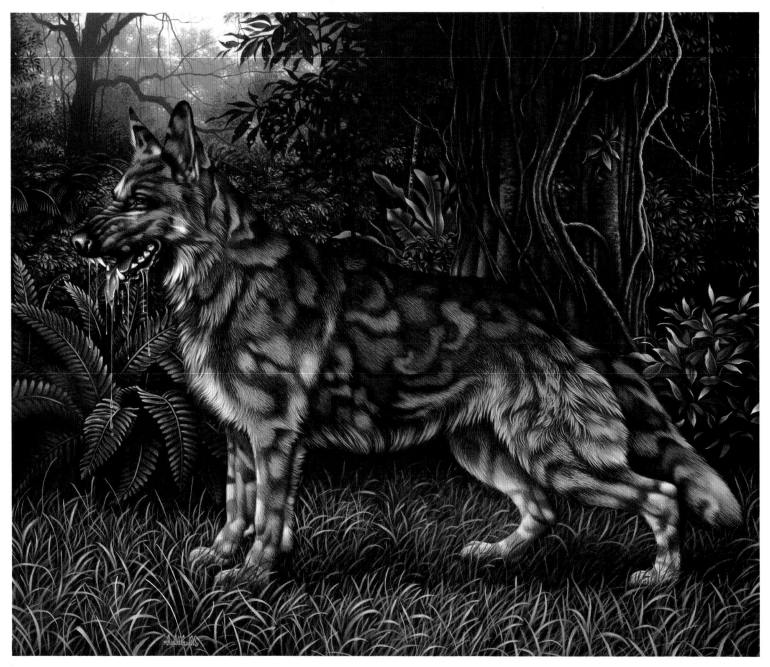

ART DIRECTOR
Tom Staebler

DESIGNER
Kerig Pope

PUBLICATION
Playboy, November 1986

PUBLISHING COMPANY
Playboy Enterprises, Inc.

WRITER
Francisco Goldman

Braldt Bralds

Braldt Bralds used camouflage as a device to illustrate a story ("The Professional Soldier") about a German shepherd used for tracking the enemy during a Central American civil war. Medium: Oil.

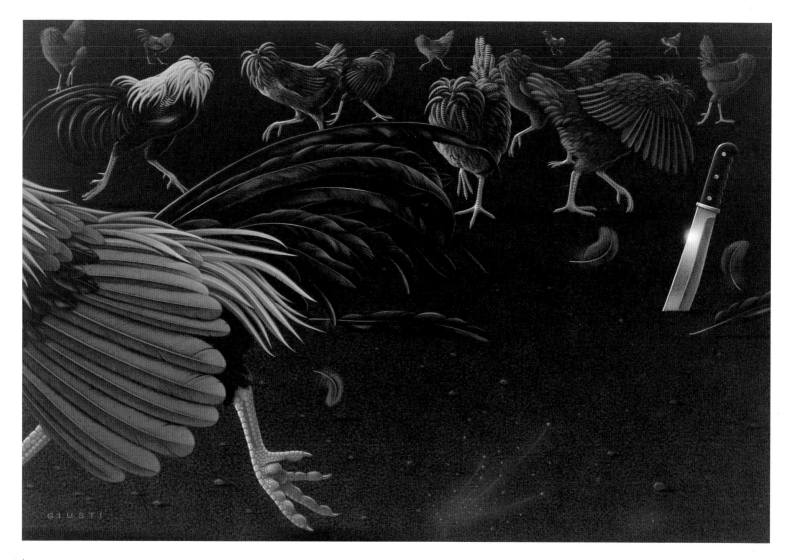

ART DIRECTOR
Len Willis

PUBLICATION
Playboy, December 1986

PUBLISHER
Playboy Enterprises, Inc.

WRITER
Herbert Gold

Robert Giusti

Robert Giusti's assignment was to depict the chaotic political situation in "Haiti After Baby Doc," following the forced exile of its dictator. Medium: Acrylic.

ART DIRECTOR
Sherri Reutiman

PUBLICATION
Magic Window, January/February 1987

PUBLISHING COMPANY
J. Publishing

WRITER
Pam Cope Leschak

Martin Harris

Martin Harris's illustration for "When You're Home Alone," a story written by Pam Cope Leschak, shows one of many methods a child uses to chase away fears of being left alone. Medium: Colored pencil.

JULIAN ALLEN

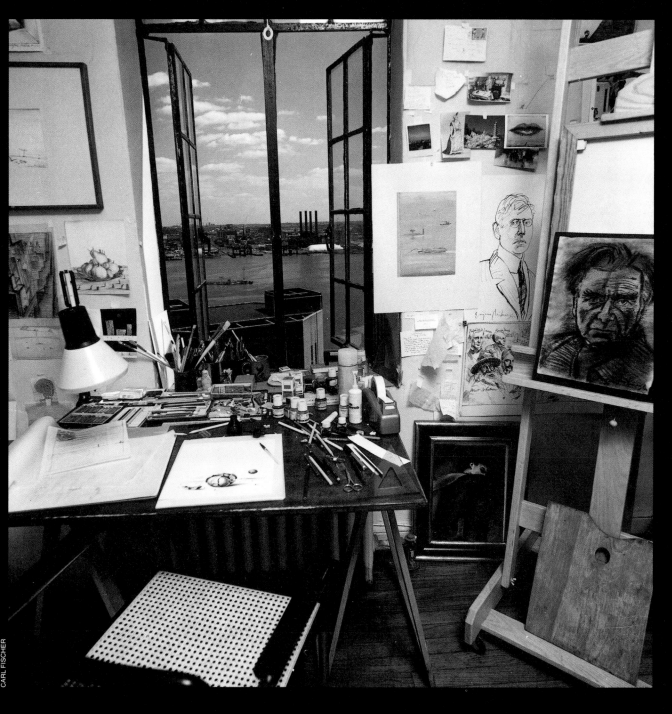

EUGENE MIHAESCO

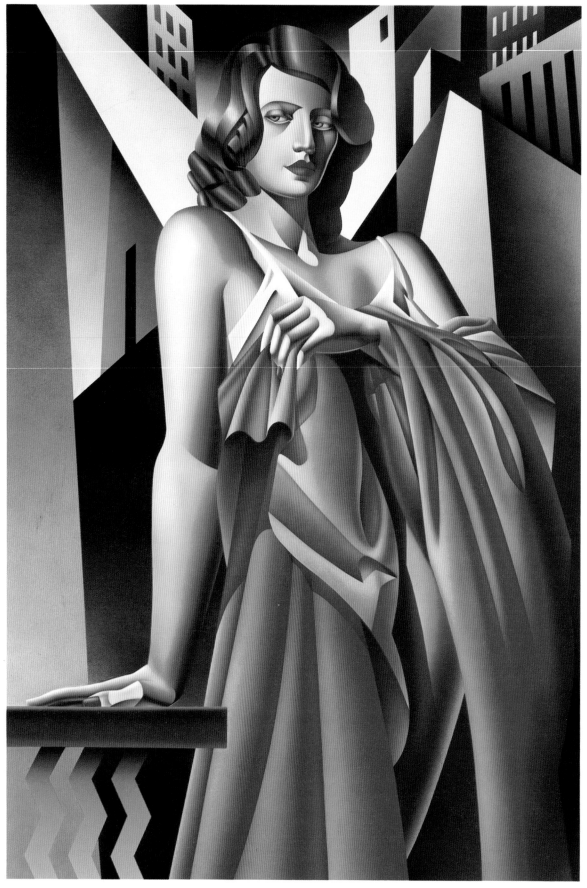

ART DIRECTOR
Sara Eisenman

DESIGNER
Jon Valk

AUTHOR
Andrew Vachss

EDITOR
Robert Gottlieb

PUBLISHER
Alfred A. Knopf, March 1987

John Jinks

For the first book in a series by the same author, John Jinks had to establish a design and illustration style that could be utilized for successive volumes. His cover illustration for *Strega* reflects the seamy underworld of New York City and the ex-con/scam artist/private eye, Burke, whose mission is to make the world unsafe for child molesters. Medium: Acrylic and gouache.

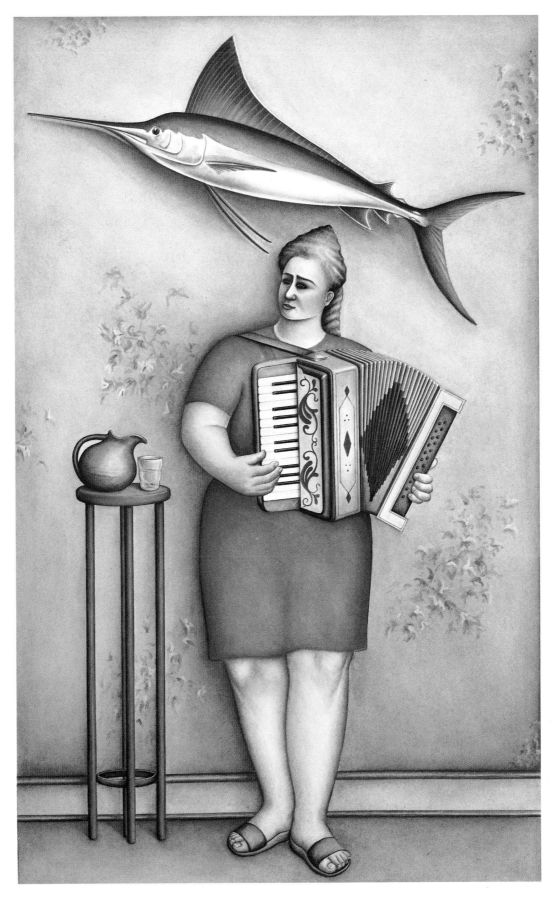

ART DIRECTOR/DESIGNER
T.M. Craan
AUTHOR
Eric McCormack
PUBLISHER
Penguin Books Canada, Ltd.
February 1987

Sandra Dionisi

Cover illustration from a collection of short stories,
Inspecting the Vaults, described as ranging from magic
realism to disturbingly macabre. Medium:
Watercolor and gouache.

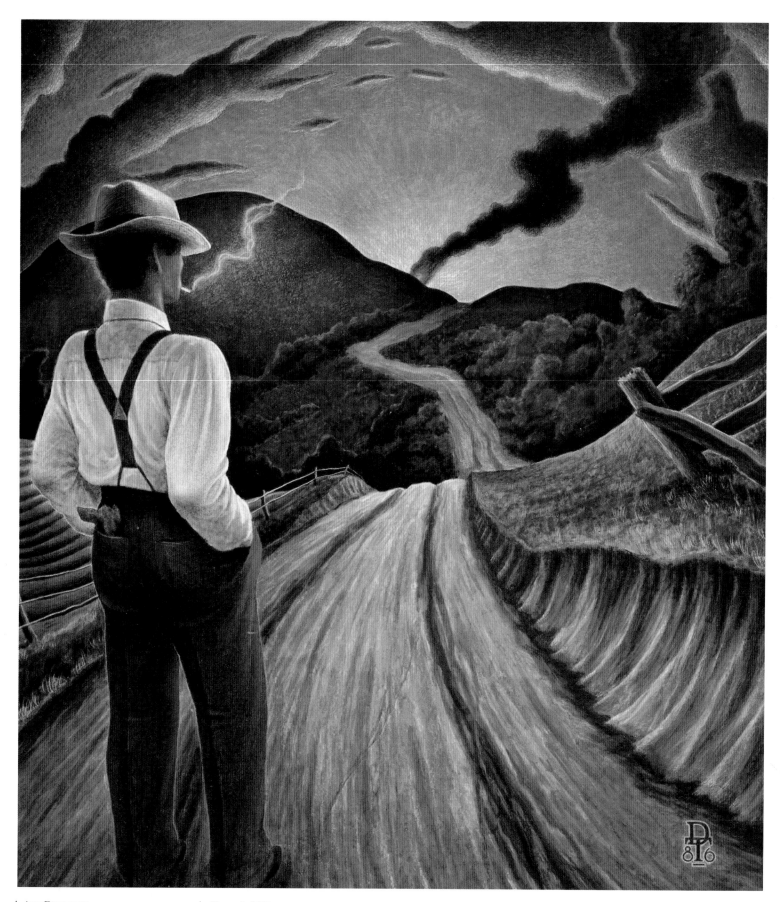

ART DIRECTOR
Judy Loeser

DESIGNER
Carin Goldberg

AUTHOR
William Faulkner

EDITOR
Carolyn Reidy

PUBLISHER
Vintage Books, December 1986

David Tamura

David Tamura successfully captured *Light in August*'s theme of tarnished Southern romanticism and the disillusionment of ambitious dreams in American Gothic style. Medium: Oil.

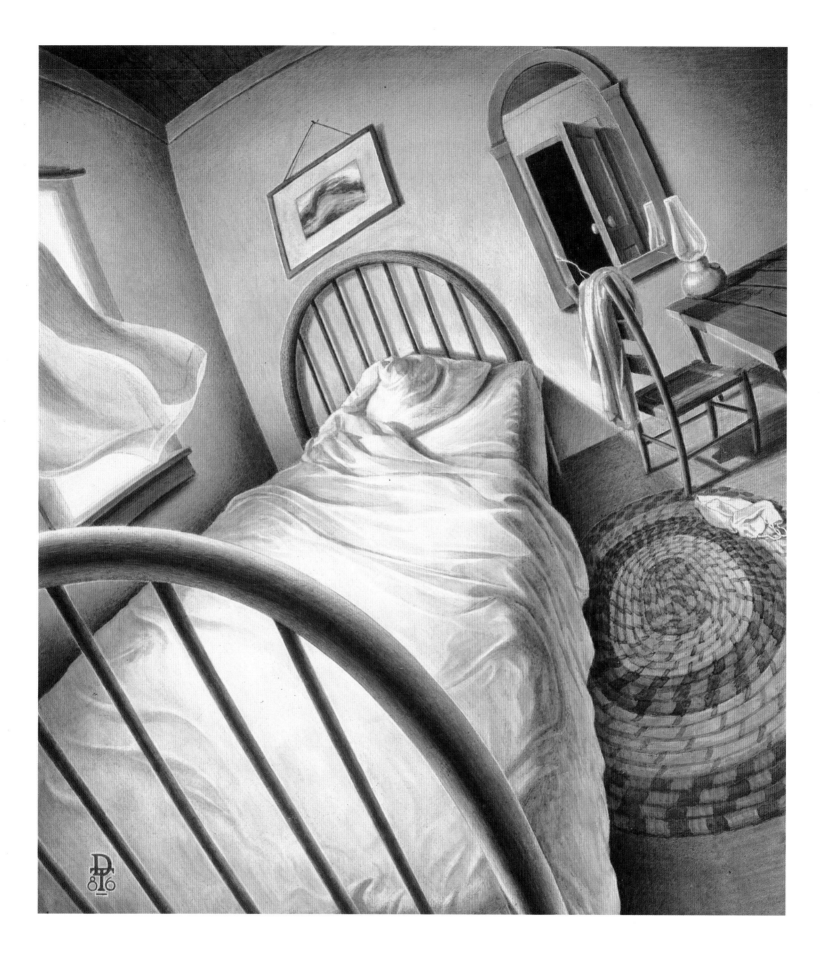

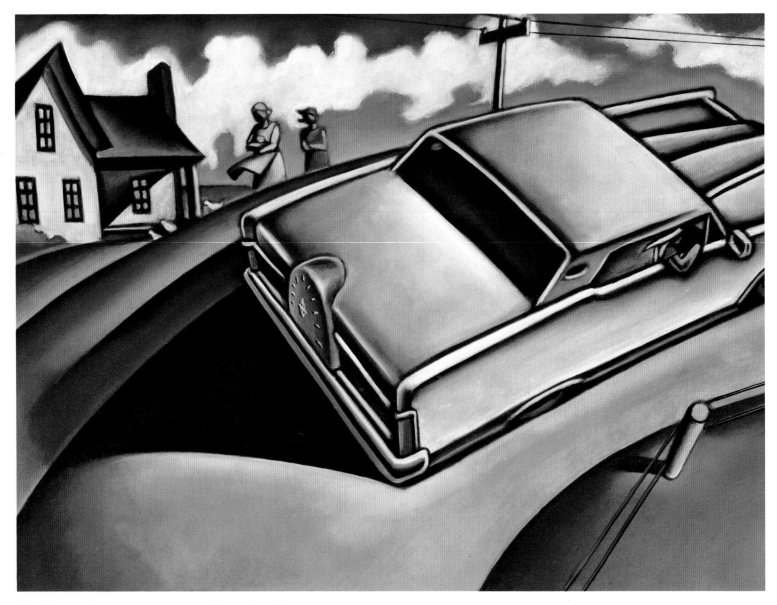

ART DIRECTOR/DESIGNER
Sara Eisenman

AUTHOR
Mona Simpson

EDITOR
Anne Close

PUBLISHER
Alfred A. Knopf, January 1987

Douglas Fraser

A big Lincoln leaves a Midwestern landscape and heads into the sun in Fraser's cover illustration for *Anywhere but Here*, about a mother and daughter fleeing Wisconsin for California. Medium: Oil and alkyd.

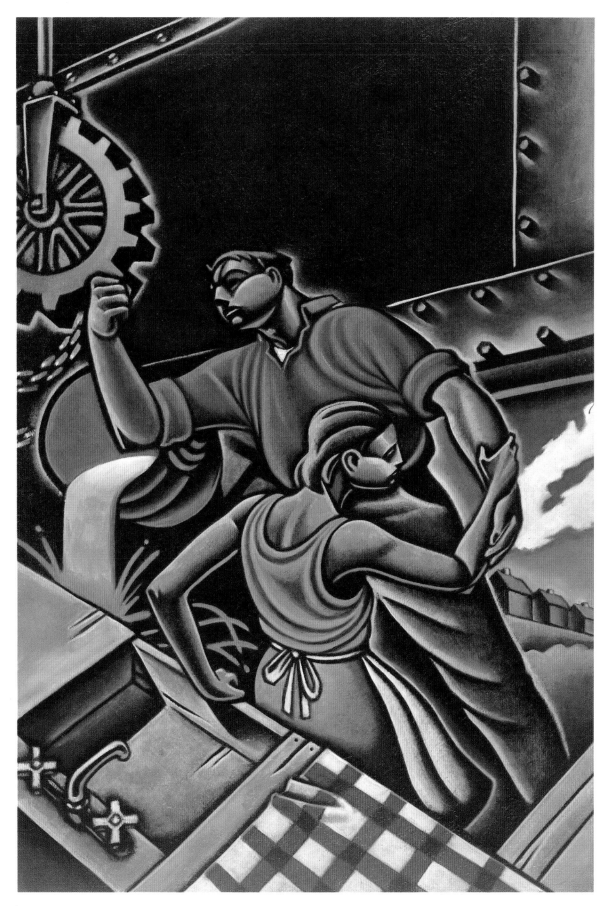

ART DIRECTOR
Sara Eisenman

DESIGNER
Sara Eisenman

AUTHOR
Robert Olen Butler

EDITOR
Lee Goerner

PUBLISHER
Alfred A. Knopf, March 1986

Douglas Fraser

Components of a humdrum existence surround the two main characters in *Wabash*, about the struggle of the working class. Medium: Oil and alkyds.

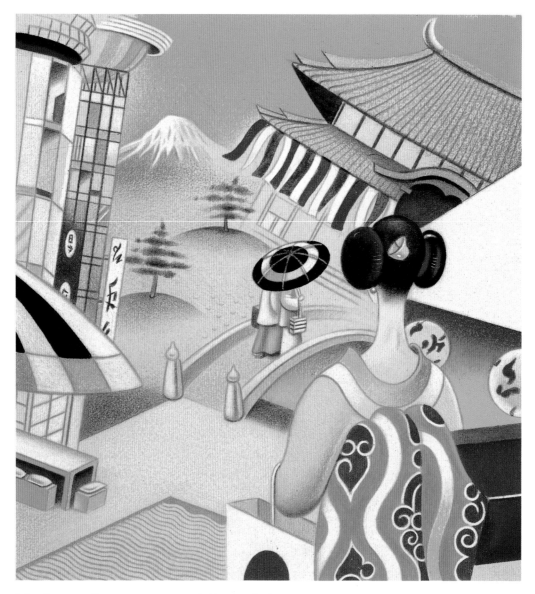

ART DIRECTOR/DESIGNER
Krystyna Skalski

AUTHORS
*Suzy Gershman and
Judith Thomas*

PUBLISHER
Bantam Books, February 1987

Dave Calver

Dave Calver illustrated the cover of a shopping guide to Tokyo (*Born to Shop Tokyo*) with several recognizable images of the city. This format was repeated in the other volumes of the series on international shopping. Medium: Colored pencil.

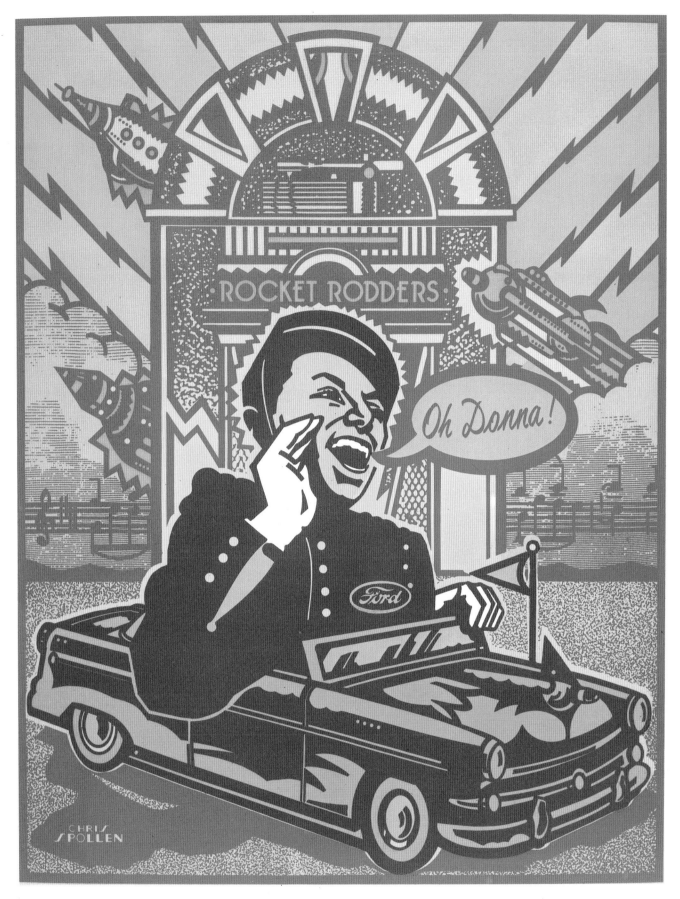

ART DIRECTOR/DESIGNER
Chris Spollen
AUTHOR
Chris Spollen
PUBLISHER
Moonlight Press Studio, May 1987

Chris Spollen

To promote the new Lectrachrome Print Room at
the Moonlight Press Studio, this illustration features
a 1950s carhop for *Oh Donna*. Medium:
Lectrachrome.

ART DIRECTOR
Dorothy Wachtenheim
DESIGNER
Bascove
AUTHOR
Rick DeMarinis
PUBLISHER
Arbor House, October 1986

Bascove

Bascove's bold style conveys the underlying passions of the characters in *The Burning Women of Far Cry*. Medium: Linocut with watercolor.

ART DIRECTOR
Louise Fili

AUTHOR
Jan Willem Van Der Wettering

EDITOR
Andre Schiffirn

PUBLISHER
Pantheon Books, November 1986

Bascove

Bascove's cover illustration for *Hard Rain*, a story set in Amsterdam about several murders that occur during a spell of heavy rain, focuses on a central figure who is unrelenting in his desire for control and power. Medium: Linocut with watercolor and pencil.

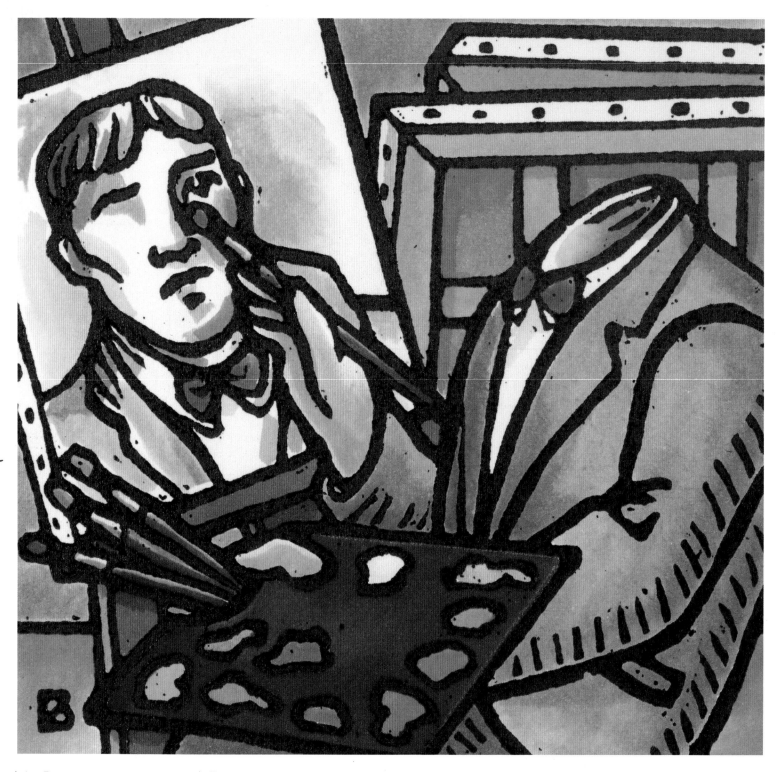

ART DIRECTOR
Neil Stuart

AUTHOR
Robertson Davies

EDITOR
Elisabeth Sifton

PUBLISHER
Viking Penguin, Inc.
November 1985.

Bascove

Bascove's cover is the embodiment of Robertson Davies's ingenious *What's Bred in the Bone*, which involves an art expert and collector of international renown. Medium: Woodcut with watercolor.

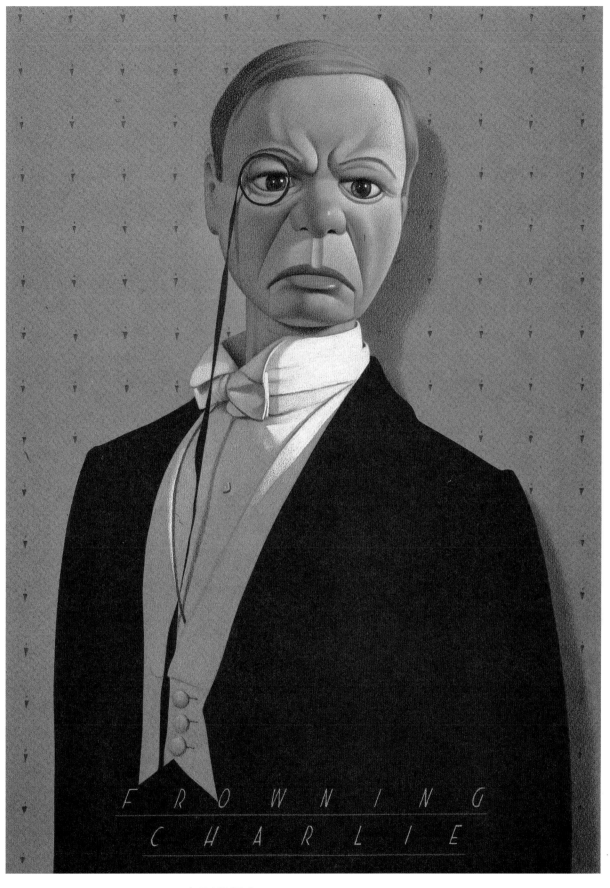

FROWNING CHARLIE

ART DIRECTOR/DESIGNER
Bill Nelson
AUTHOR
Bill Neslon
PUBLISHER
Taylor Publishing Co.
November 1986

Bill Nelson

A portrait of Edgar Bergen's popular dummy, Charlie McCarthy, illustrates *Finishing the Hat*, by Bill Nelson. Medium: Colored pencil and acrylic.

ART DIRECTOR/DESIGNER
Michelle Barnes
AUTHOR
Michelle Barnes

Michelle Barnes

"Walking at night through back streets and alleys seemed to attract a lot of attention," Michelle Barnes says. "Dogs would appear from nowhere in the strange fluorescent lights of back porches and street lamps". Intrigued by these suburban images, Barnes created a series of drawings called *Dogs at Night*.
Medium: Pastel.

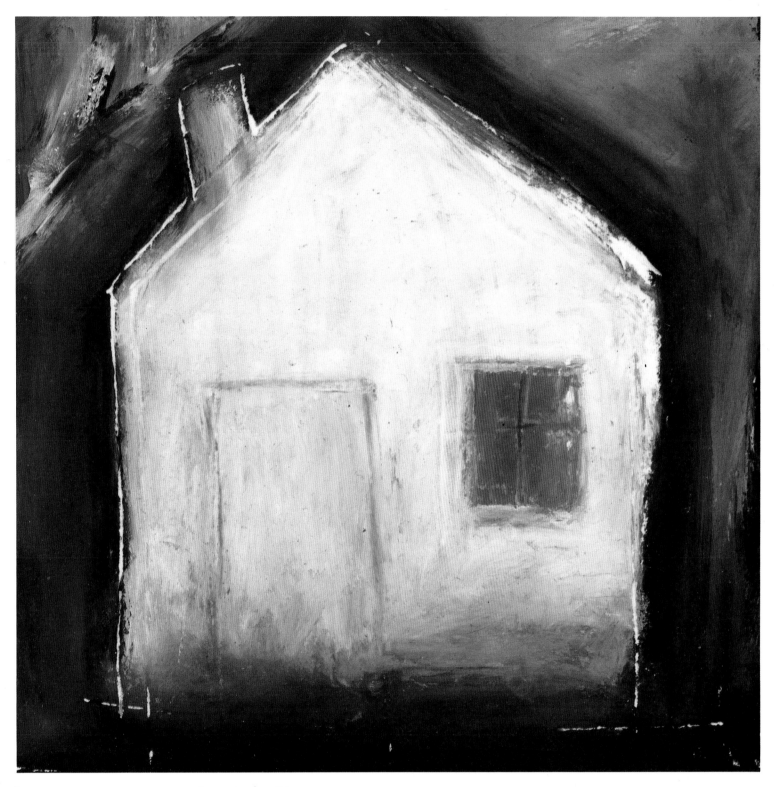

Art Director/Designer
Carin Goldberg
Author
James Robison
Publisher
Summit Books, August 1985

Vivienne Flesher

Vivienne Flesher's white house on a stark black background illustrates James Robison's collection, *Rumor and Other Stores*. Medium: Pastel.

A ROMANTIC COMEDY

ART DIRECTOR
Sara Eisenman
DESIGNER
Sara Eisenman
AUTHOR
Ann Arensberg
EDITOR
Alice Quinn
PUBLISHER
Alfred A. Knopf, September 1986

Philippe Weisbecker

Philippe Weisbecker's Victorian-inspired drawing contrasts amusingly with the racy title (*Group Sex*) of the romantic comedy. Medium: Watercolor.

ART DIRECTOR/DESIGNER
Louise Fili
EDITOR
Jane Yolen
PUBLISHER
Pantheon Books, November 1986

Philippe Weisbecker

An image evoking Mother Goose is the central figure
in Philippe Weisbecker's cover for Jane Yolen's
Favorite Folktales From Around the World. Medium:
Ink and watercolor.

ART DIRECTOR/DESIGNER
Vaughn Andrews

AUTHOR
Conrad Detrez

EDITOR
Derenka Willen

PUBLISHER
*Harcourt Brace Jovanovich, Inc.,
November 1986*

Karen Barbour

For *Zone of Fire*, a novel about a French seismologist
who goes to Nicaragua and gets involved with the
Sandinistas, Karen Barbour painted a volatile Latin
American landscape. Medium: Gouache.

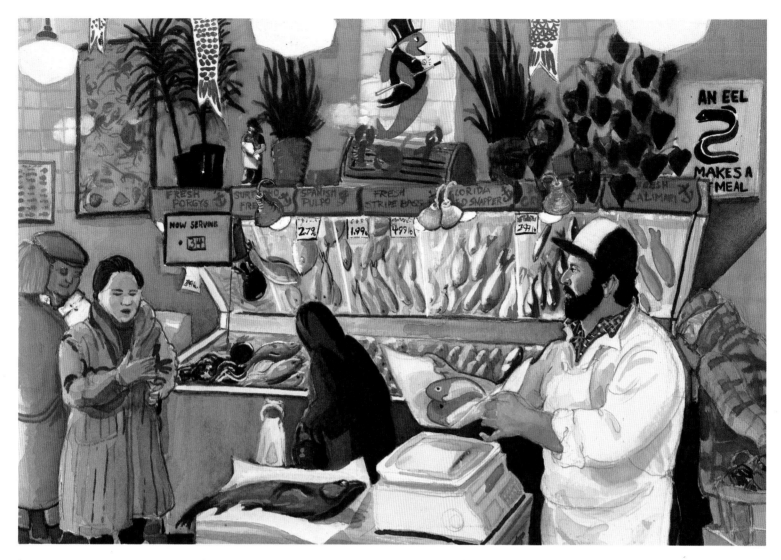

ART DIRECTOR/DESIGNER
Kevin McCloskey

AUTHOR
Kevin McCloskey

PUBLISHER
Kevin McCloskey, November 1986

Kevin McCloskey

In this painting from his guide book *Walking Around Hoboken*, Kevin McCloskey captures the atmosphere of one of Hoboken's last traditional fish markets. Medium: Watercolor.

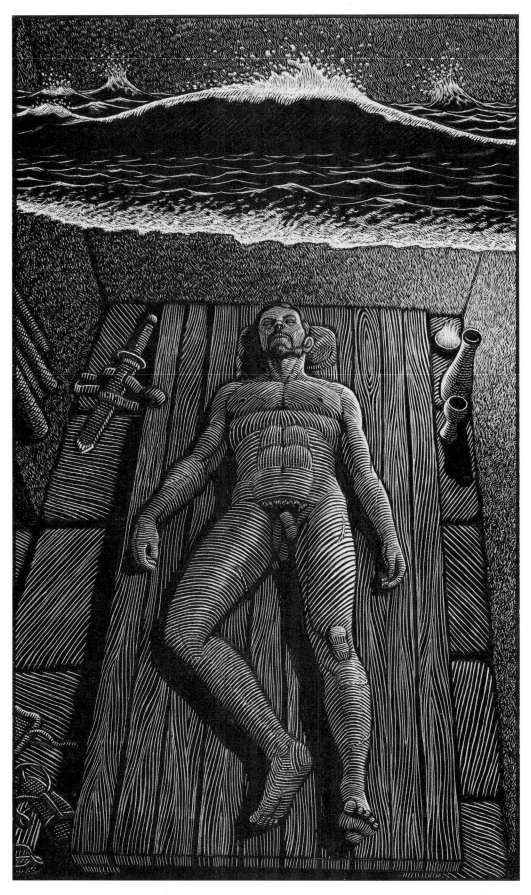

AUTHOR
Tanith Lee

EDITOR
James Turner

PUBLISHER
Arkham House Publishers, Inc., August 1986

Douglas Smith

Douglas Smith visualized a passage from Dreams of Dark Light (a short story in a collection called *The Dry Season*), wherein a centurion-like commander lies in a flaming desert city and dreams of water. Medium: Scratchboard.

ART DIRECTOR/DESIGNER
Michael Mendelsohn

AUTHOR
Vance Bourjaily

PUBLISHER
The Franklin Library
December 1986

John H. Howard

John H. Howard provides a period flavor to his frontispiece for *The Great Fake Book* a novel about a man who uncovers what his father's life was like in the '40s. Medium: Pencil.

ART DIRECTOR/DESIGNER
Krystyna Skalski
AUTHOR
Ruth Rendell
PUBLISHER
Bantam Books, January 1987

John H. Howard

John H. Howard rendered this expressive portrait which appeared on the cover of the final volume *Means of Evil* of the popular Inspector Wexford mystery series. Medium: Pencil.

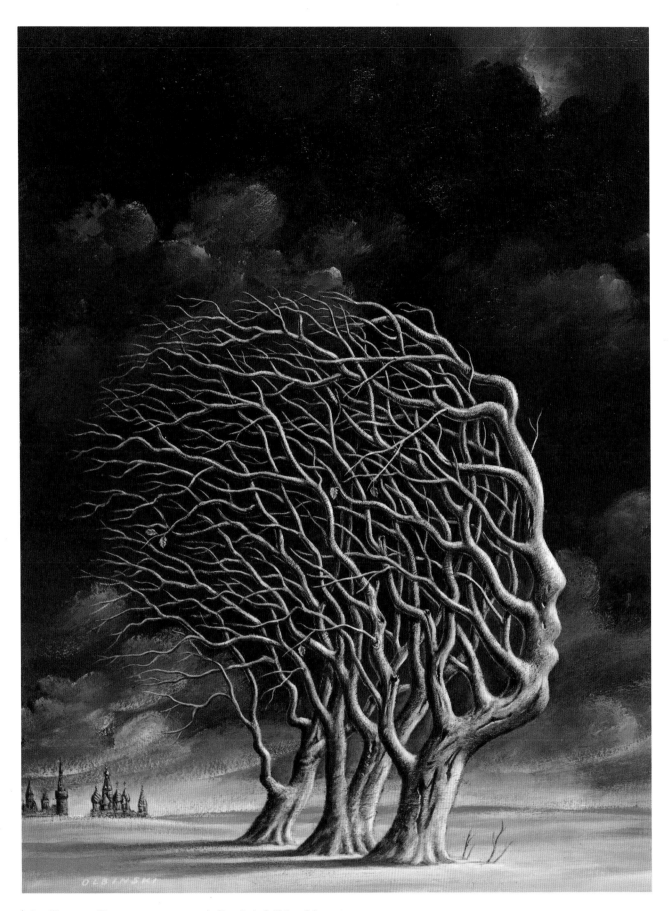

ART DIRECTOR/DESIGNER
Neil Stuart

AUTHOR
D.M. Thomas

PUBLISHER
Viking Penguin, Inc., November 1986

Rafal Olbinski

A sense of foreboding permeates Rafal Olbinski's painting for *Sphinx*'s cover. Medium: Acrylic.

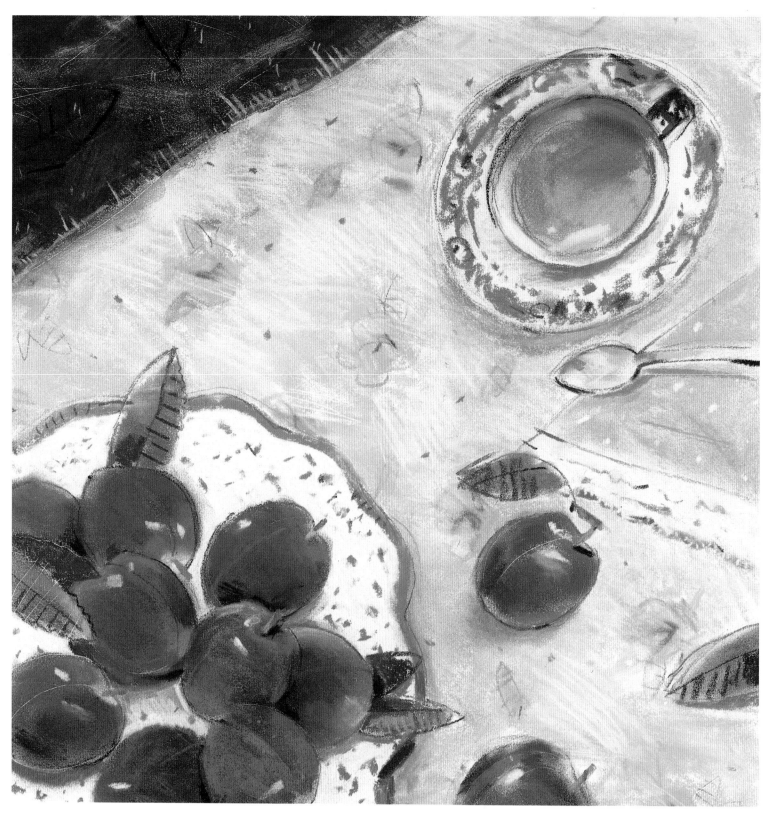

ART DIRECTOR
Steve Allen

PUBLISHER
*East Coast Graphics, February
1987*

Gary Head

A still life of purple plums in the French
impressionist manner adorns Gary Head's illustration
for *Le Bistro*'s menu cover. Medium: Pastel.

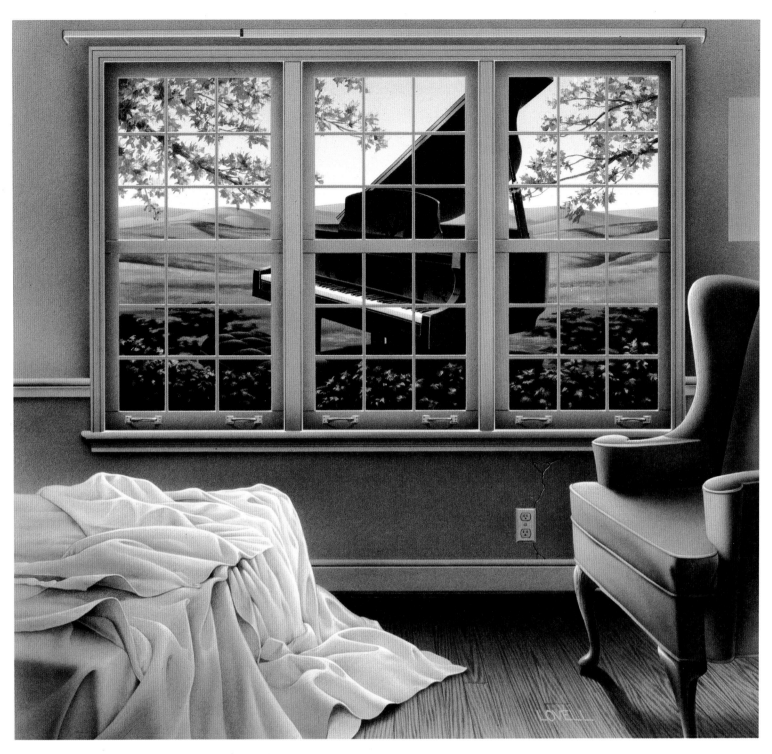

ART DIRECTOR
Judy Loeser

DESIGNER
Lorraine Louie

AUTHOR
Janet Hobhouse

EDITOR
Joe Fox

PUBLISHER
Vintage Books, November 1986

Rick Lovell

In his cover piece Rick Lovell's surreal landscape
with a piano represents a 40-year old musician who
has just been deserted by his wife and his ambition,
in *November*. Medium: Airbrush and acrylic.

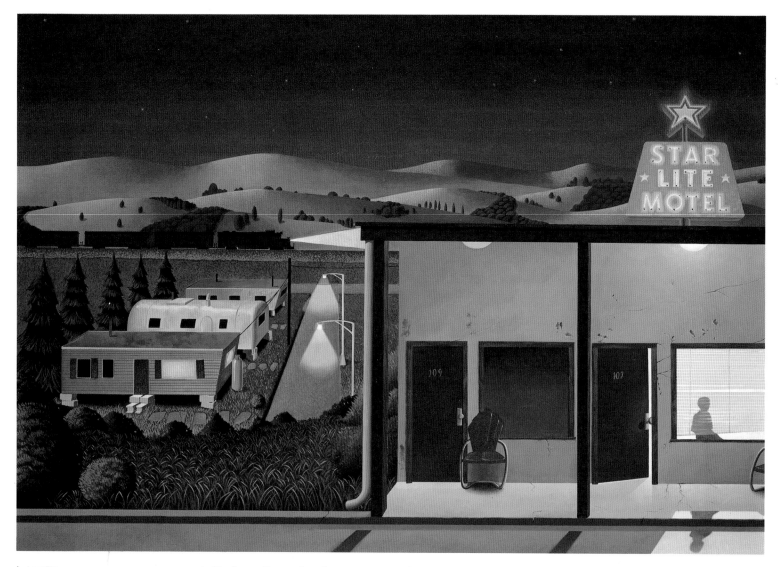

ART DIRECTOR
Greg Wilkin

DESIGNER
Susan Bissett

AUTHOR
Greg Matthews

PUBLISHER
New American Library, April 1987

Robert Crawford

For a story about a boy's adventures as he enters
adolescence, Robert Crawford researched roadside
motels and neon signs, elements crucial to *Little Red
Rooster*. Medium: Oil and acrylic.

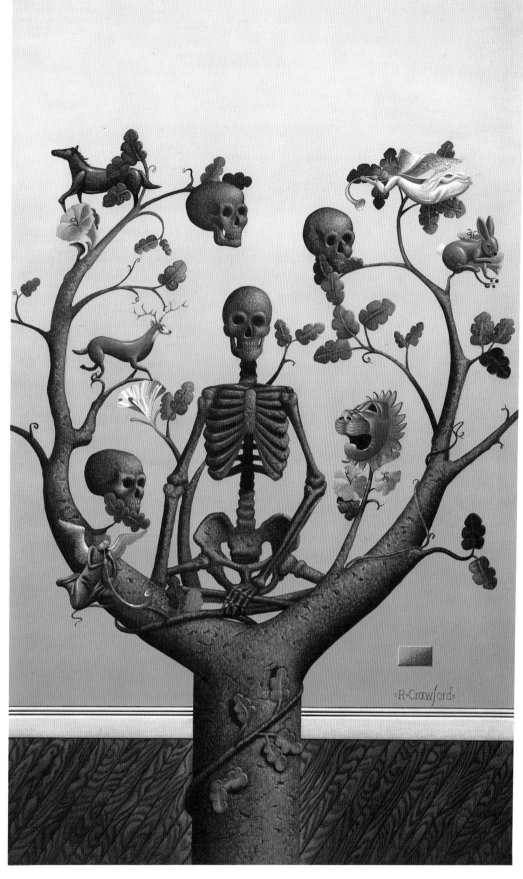

ART DIRECTOR
Greg Wilkin

DESIGNER
James Wang

AUTHOR
Marcia Muller

PUBLISHER
*New American Library
March 1987*

Robert Crawford

For a book about murder in an art museum, Robert Crawford has transformed the fruitful tree of life into a mysterious *Tree of Death*. Medium: Acrylic.

ART DIRECTOR/DESIGNER
Walter Gurbo

AUTHOR
Walter Gurbo

PUBLISHER
Man Made Books, February 1987

Walter Gurbo

Three illustrations from Walter Gurbo's handmade, handsewn, handcolored, limited-edition, *Fun & Brains*. Medium: Watercolor.

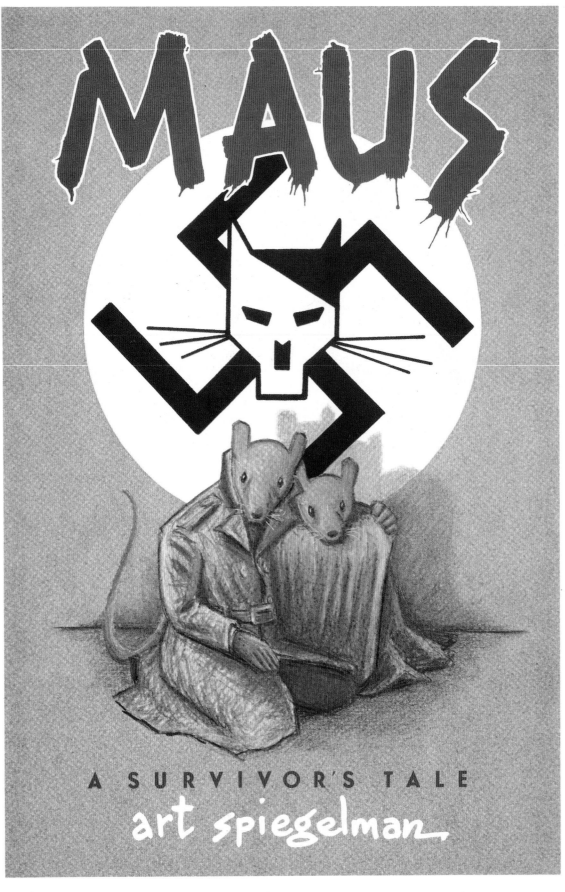

ART DIRECTOR
Louise Fili

DESIGNER
Art Spiegelman

AUTHOR
Art Spiegelman

EDITOR
Tom Engelhardt

PUBLISHER
Pantheon Books, September 1986

Art Spiegelman

In this memoir of his father, Art Spiegelman tells a story of the Nazi holocaust by using animals with human characteristics. Type, swastika and figures are composed by the author/artist into a poster-like cover. Medium: Ink.

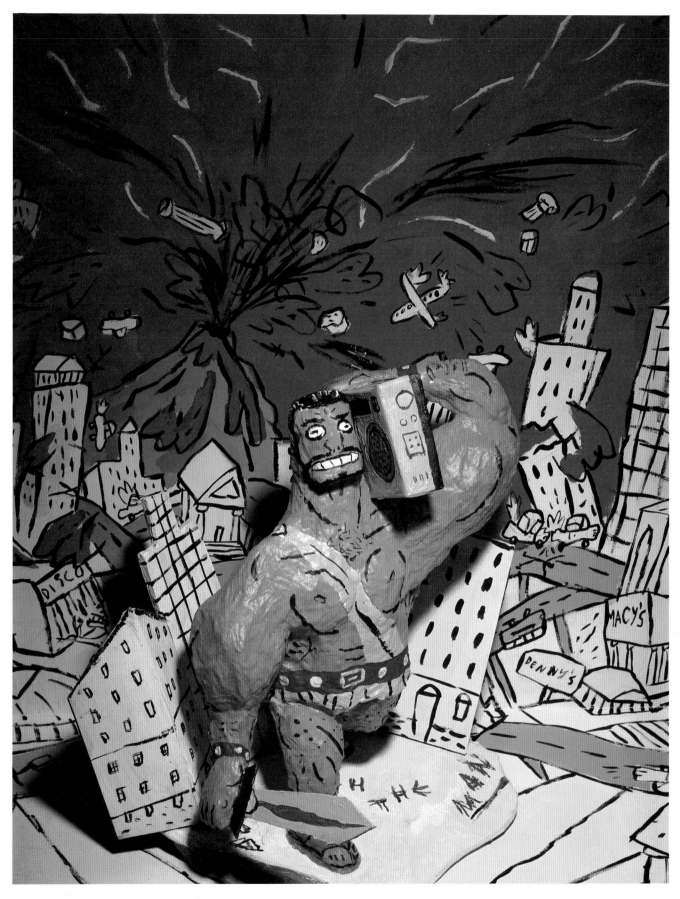

AUTHOR
Mark Marek
EDITOR
Pat Mulcahy
PUBLISHER
Viking Penguin, Inc., April 1986

Mark Marek

Three incidents from a collection of Mark Marek's popular "Hercules" strips, *Hercules Amongst the North Americans*. Medium: Pen and ink, watercolor, mechanical overlay.

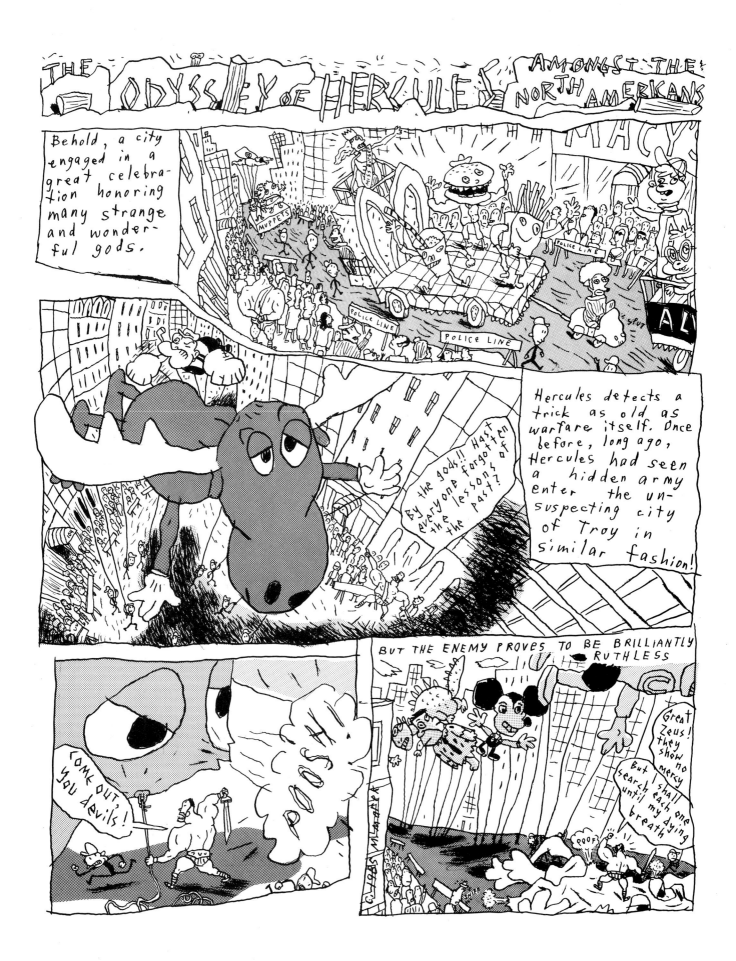

Behold, a city engaged in a great celebration honoring many strange and wonderful gods.

By the gods!! Hast everyone forgotten the lessons of the past?

Hercules detects a trick as old as warfare itself. Once before, long ago, Hercules had seen a hidden army enter the unsuspecting city of Troy in similar fashion!

BUT THE ENEMY PROVES TO BE BRILLIANTLY RUTHLESS

COME OUT, you devils!

Great Zeus! they show no mercy. But I shall search each one until my dying breath

DESIGNS FROM A RED-FIGURED VASE FOUND IN CENTRAL SAN DIEGO. excavated by Sir Marek, 1985.

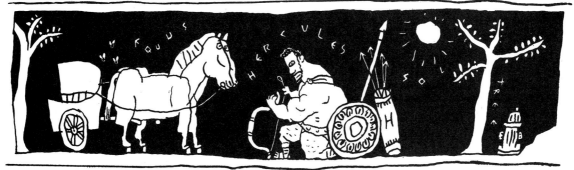

preparing for the hunt

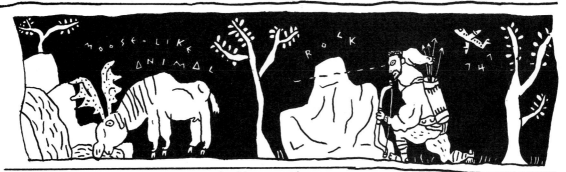

stalking the prey

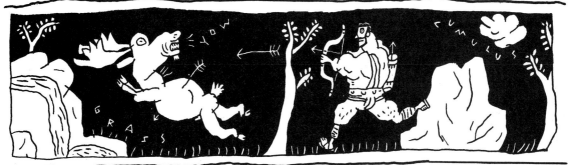

the kill

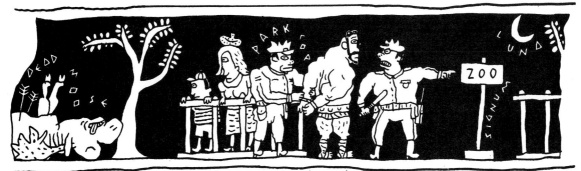

the criminal citation

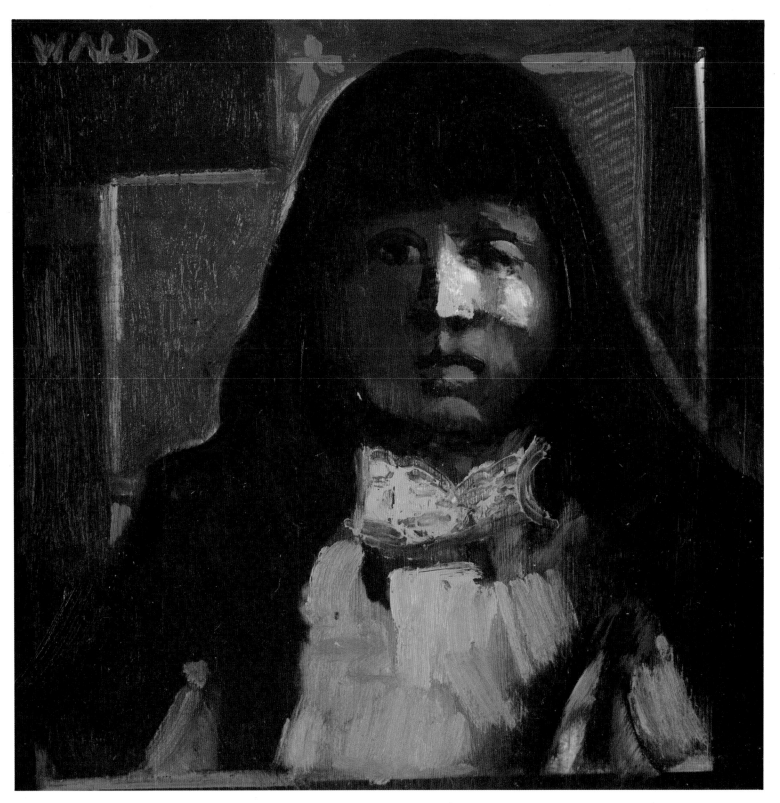

ART DIRECTOR/DESIGNER
Carol Wald

Carol Wald

Two portraits from Carol Wald's series of twenty small, oil-painted montages. *The Americans* included Native Americans, Black Americans and neighborhood kids. Medium: Oil.

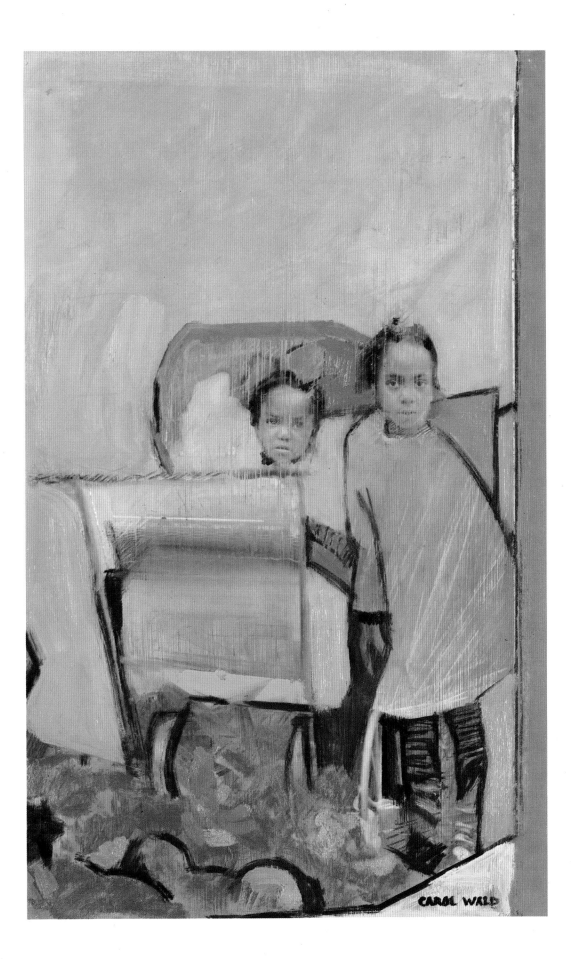

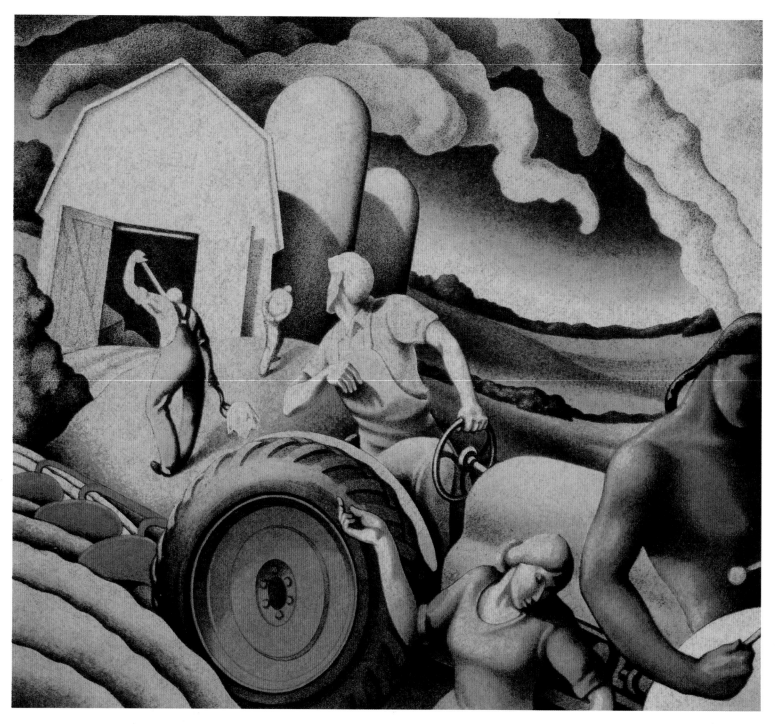

ART DIRECTOR
Frank Metz

DESIGNER
Phil Huling

AUTHOR
Will Weaver

EDITOR
Patricia Soliman

PUBLISHER
Simon and Schuster, October 1986

Phil Huling

Phil Huling used a Bentonesque style to portray a contemporary struggle over land and values between the whites and the Native Americans for *Red Earth, White Earth*. Medium: Pencil, oil and ink.

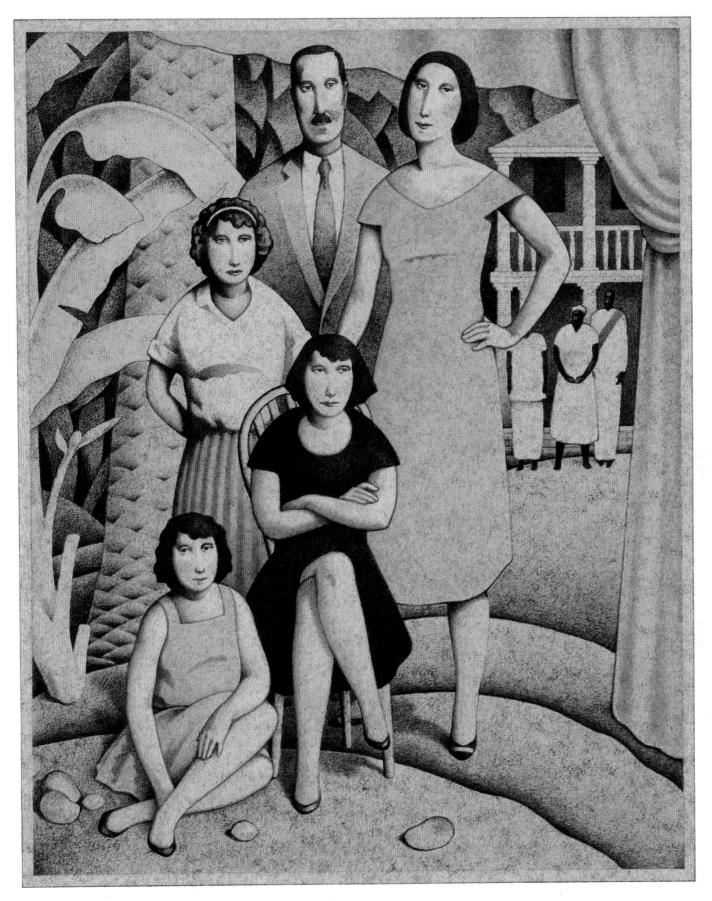

ART DIRECTOR
Frank Metz
DESIGNER
Phil Huling
AUTHOR
Lynn Freed
EDITOR
Ileene Smith
PUBLISHER
Summit Books, August 1986

Phil Huling

A family portrait is featured in Phil Huling's jacket illustration for a story about a young Jewish girl who grows up in Durban, South Africa. The theater curtain in the painting depicts the theater background of the family and also serves as a metaphor for white South Africa's claim to a homeland (*Home Ground*) Medium: Pencil, oil and ink.

PALLADIAN ARCH

ART DIRECTOR
Lowell Williams

DESIGNER
Lana Rigsby and Lowell Williams

AUTHOR
Lee Herrick

PUBLISHER
*Gerald D. Hines Interests,
November 1986*

Lana Rigsby

Lana Rigsby's paintings of Philip Johnson's project in Boston, *500 Boylston*, were commissioned for a promotional book. Medium: Watercolor.

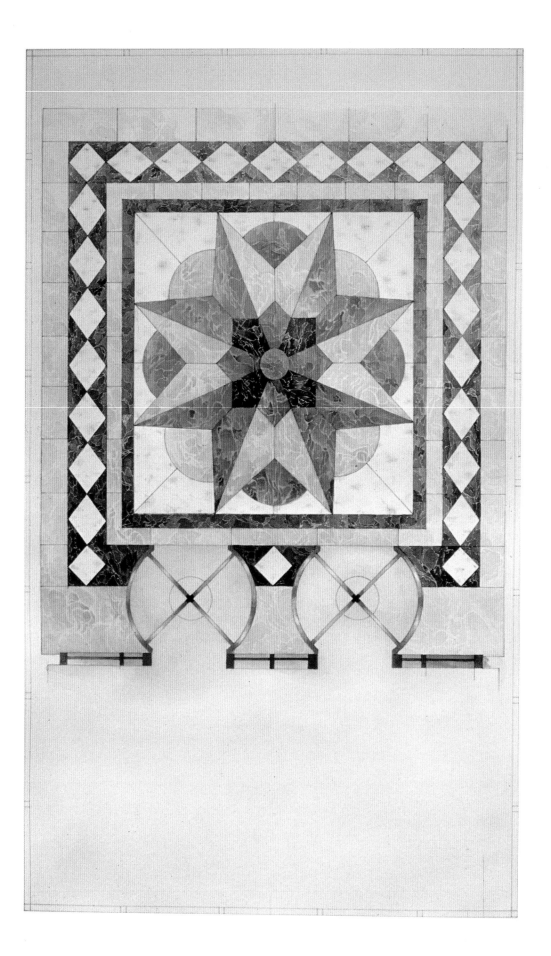

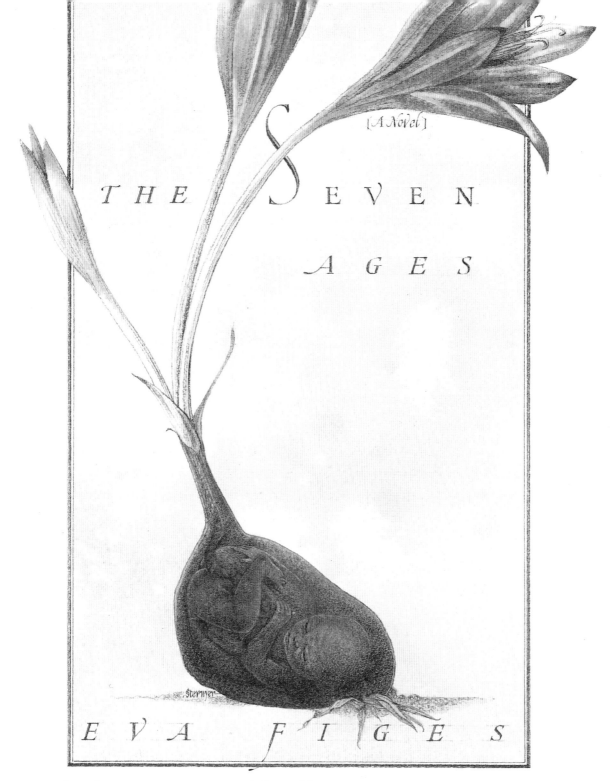

[A Novel]

THE SEVEN AGES

EVA FIGES

ART DIRECTOR
Louise Fili

AUTHOR
Eva Figes

EDITOR
Tom Engelhardt

PUBLISHER
Pantheon Books, January 1987

Dugald Stermer

Dugald Stermer combined botanical imagery with traditional hand-lettering to illustrate a historical novel about one thousand years of England, *The Seven Ages,* as viewed through a woman's eyes. Medium: Pencil and watercolor.

MALCOLM LIEPKE

MARSHALL ARISMAN

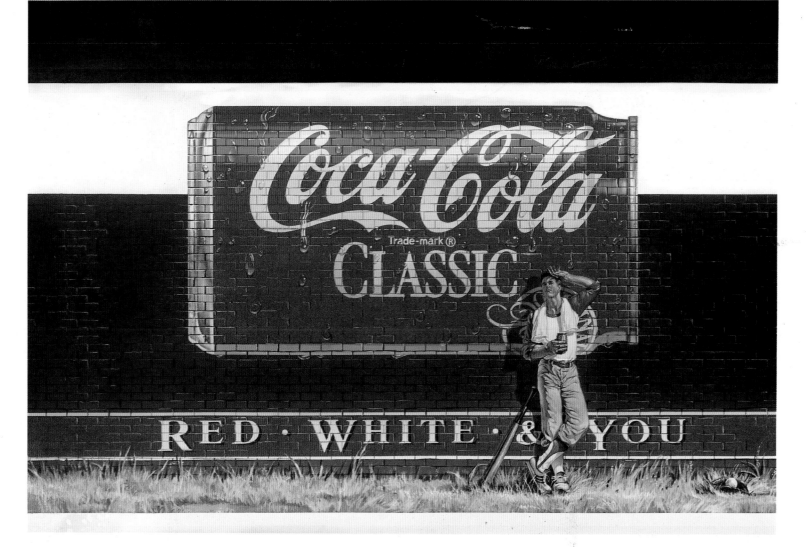

ART DIRECTOR
Laury Wolfe
ADVERTISING AGENCY
McCann-Erickson, Inc.
CLIENT
Coca-Cola Classic, Summer 1986

Ezra N. Tucker

Ezra N. Tucker's graphic image of a hot, tired softball player refreshing himself with a soft drink, became a billboard ad for Classic Coke. Medium: Acrylic.

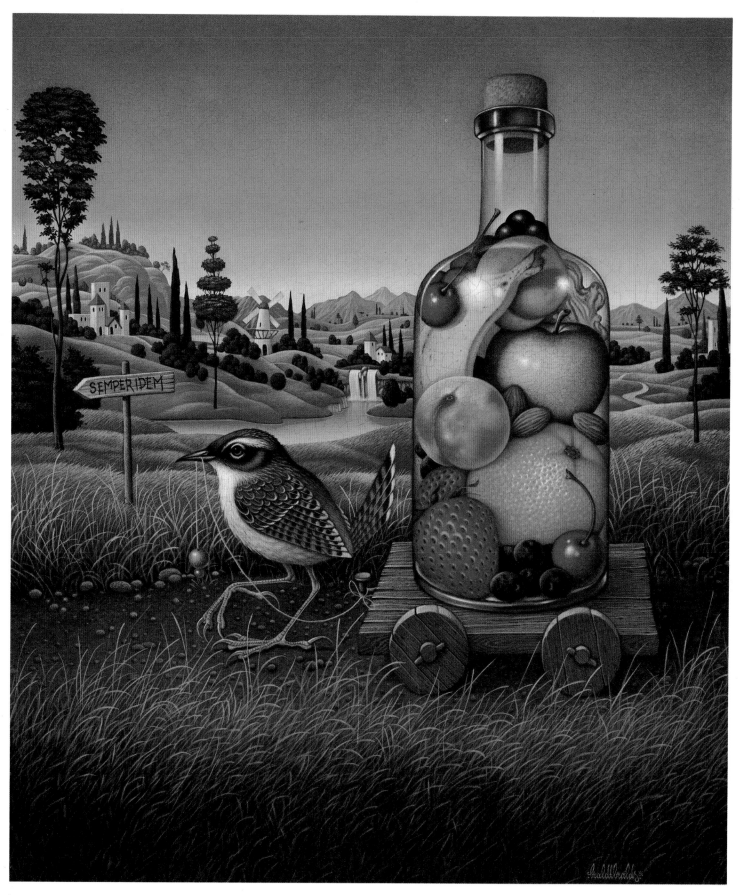

ART DIRECTOR
*Victor Vorderstrasse and Braldt
Bralds*

ADVERTISING AGENCY
BFV & L Advertising

CLIENT
*Bols Liqueurs, November/
December 1986*

Braldt Bralds

Braldt Bralds created this unusual image to convey
the classical quality of the liqueur for an ad which ran
in various consumer magazines. Medium: Oil.

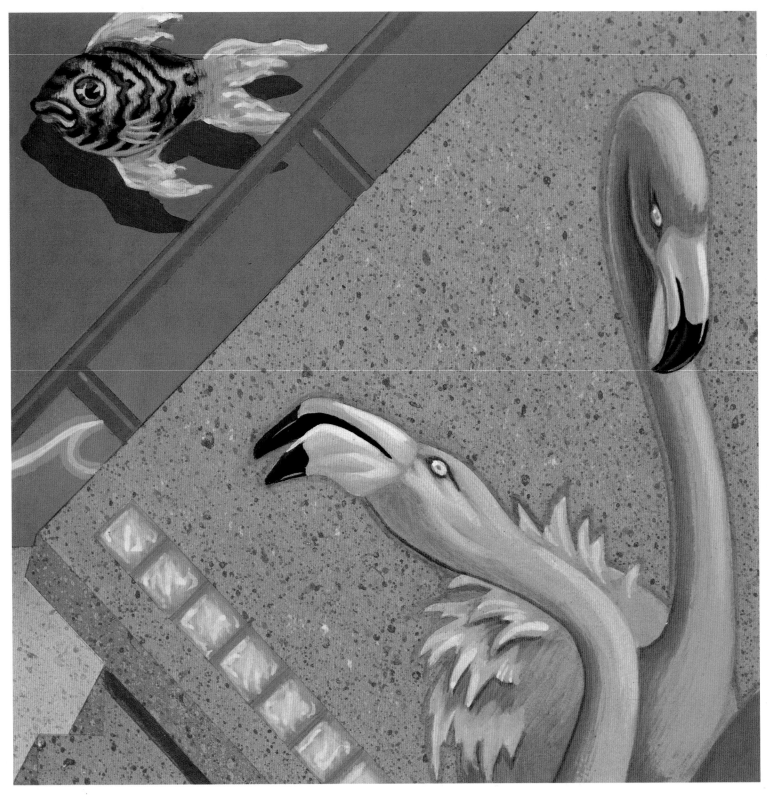

ART DIRECTOR
Suzanne Ball
CLIENT
New York, Winter 1987

Morgan Pickard

This advertisement depicting Florida wildlife ran in
New York Magazine's special section on travel.
Medium: Acrylic.

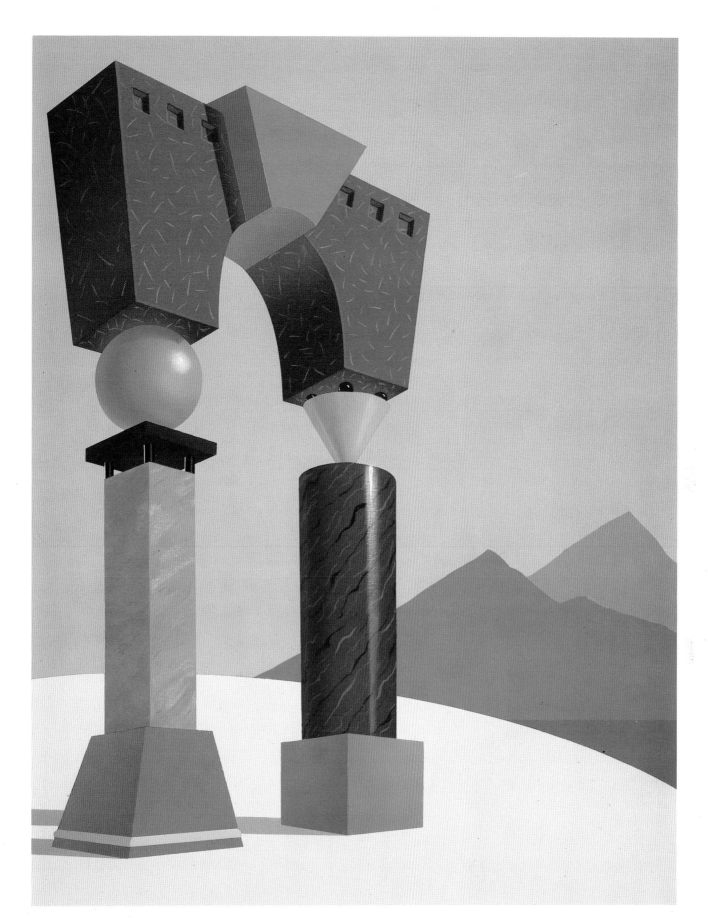

ART DIRECTOR
Ken Kulwiek

AVERTISING AGENCY
Thomas Relth and Co.

CLIENT
*Thomas Relth Advertising
March 1986*

Morgan Pickard

Morgan Pickard was asked to create an image that
was both structurally sound and aesthetically pleasing
for an advertising company to promote its slogan
"Advertising That Works for Business."
Medium: Acrylic.

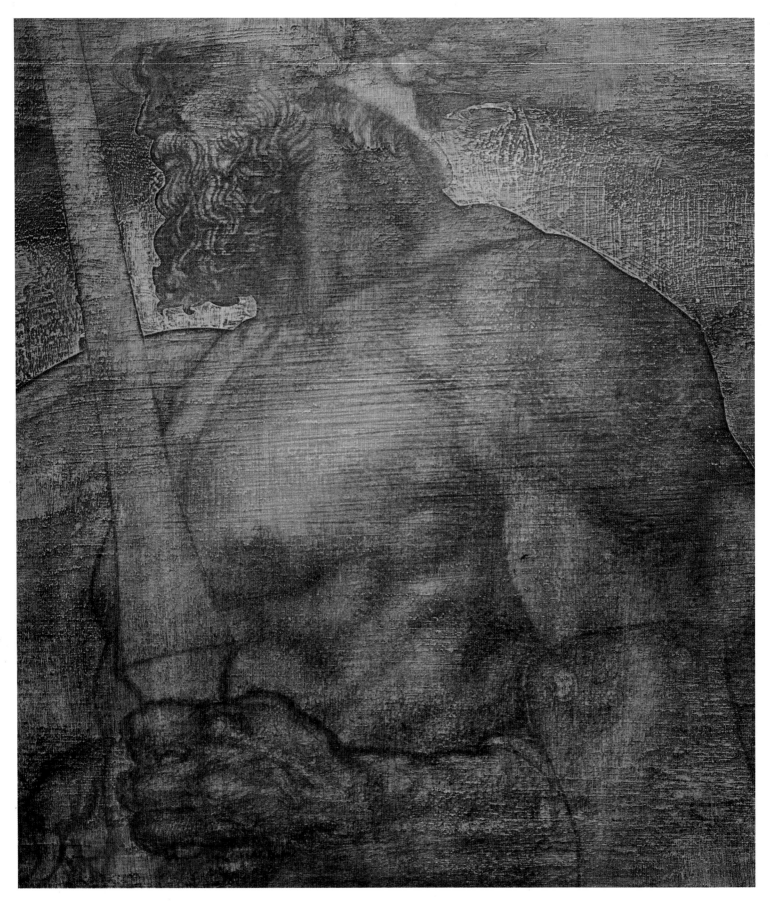

ART DIRECTOR
David Bartels
ADVERTISING AGENCY
Bartels & Carstens Inc.
CLIENT
Anheuser-Busch, Inc., 1986

John Rush

John Rush creates a mythological figure to represent the University of Idaho Vandals in a football poster promoting the company's Budweiser beer.
Medium: Gouache.

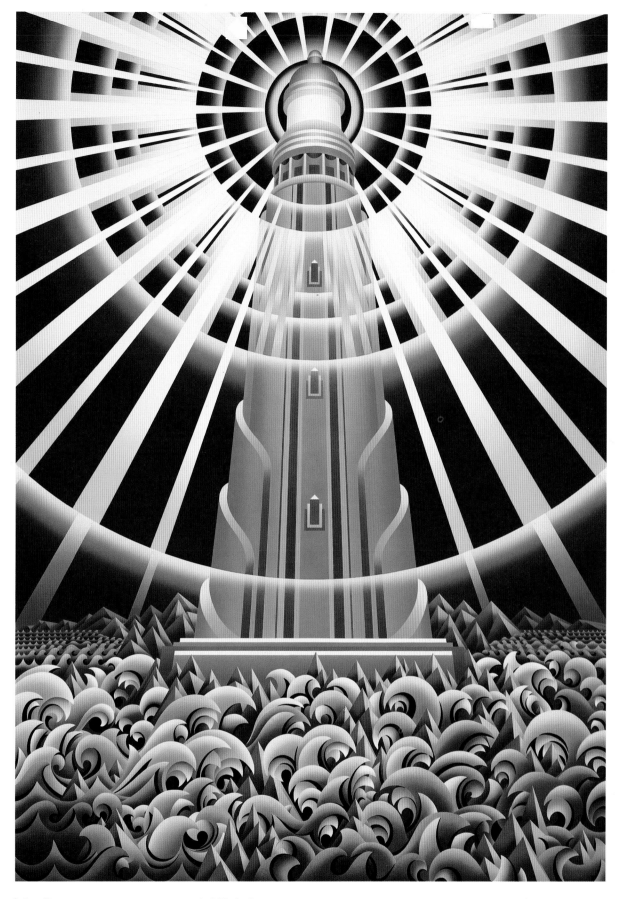

ART DIRECTOR
Charles Schmalz

COPYWRITER
Diane Koerner

ADVERTISING AGENCY
Rainoldi, Kerzner & Radcliffe

CLIENT
Smith Kline Diagnostics, Inc. 1987

Nick Gaetano

For an ad placed with various medical journals, Nick Gaetano's lighthouse in the midst of a turbulent sea communicates confidence in a diagnostic test for colorectal cancer. Medium: Airbrush, acrylic.

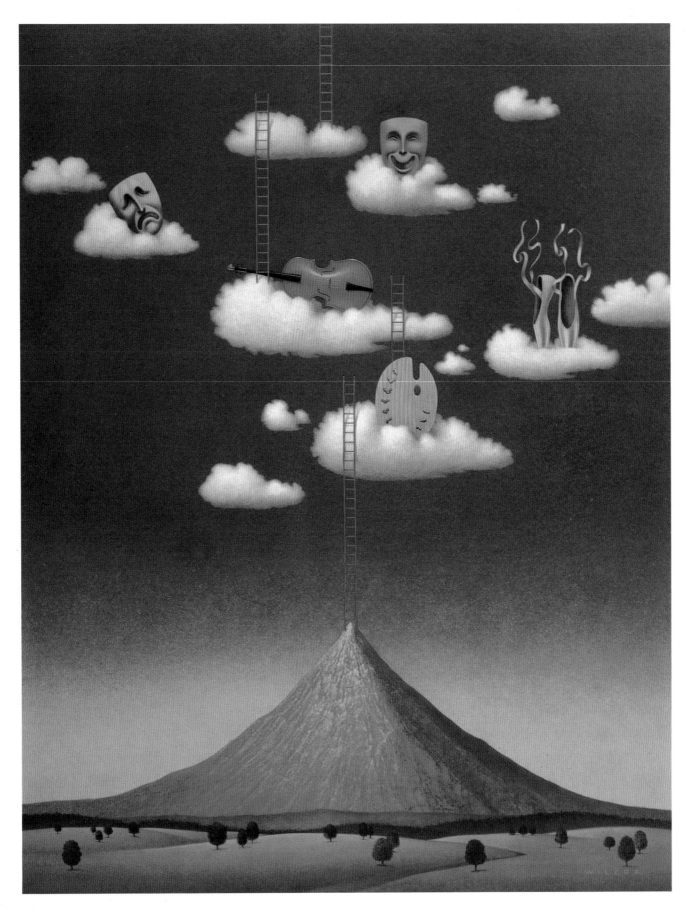

ART DIRECTOR
David Kingman
COPYWRITER
Maryanne Renz
ADVERTISING AGENCY
N.W. Ayer Inc.
CLIENT
AT&T, Fall 1986

David Wilcox

In this ad to communicate AT&T's support of the arts, David Wilcox portrayed AT&T as the connecting link by which the arts are made accessible. Medium: Acrylic.

ART DIRECTOR
Seth Jaben

COPYWRITER
Seth Jaben

ADVERTISING AGENCY
Seth Jaben Studio

CLIENT
E.G. Smith, Inc., 1986

Seth Jaben

Inspired by Chinese pharmaceutical packaging, Seth Jaben created this humorous, but sophisticated label for E.G. Smith Color Sock Company. Medium: Watercolor.

ART DIRECTOR
Norman Mallard

COPYWRITER
Beth Richardson

ADVERTISING AGENCY
Peter Wong & Associates

CLIENT
United Virginia Bankshares
Summer 1986

Guy Billout

Guy Billout's concept for a piece titled "Merger",
was one of five paintings which ran in a bank's 1985
annual report. Medium: Watercolor, brush and
airbrush.

ART DIRECTOR
Robert Miles Runyan

DESIGNER
Douglas Joseph

COPYWRITER
Micom Systems, Inc.

ADVERTISING AGENCY
Robert Miles Runyan & Associates

CLIENT
Micom Systems, Inc.
Summer 1986

Guy Billout

The theme, "Solution", illustrated by Guy Billout,
for a data communications producer's annual report.
Medium: Watercolor.

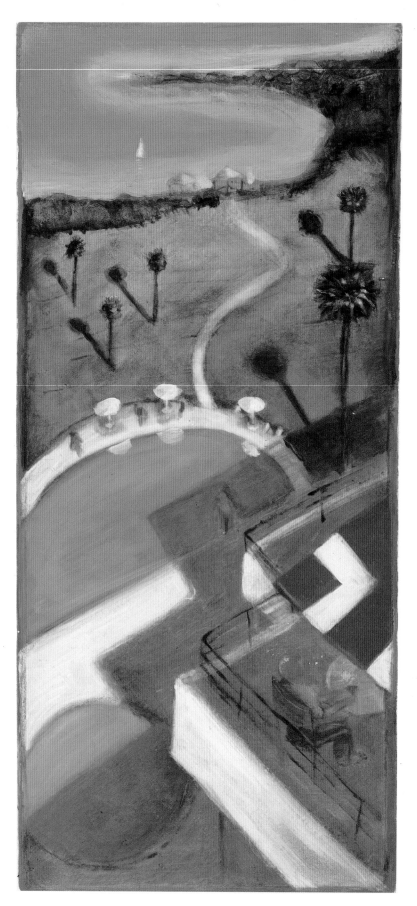

ART DIRECTOR
Michael Ostro

ADVERTISING AGENCY
The Douglas Group

CLIENT
*The Douglas Group for
Lake Hartridge Estates
Summer 1987*

Deborah Healy

Palm trees line the entry to an atrium and swimmers bask by the pool in two of a series of paintings used to advertise a Florida retirement community. Medium: Oil.

ART DIRECTOR
Ellie Costa
CLIENT
Ellis Matches, 1985

Joel Nakamura

Nakamura's painting for an advertisement introducing a new line of informal wear based on formal clothes. Medium: Acrylic and mixed media.

ART DIRECTOR
Holly Russell
ADVERTISING AGENCY
Altman & Manley
CLIENT
ABC Travel, Fall 1986

Philippe Weisbecker

Philippe Weisbecker used a square of stamps to express international travel in his illustration for a promotional postcard. Medium: Watercolor and ink.

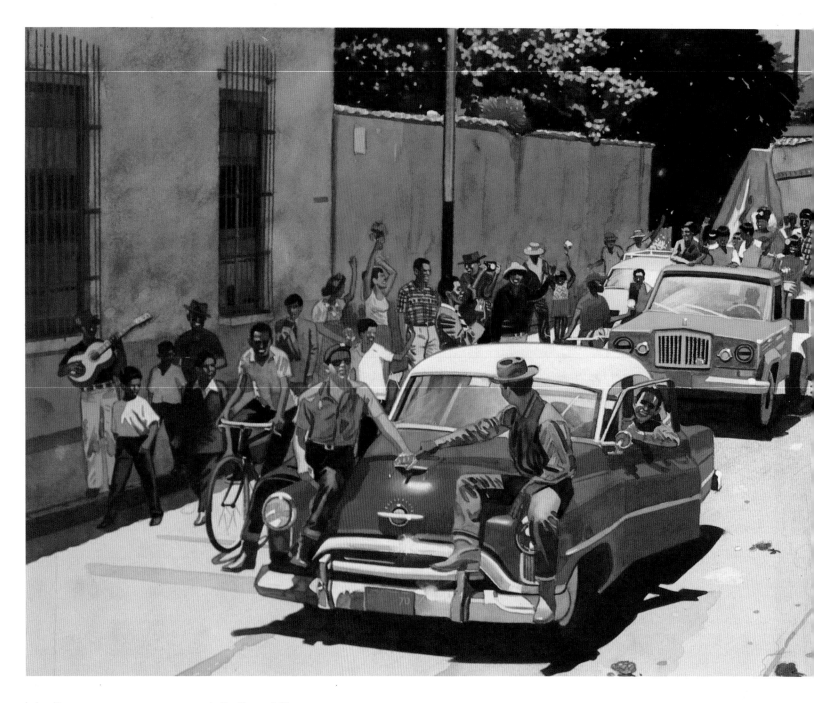

ART DIRECTOR
Bennett Robinson

AVERTISING AGENCY
Corporate Graphics Inc.

CLIENT
Heinz, 1986

Julian Allen

This optimistic annual report piece, depicts a small town in Venezuela celebrating the opening of a new Heinz plant. Medium: Watercolor.

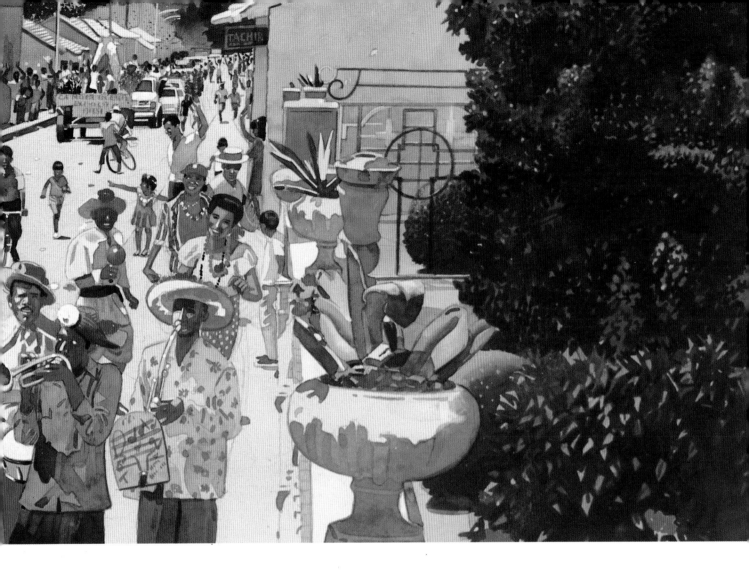

JOSE CRUZ

JAMES McMULLAN

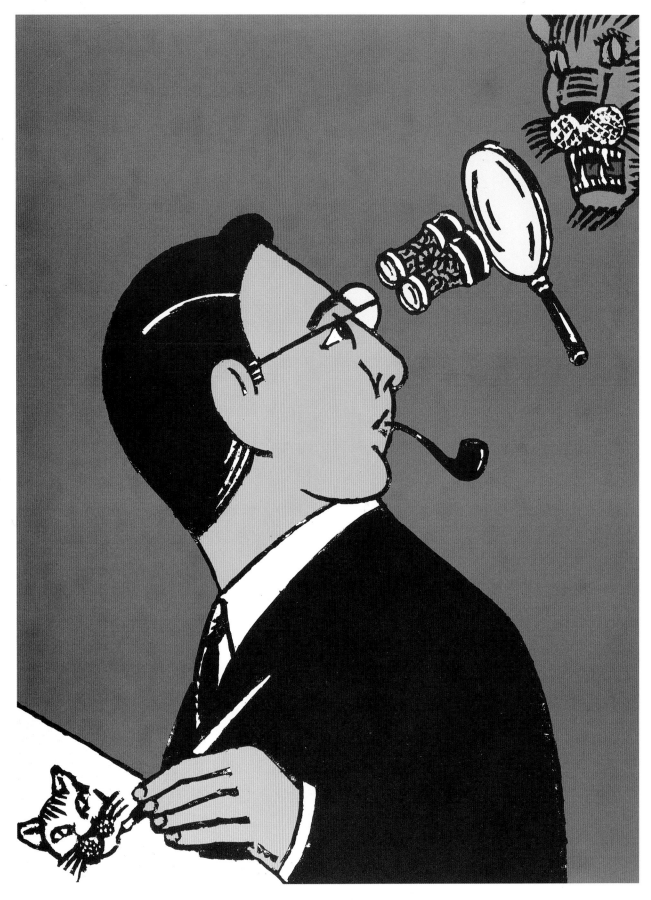

CLIENT
The Cooper Union Gallery
November 1986

Seymour Chwast

The Cooper Union Gallery's poster announcing
Seymour Chwast's 30-year retrospective as executed
by the artist. Medium: Linoleum and color overlays.

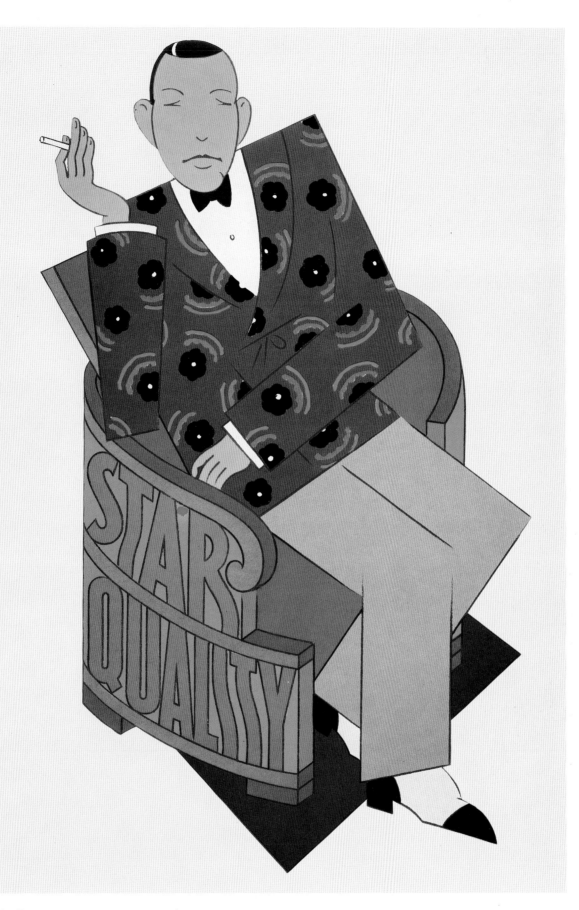

ART DIRECTOR
Sandra Rusch
COPYWRITER
Sandra Rusch
CLIENT
Mobil, February 1987

Seymour Chwast

Seymour Chwast's poster announcing a televised
series of Noel Coward's short stories is executed in
Art Deco style to recall Coward's association with the
1930's. Medium: Color overlays.

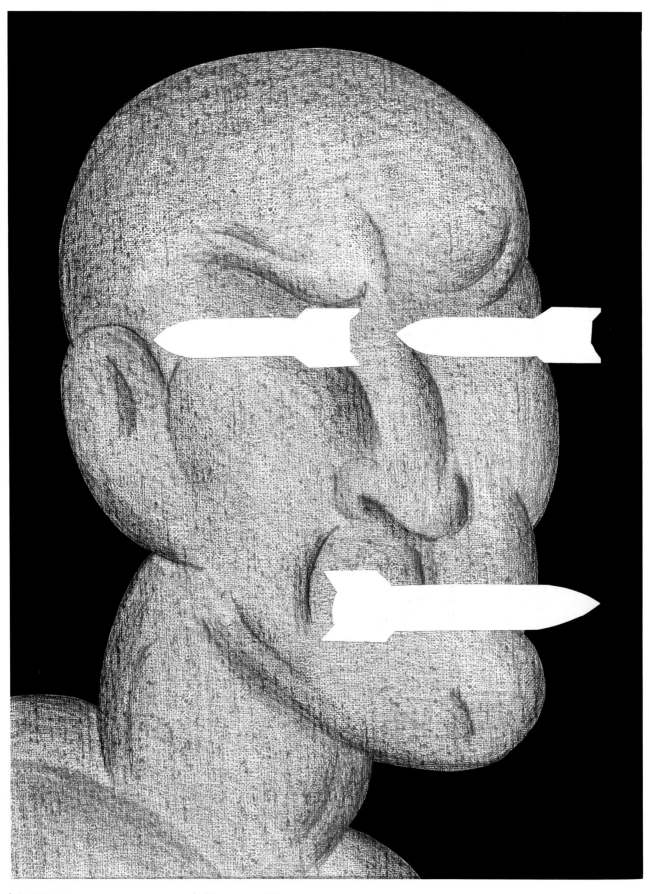

ART DIRECTOR
Seymour Chwast

CLIENT
Shoshin Society, Spring 1986

Seymour Chwast

"War Is Madness", this poster was distributed
internationally to represent the American design
community in international peace activities.
Medium: Colored pencil.

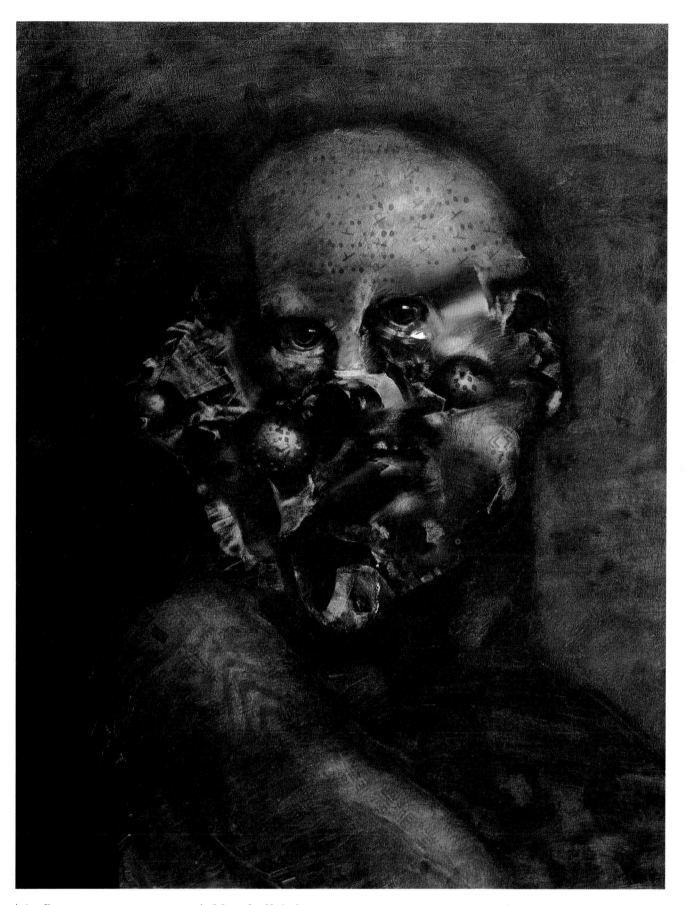

ART DIRECTOR
Tony Taylor
CLIENT
Graphic Communication
Society of Oklahoma, 1987

Marshall Arisman

Marshall Arisman chose this painting from his series "The Last Tribe", to illustrate a poster announcing a talk he was giving in Oklahoma City. Medium: Oil.

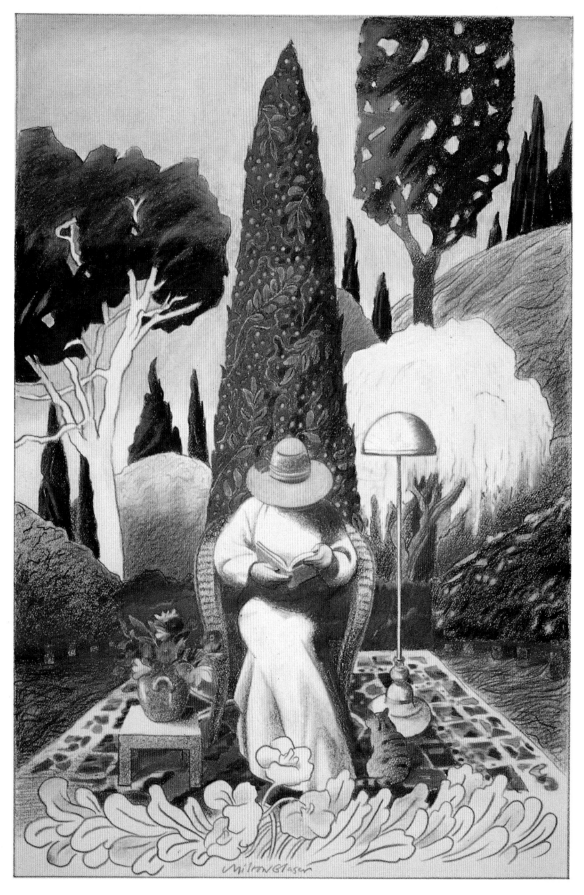

ART DIRECTOR/COPYWRITER
Jessica Weber
CLIENT
Book-of-the-Month Club, Inc.,
1987

Milton Glaser

Milton Glaser's poster commemorating The Book-of-the-Month Club's sixtieth anniversary. Medium: Colored pencil.

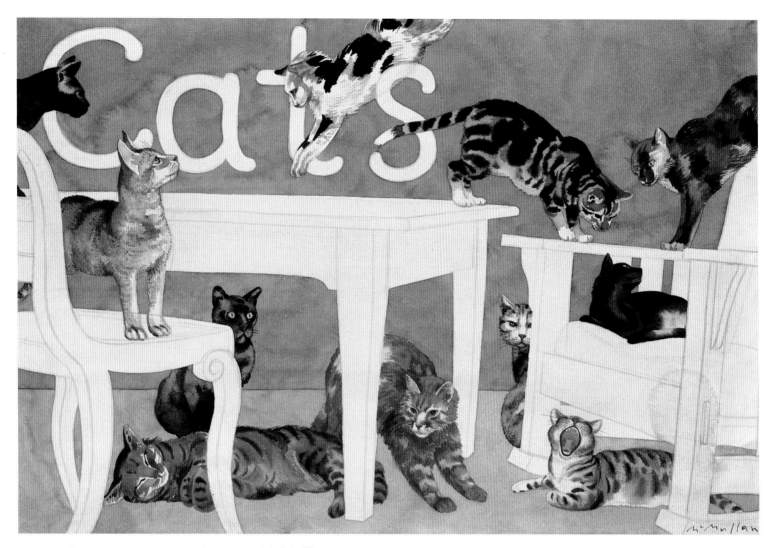

ART DIRECTOR
Carol Carson

COPYWRITER
Jean Marzollo

CLIENT
*Scholastic Publishing,
May 1986*

James McMullan

James McMullan's painting illustrates a poem that
asks preschool children which of a cat's physical
activities they can imitate. Medium: Watercolor.

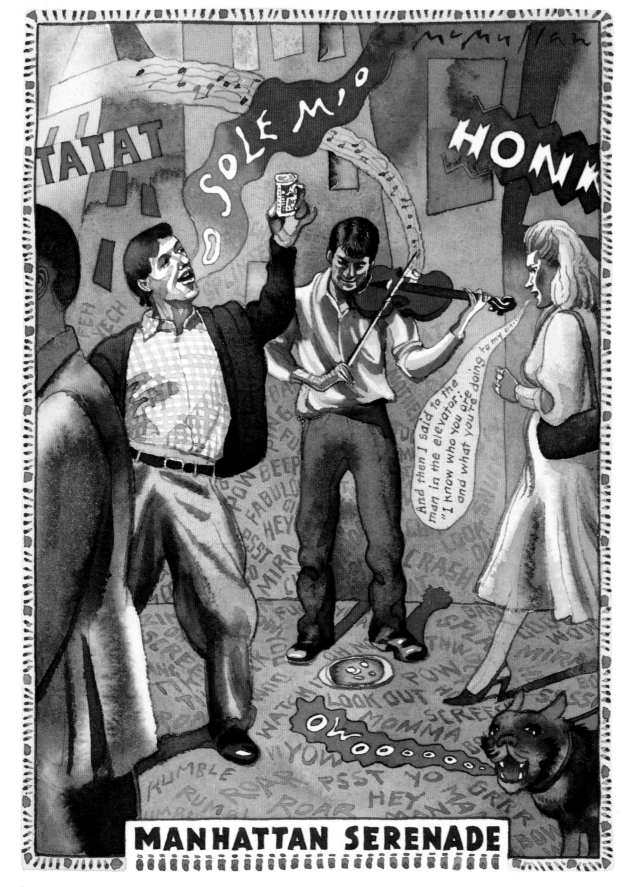

MANHATTAN SERENADE

ART DIRECTOR
Lew Fifield
CLIENT
The Maryland Institute College of Art, February 1986

James McMullan

James McMullan chose this image from his series on New York street scenes to advertise a lecture he was giving. Medium: Watercolor.

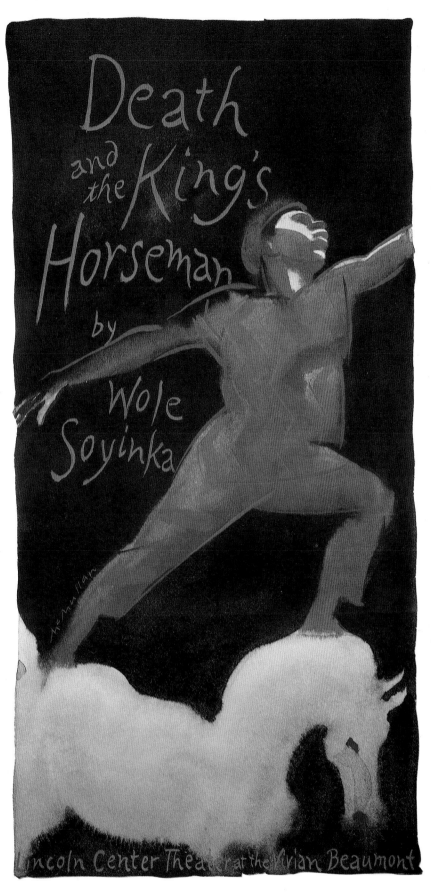

ART DIRECTOR
Jim Russek

ADVERTISING AGENCY
Russek Advertising

CLIENT
Lincoln Center Theatre
February 1987

James McMullan

James McMullan's poster advertising "Death and the King's Horseman", a play by Wole Soyinka, suggests the main character's movement toward—and finally, away from—ritual suicide with a reaching, dance-like gesture. Medium: Watercolor and pastel.

ART DIRECTOR
Dick Davis

COPYWRITER
Dan Altman

ADVERTISING AGENCY
Altman & Manley

CLIENT
Placewares, March 1986

Steven Guarnaccia

This poster which doubled as a mailer, was commissioned by a design-oriented furniture store whose annual sale announced, "Clean Out Your Attic". Medium: Pen and ink with color overlays.

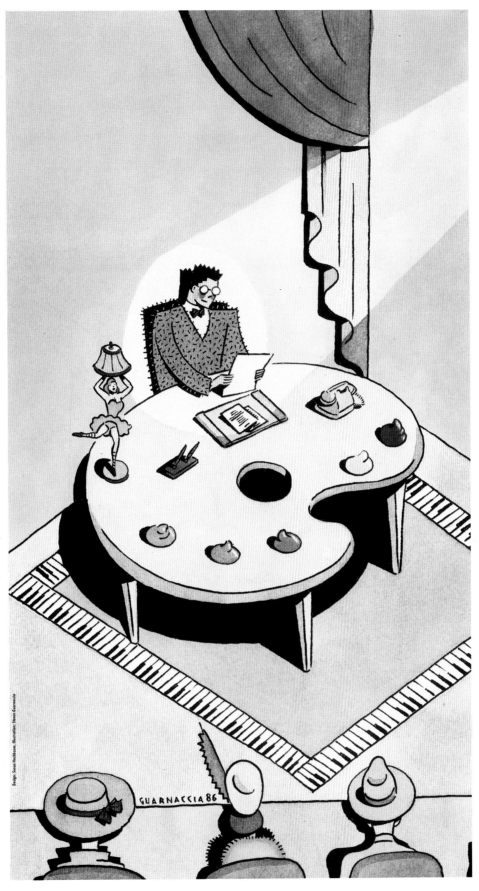

Design: Susan Hochbaum Illustration: Steven Guarnaccia

GUARNACCIA 86

ART DIRECTOR
Susan Hochbaum

COPYWRITER
David Bither

CLIENT
*University of Wisconsin
January 1986*

Steven Guarnaccia

Interpreting the slogan "Arts Must Survive as a
Business To Thrive as Art", Guarnaccia's poster was
used to promote Wisconsin University's art
administration program. Medium: Pen and ink,
watercolor.

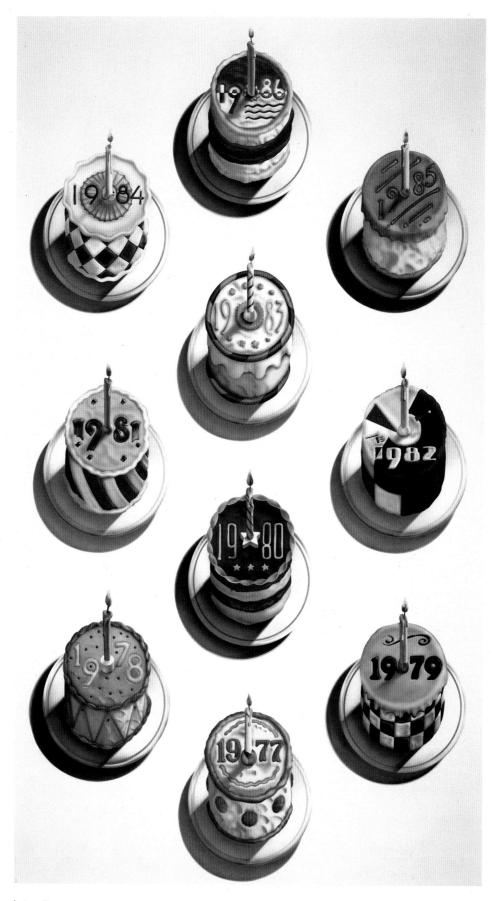

ART DIRECTORS
Kit Hinrichs and Lenore Bartz
COPYWRITER
Lewis Browand
DESIGN GROUP
Pentagram, 1986
CLIENT
Computerland

John Mattos

A poster created by John Mattos for Computerland, a chain of computer stores, enumerated the ten years of the company's existence. Medium: Ink.

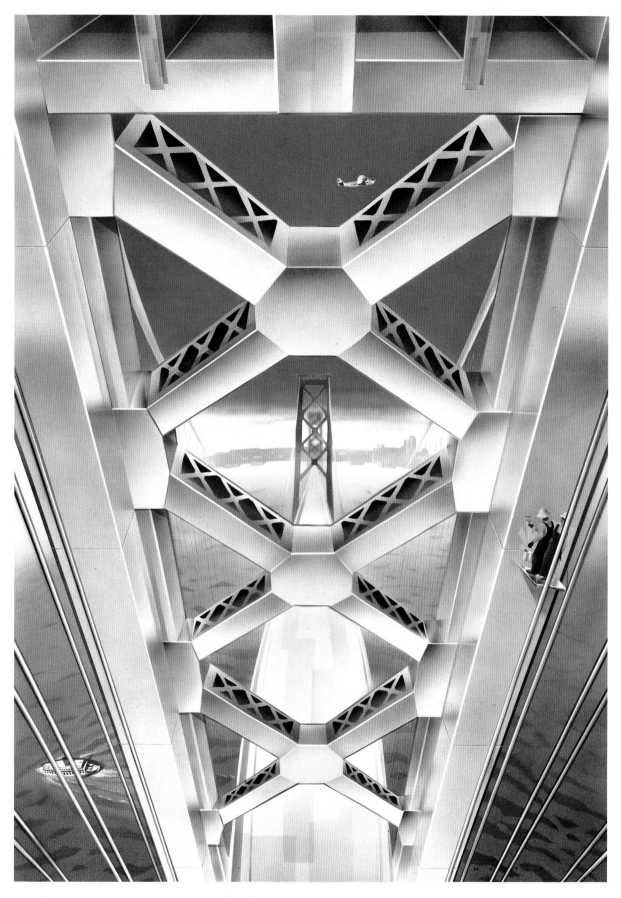

ART DIRECTOR
Lance Anderson
CLIENT
Bechtel Inc., 1986

John Mattos

Proceeds from the sale of John Mattos's poster commemorating the golden jubilee of the Oakland-San Francisco Bay Bridge helped in the installation of lights on the bridge cables. Medium: Ink.

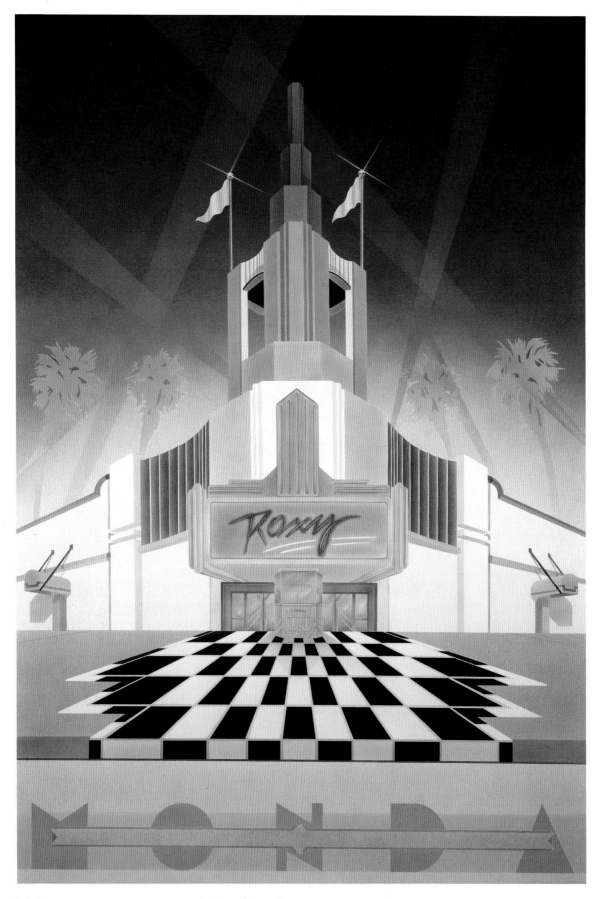

ART DIRECTOR
Steven Romm

CLIENT
Romm-Lande International, Ltd.
March 1987

Ken Monda

Ken Monda's gallery poster uses Art Deco
architecture and incorporates both his name and the
gallery's. Medium: Airbrush, dyes and acrylic.

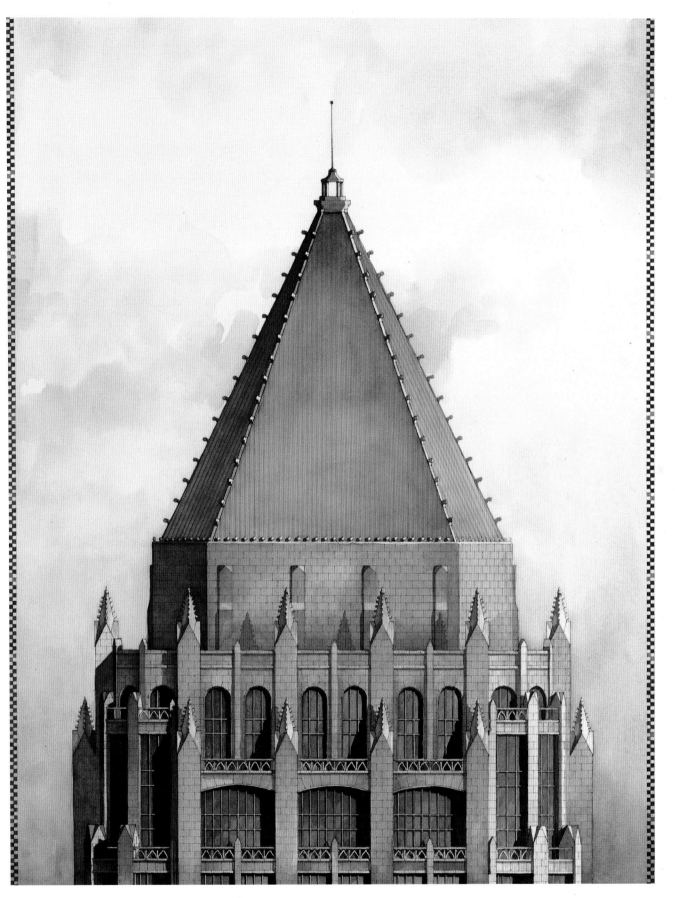

ART DIRECTOR
Lowell Williams

DESIGNERS
Lana Rigsby and Lowell Williams

ADVERTISING AGENCY
Lowell Williams Design, Inc.

CLIENT
Cadillac Fairview, December 1986

Lana Rigsby

Lana Rigsby's poster promoting the IBM Tower at Atlantic Center is intended to emphasize the richness of the building materials and at the same time convey the somewhat Gothic character of the building.
Medium: Pen, ink and watercolor.

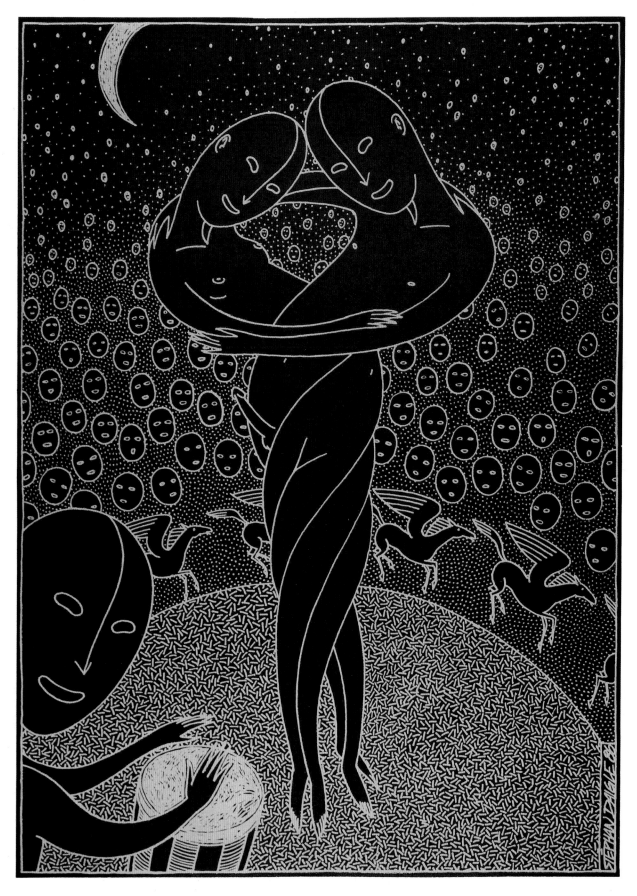

ART DIRECTOR
Gianni Caccia

COPYWRITERS
Lamberto Tassinari
Fulvio Caccia, and Gianni Caccia

CLIENT
Vice-Versa Magazine, June 1986

Stephan Daigle

"A Midsummer Night's Vice" serves as the theme for Stephan Daigle's poster announcing the latest publication of Montreal's Vice-Versa Magazine and a multicultural entertainment celebrating the summer solstice. Medium: Felt pen.

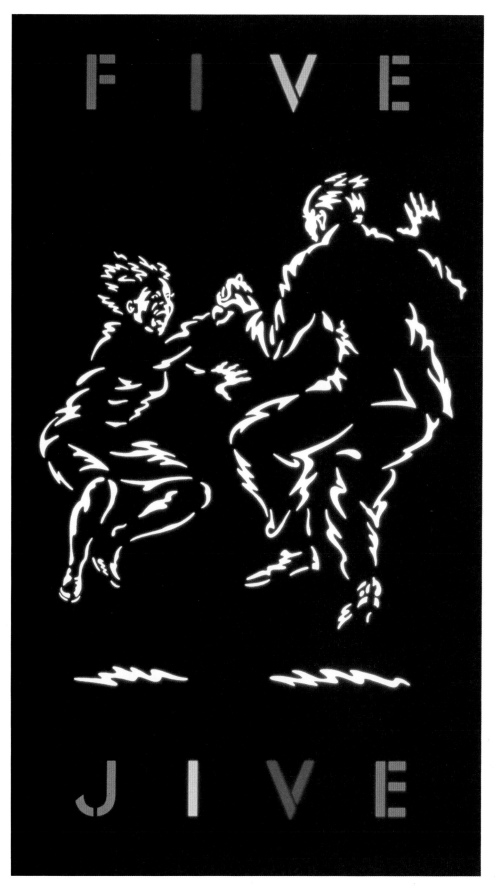

ART DIRECTOR
Joe Duffy
DESIGN GROUP
Duffy Design Group
CLIENT
Fallon McElligott Ad Agency,
August 1986

Joe Duffy

Joe Duffy's poster for an ad agency's
fifth-anniversary celebration featuring the music
group Manhattan Transfer. Medium: Pen and ink.

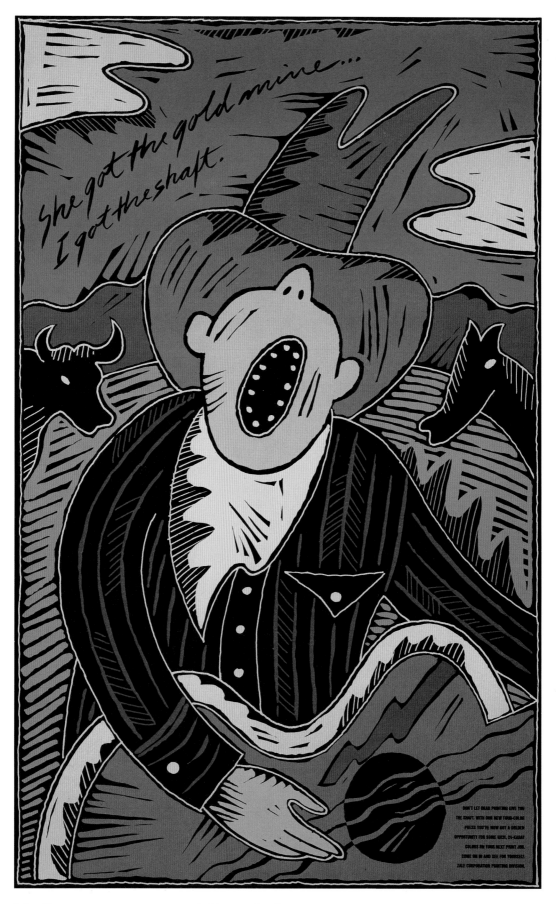

ART DIRECTOR
Bryan L. Peterson

COPYWRITER
Norm A. Darais

ADVERTISING AGENCY
Peterson & Company

CLIENT
Zale Corporation, November 1986

Bryan L. Peterson

Peterson was art director and illustrator for this colorful, upbeat poster, one in a series mailed to prospective clients as a showpiece demonstrating the capabilities of a new printing press installed at the Zale Corporation. Medium: Ink.

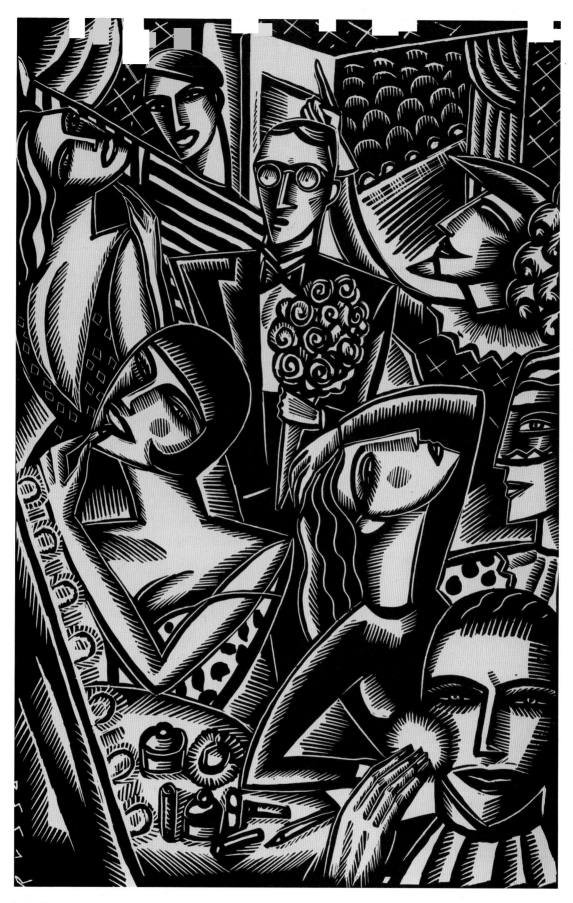

ART DIRECTOR
Tyler Smith
CLIENT
*Trinity Repertory Company
December 1986*

Anthony Russo

Anthony Russo created this illustration for a poster
announcing a fundraising party for the repertory
company. Medium: Scratchboard.

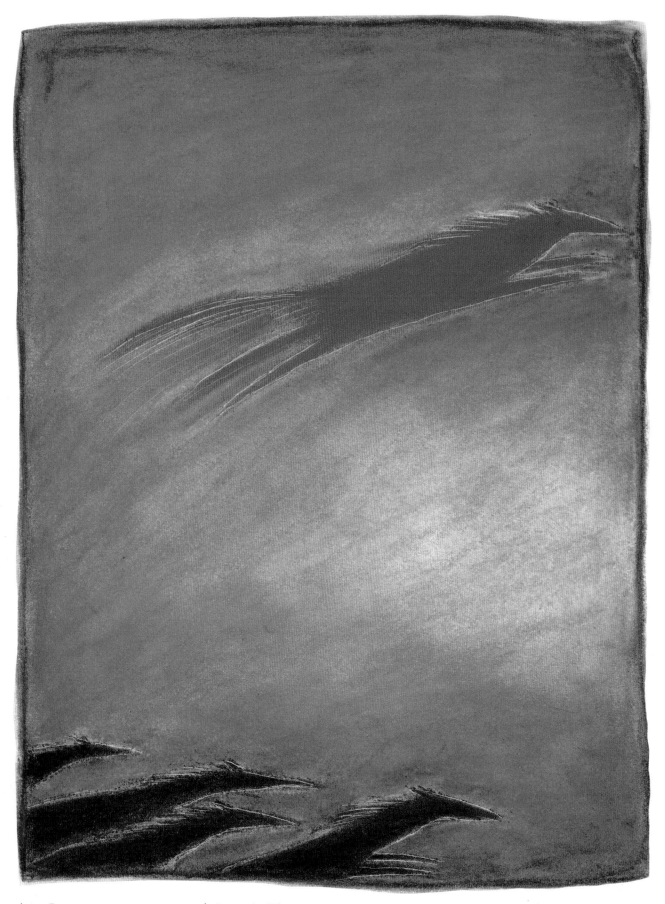

ART DIRECTOR
Elaine Shiramizu
COPYWRITER
Bonnie Timmons
CLIENT
Elaine Shiramizu, 1986

Bonnie Timmons

Bonnie Timmons used the image of a horse soaring overhead for a mailer announcing an art director's move. Medium: Pastel.

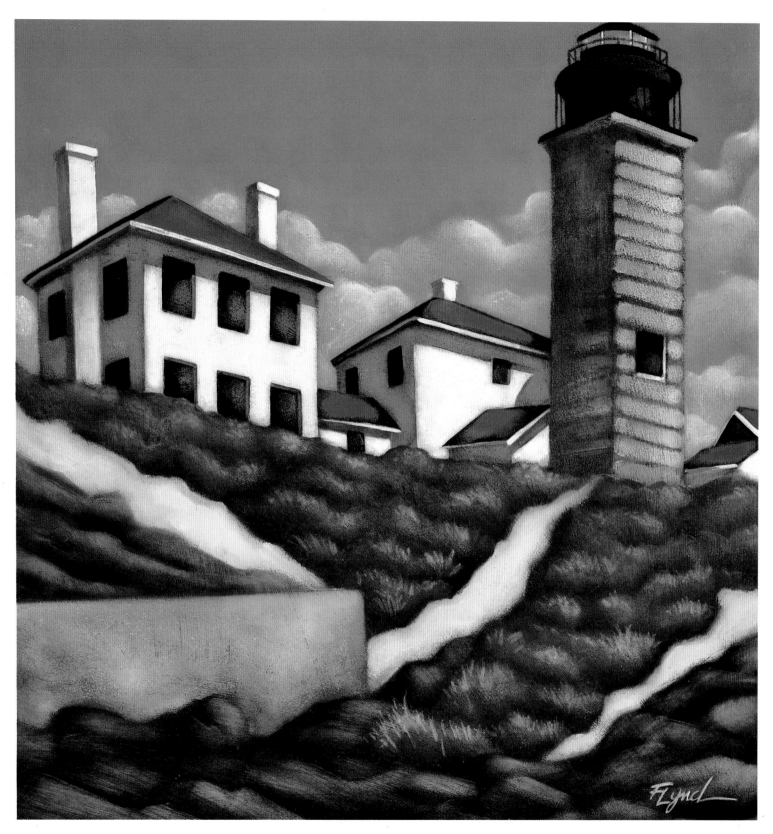

ART DIRECTOR
Peter Marcionetti
COPYWRITER
Al Lowe
ADVERTISING AGENCY
Duffy & Shanley Inc.
CLIENT
*Rhode Island Parks
Association, Fall 1986*

Fred Lynch

Fred Lynch's architectural illustration was used for a
poster to raise funds for the renovation of Beavertail
Lighthouse, the third oldest operating lighthouse in
North America. Medium: Oil.

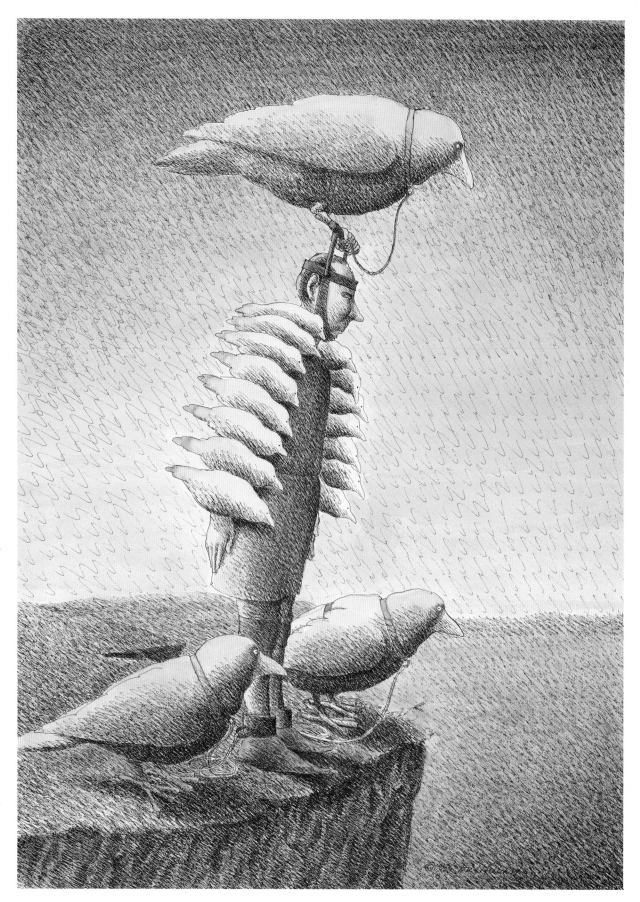

COPYWRITER
Johanne von Goethe
ADVERTISING AGENCY
Spangler and Associates
CLIENT
Boeing, 1986-1987

Fred Hilliard

A quotation from Goethe, "Daring ideas are like chessmen moved forward. They may be beaten, but they may start a winning game", is interpreted by Fred Hilliard for a motivational poster. Medium: Ink and watercolor.

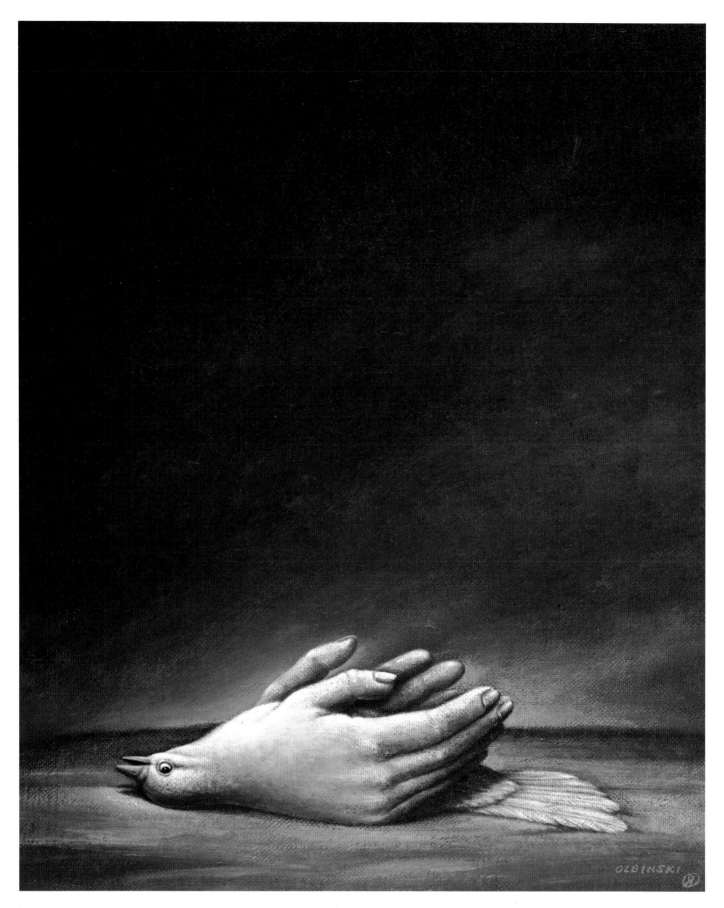

ART DIRECTOR
Rafal Olbinski

COPYWRITER
Nancy Reagan

CLIENT
Daytop Village Inc., Fall 1986

Rafal Olbinski

"Say No to Drugs Before It's Too Late", the First Lady's project to combat the abuse of drugs, was interpreted by Rafal Olbinski in his poster for Daytop, an organization that helps rehabilitate drug addicts. Medium: Acrylic.

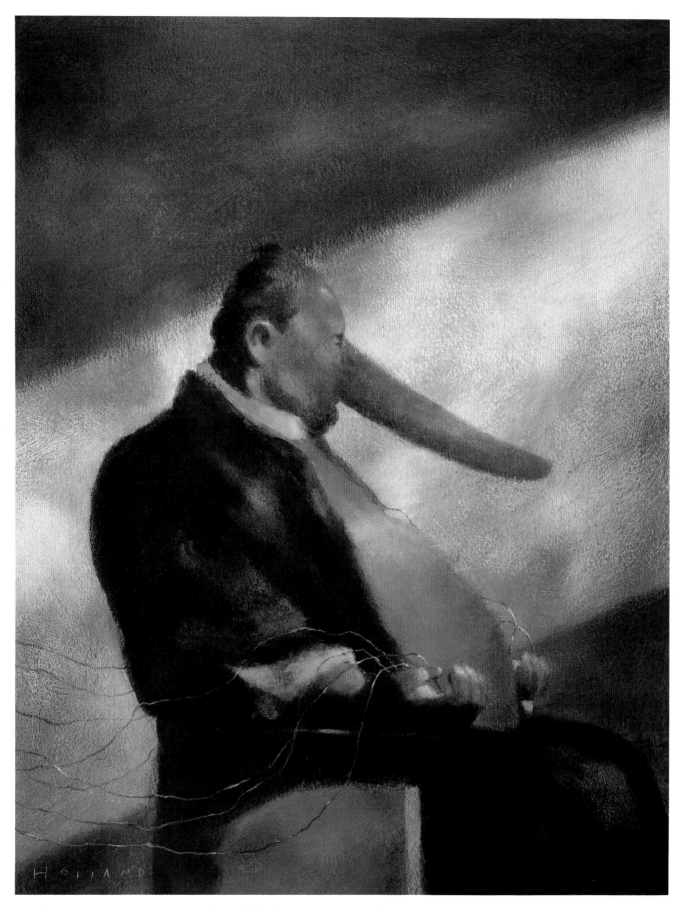

ART DIRECTOR
Brad Holland
CLIENT
Tulsa Art Directors Club
April 1986

Brad Holland

"Confessions of a Short Order Artist" was the name
of this poster advertising a lecture by Brad Holland.
Medium: Acrylic.

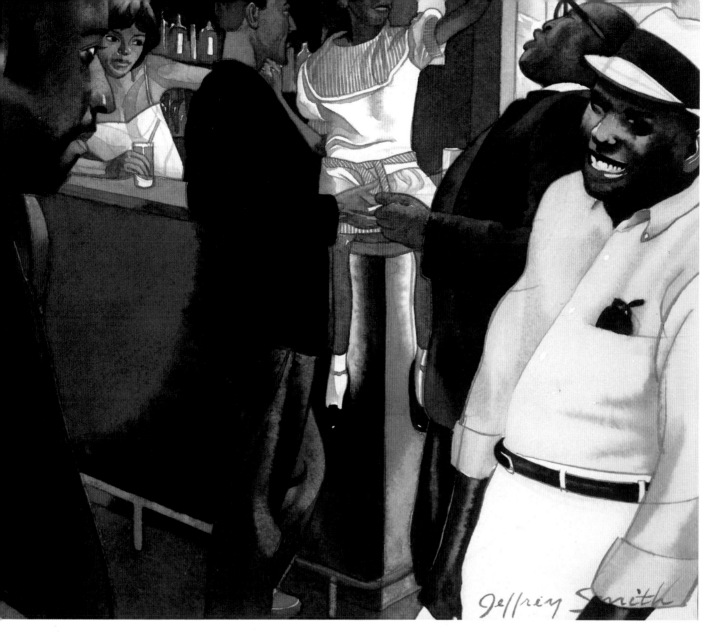

CTOR
Howell

rsity of Buffalo
86

Jeffrey Smith

An existing painting done by Jeffrey Smith was used
to illustrate a poster promoting his workshop at the
University of Buffalo. Medium: Watercolor.

GUY BILLOUT

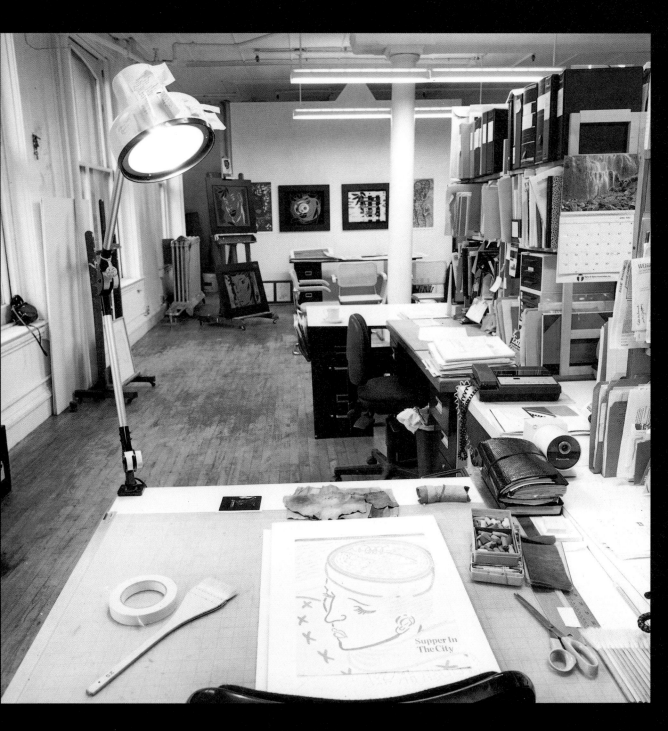

BARBARA NESSIM

ART DIRECTOR
Louis Fishauf
DESIGN GROUP
Reactor Art & Design, Ltd.
PUBLISHER
Reactor Art & Design, Ltd.

Jamie Bennett

Commissioned to design a line of t-shirts in Spring 1987 for Reactor Artwear, Jamie Bennett created an illustration style called Mumbo Jumbo. Medium: Silkscreen on fabric.

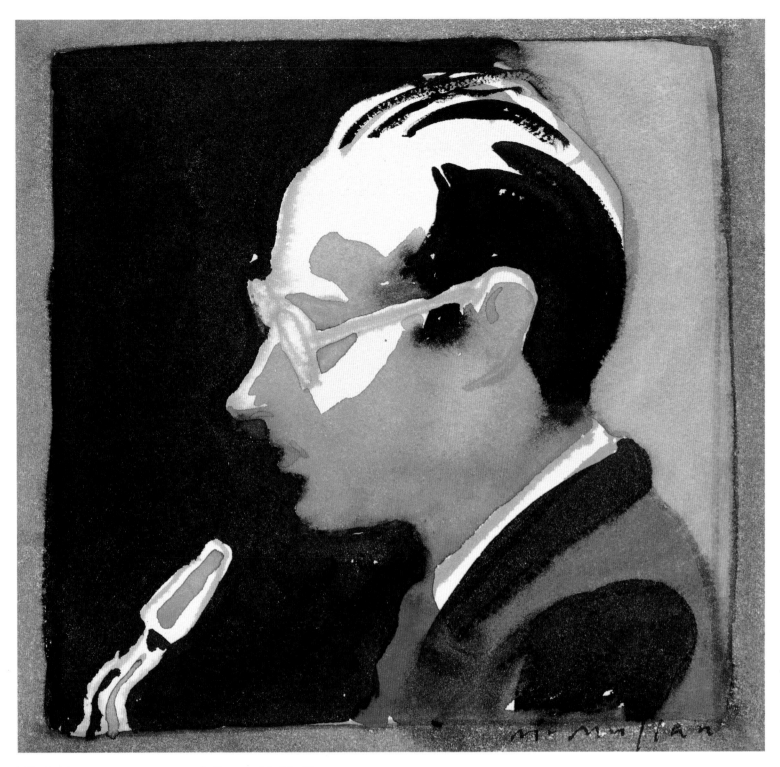

DESIGNER
Neal Pozner
PUBLISHER
RCA Records

James McMullan

James McMullan painted a portrait of Paul Desmond
for his 1986 album, "Late Lament".
Medium: Watercolor.

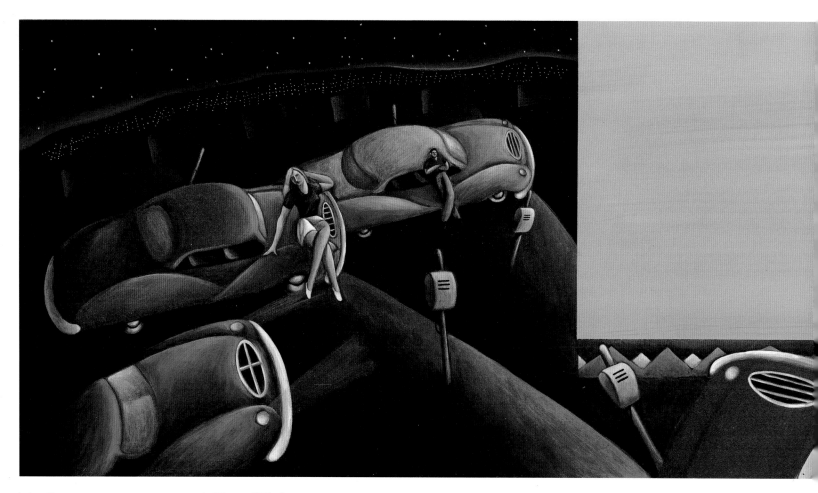

ART DIRECTOR
Phillip Lamb
DESIGN GROUP
TM Productions

Terry Widener

Produced in May 1986 for an audio-visual show celebrating Coca-Cola's centennial, Widener's painting appeared as a billboard sized transparency upon which movies were shown. Medium: Acrylic.

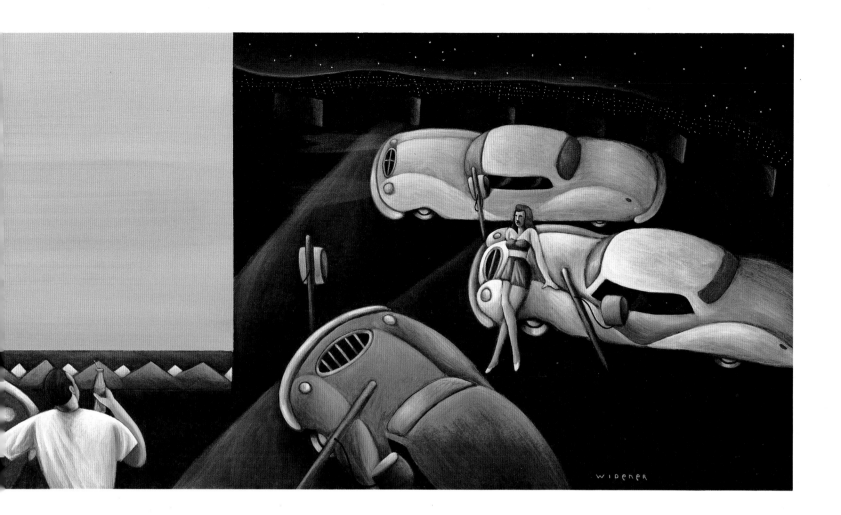

DESIGNER
Craig Fuller
DESIGN GROUP
Crouch & Fuller

Allen Garns

Allen Garns created a series of elegant, still life drawings to illustrate a 1986 brochure promoting a California hotel. Medium: Pastel

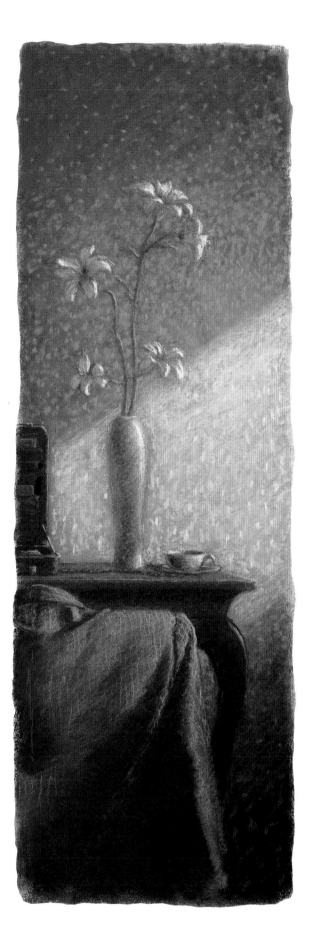

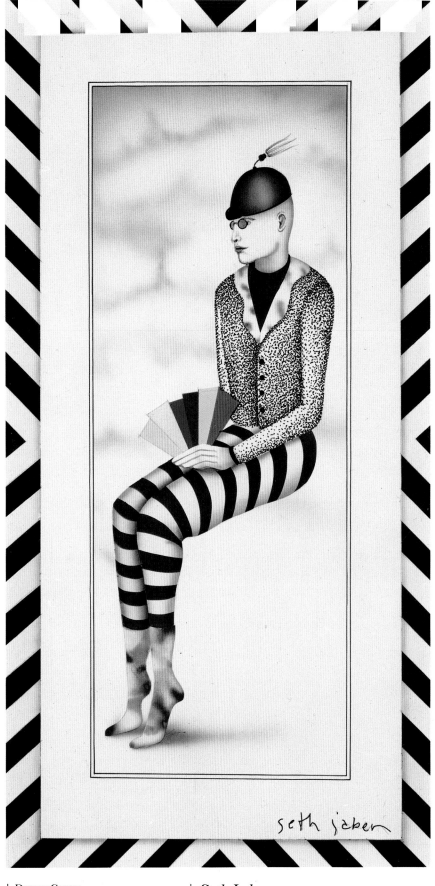

seth jaben

DESIGN GROUP
Seth Jaben Studio
PUBLISHER
E.G. Smith, Inc.

Seth Jaben

In an 1986 ad campaign for this unconventional color sock company, Seth Jaben invents a positive form of propaganda and designates his friend, E.G. Smith, as "optimistic icon of the company". Medium: Watercolor.

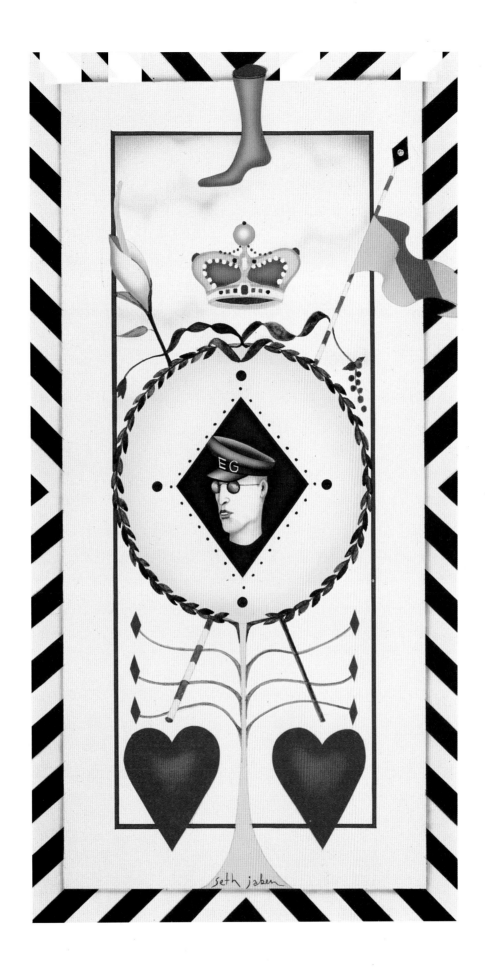

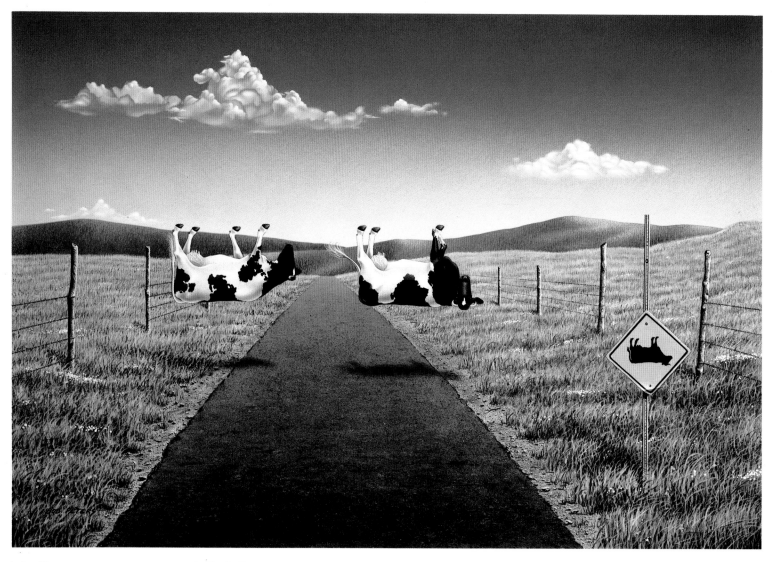

ART DIRECTOR
Bob Peters
DESIGN GROUP
Richardson or Richardson

Bob Peters

Bob Peters shares a surrealistic joke in his 1986
self-promotional mailer. Medium: Acrylic.

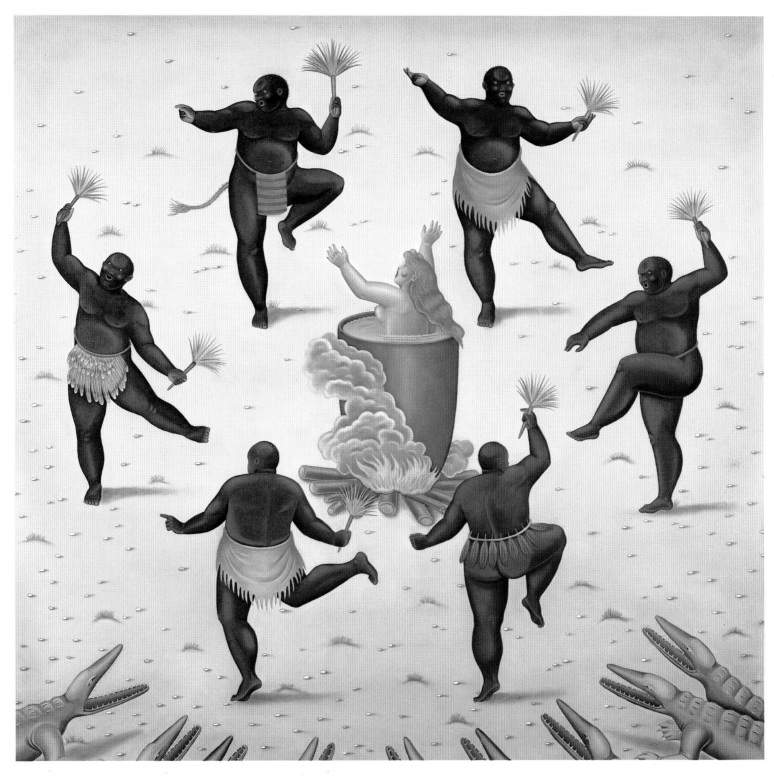

Sandra Hendler

Sandra Hendler's 1986 promotional mailer illustrates
a cautionary tale about a meddling missionary in
Africa. Medium: Oil.

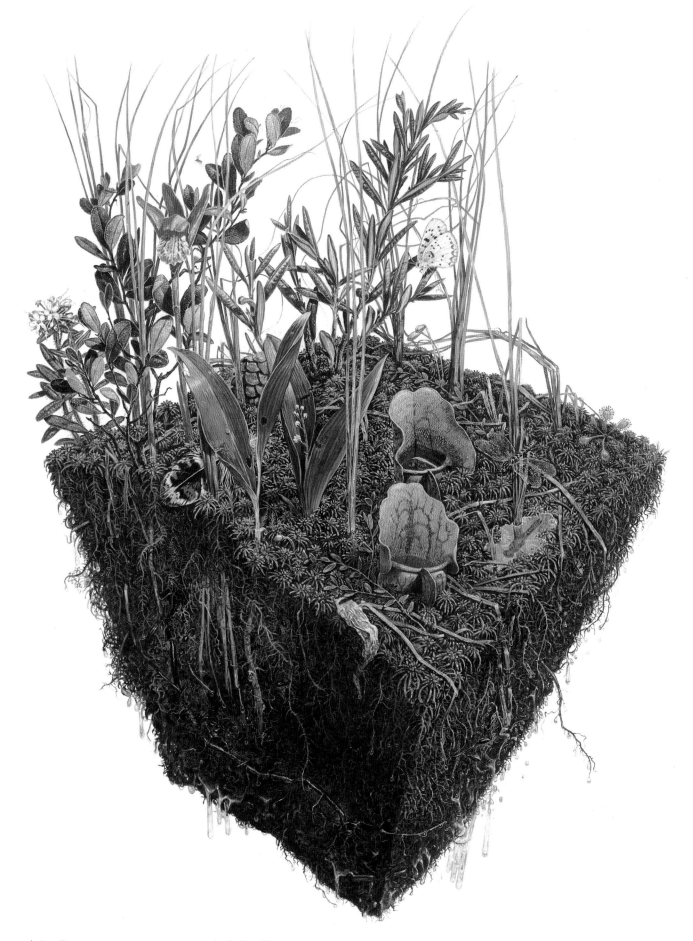

ART DIRECTOR
Allen Carroll

WRITER
Louise Levathes

PUBLICATION
National Geographic, March 1987

John Dawson

John Dawson's painting reveals the plant and animal
life contained in a shovelful of peat bog. Medium:
Acrylic.

BRAD HOLLAND

EDWARD SOREL

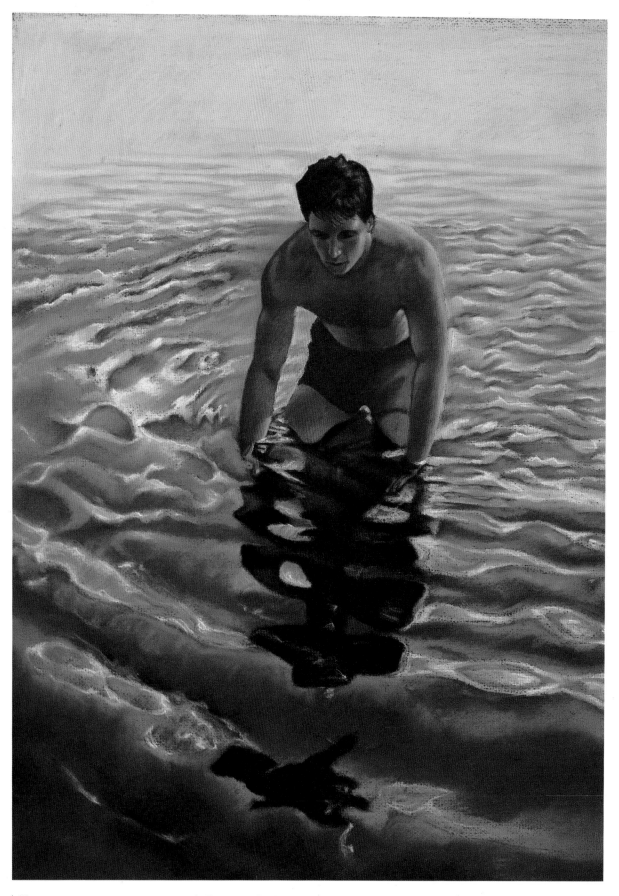

Donna Perrone

Donna Perrone created this piece for her portfolio the
summer after graduating from the School of Visual
Arts. Medium: Pastel.

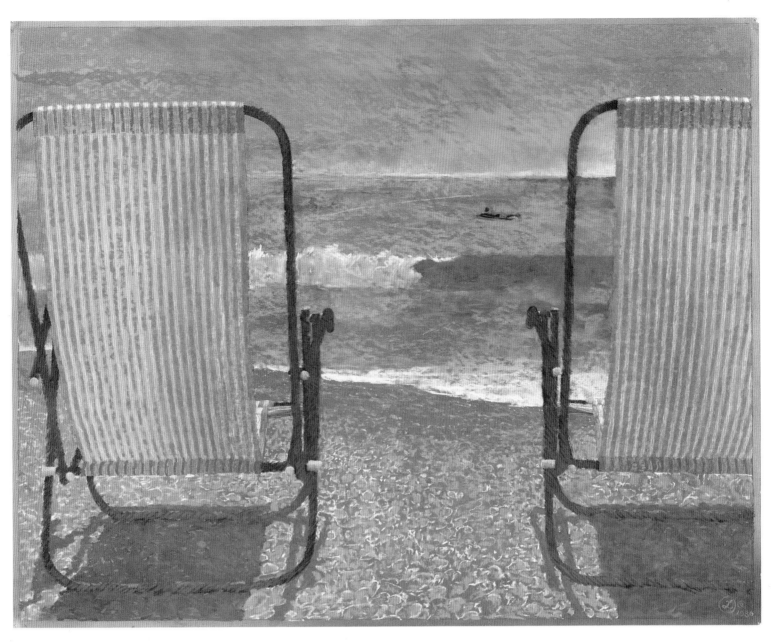

TITLE
Beach Chairs, August 1986

Mark Langeneckert

From research gathered on Sanibel Island, Florida,
Mark Langeneckert created a series of illustrations
for possible publication as greeting cards or
limited-edition prints. Medium: Pastel and oil.

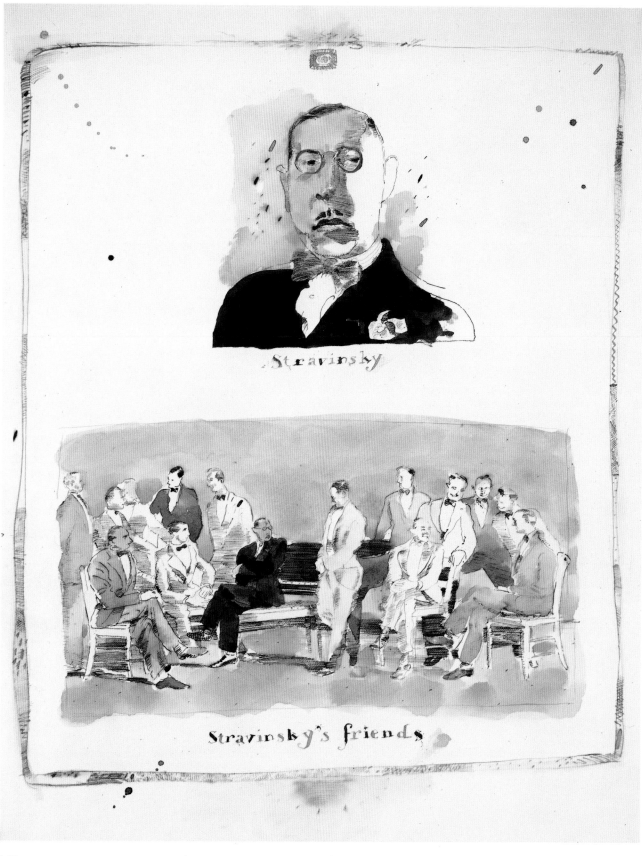

TITLE
Stravinsky, 1986

Barry Blitt

Stravinsky's portrait is part of a series of drawings by
Barry Blitt which illustrate the quasi-humorous
biographies of his heroes. Medium: Ink.

Waltz going on

TITLE
Waltz Going On?, 1986

Barry Blitt

Barry Blitt's pictorial play on words for a group show
with the theme "What's Going On?". Medium: Ink.

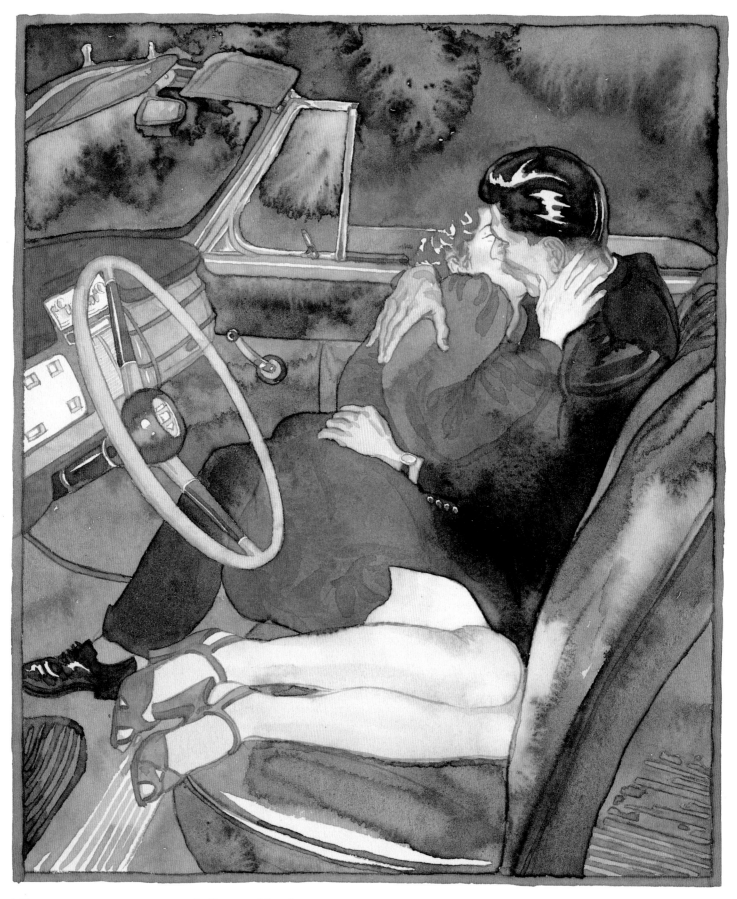

TITLE
The Kiss, April 1986

Garnet Henderson

Garnet Henderson's figure study is part of an ongoing
personal work on sensuality. Medium: Watercolor.

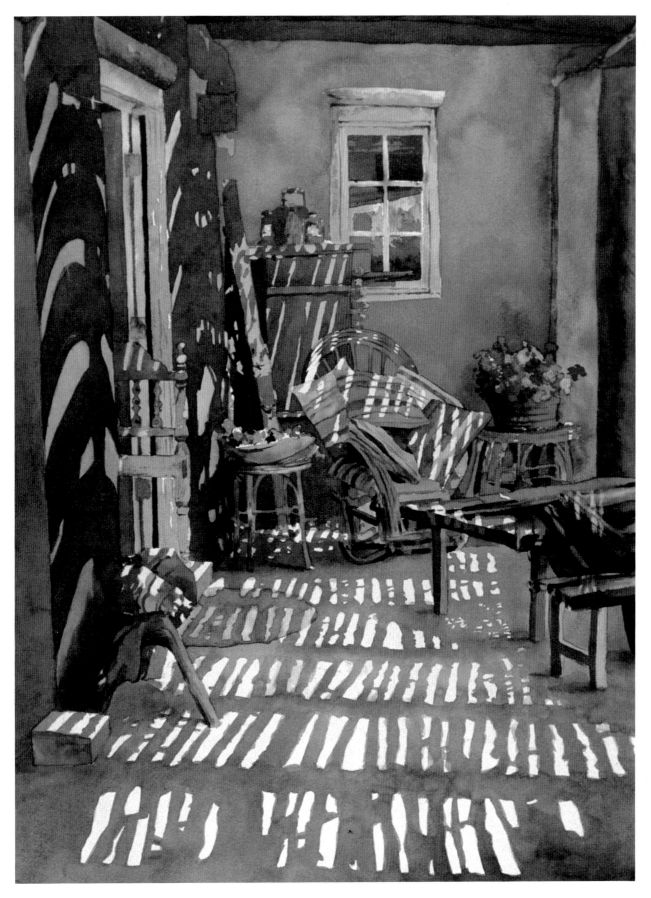

TITLE
Santa Fe Shadows, December 1986

Leo Smith

Sunlight and shadow play on a Santa Fe room in Leo Smith's illustration for his personal portfolio.
Medium: Watercolor.

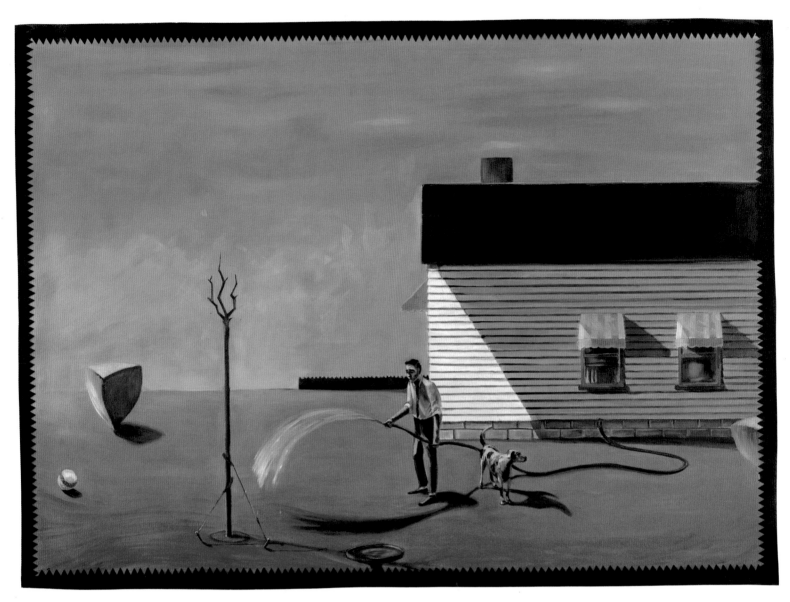

TITLE
Summer, 1986

Lissa Pollie

This piece was one of a series of four illustrations
based on the seasons executed for Lissa Pollie's
portfolio. Medium: Oil.

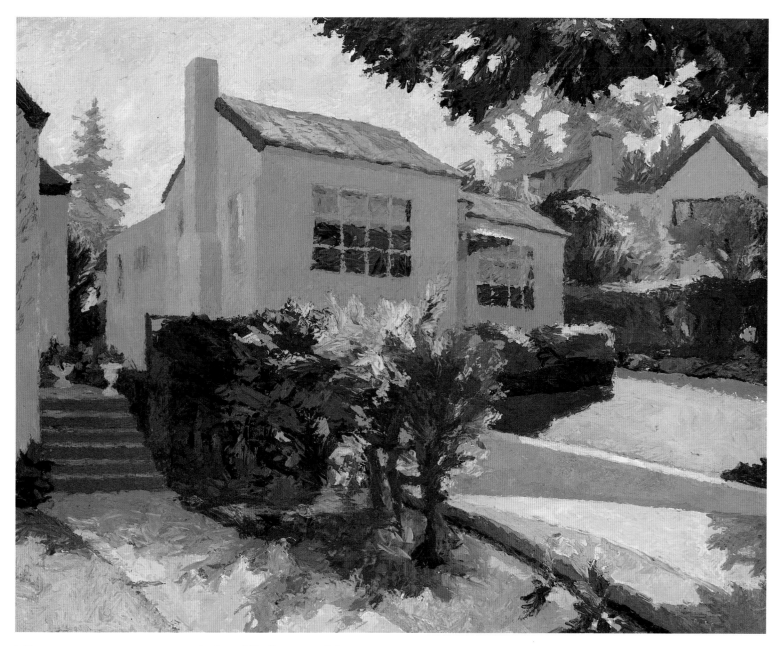

TITLE
West Side Burlingame, Fall 1986

Camille Przewodek

This painting, done on location in the early morning light, became Camille Przewodek's self-promotional piece. Medium: Oil.

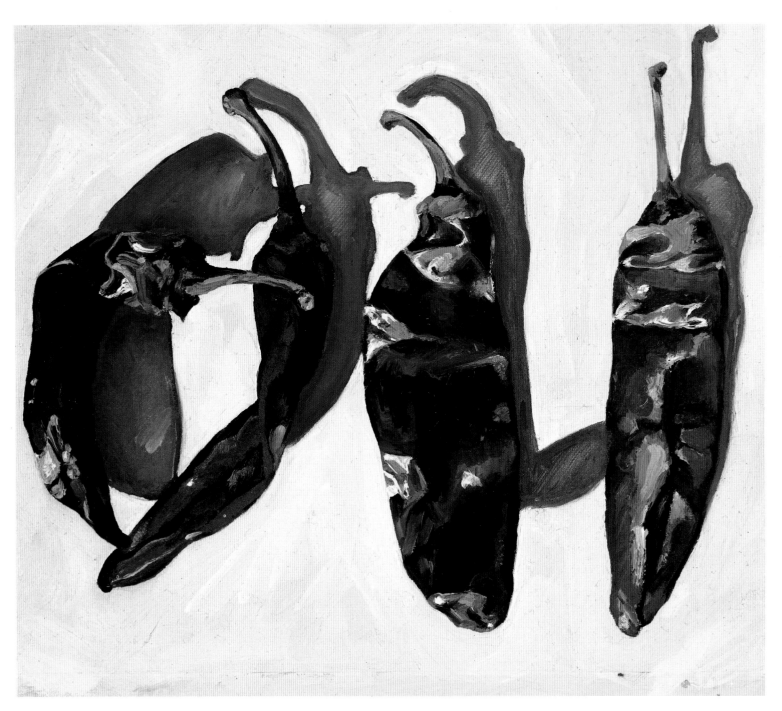

TITLE
Chili Peppers, August 1986

Kristen Funkhouser

Kristen Funkhouser's self-promotional piece was made to capture the variety of flavor and color in modern Mexican cuisine. Medium: Oil.

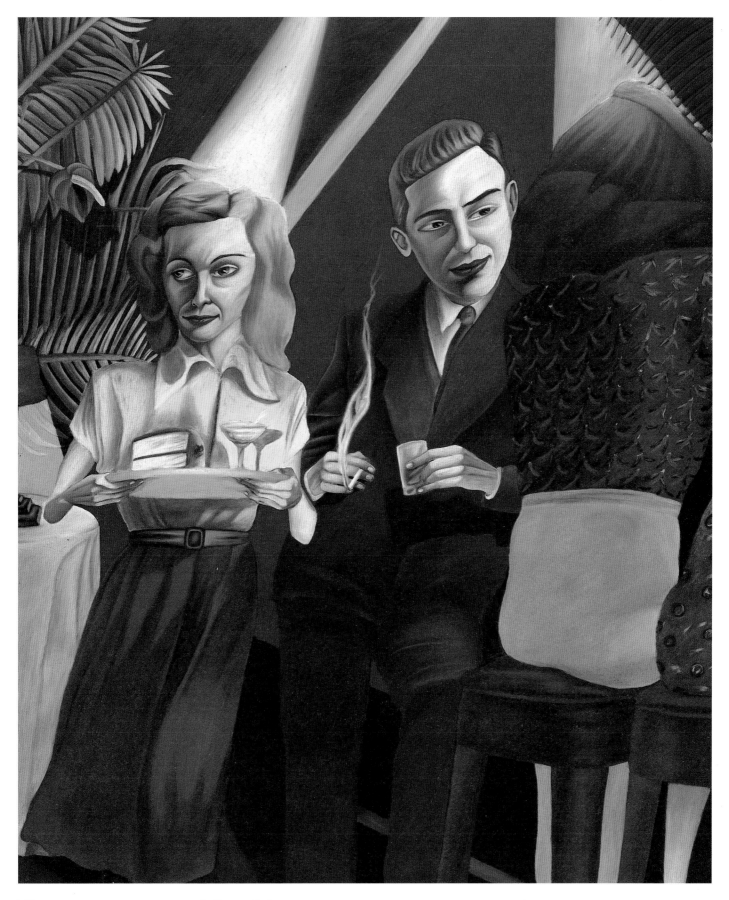

TITLE
The Intimate Cafe, January 1987

Sara Schwartz

One of a series of drawings titled "Couples in New York", depicts a familiar scene, the pickup.
Medium: Colored pencil and crayon.

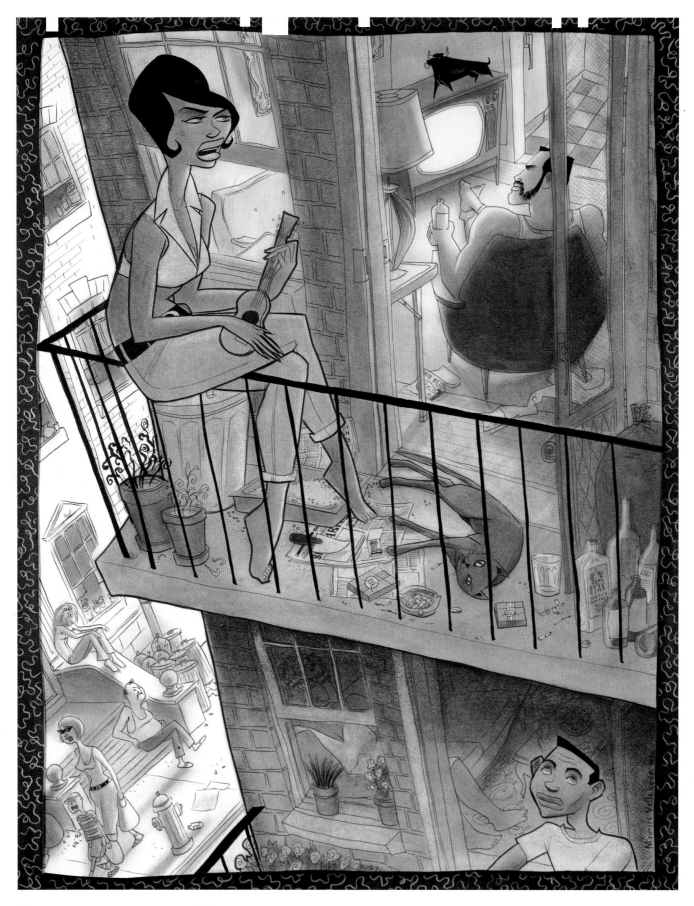

TITLE
Summertime, Winter 1986

Maurice Vellekoop

A man's attention is drawn to a woman playing a guitar on her terrace in this painting by Maurice Vellekoop. Medium: Mixed media.

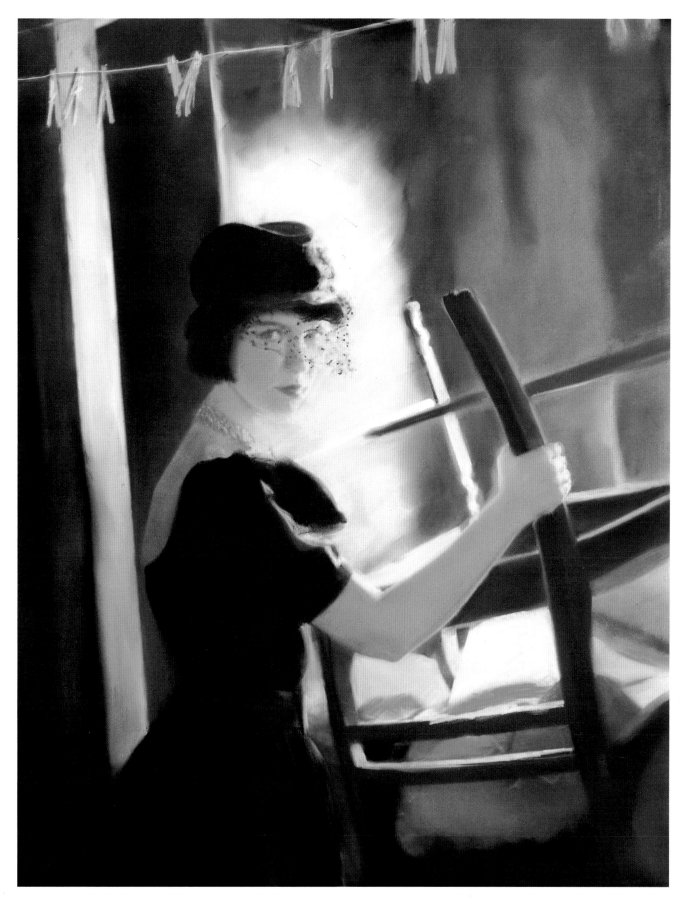

TITLE
Untitled, 1986

Hilary Mosberg

Hilary Mosberg was thinking of Henry James and Manet when she created this portrait of a modern woman in the 19th-century style for her self-promotional mailer. Medium: Mixed media.

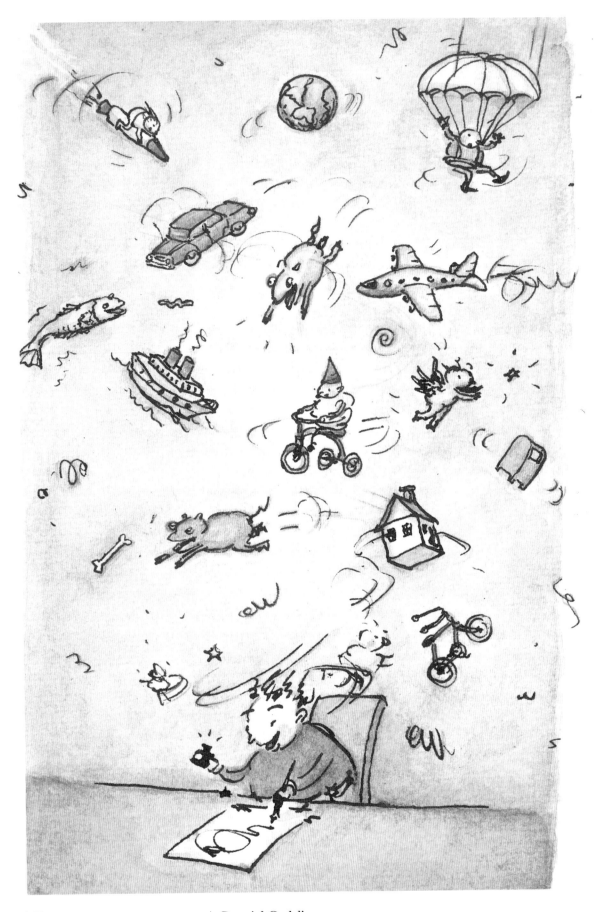

Title
The Drawing Table, February 1987

David Goldin

David Goldin was in a lighthearted mood when he executed this self-promotional illustration. Medium: Watercolor and ink.

VIVIENNE FLESHER

KEVIN BOND

DUGALD STERMER

ANIMATORS
*Maciek Albrecht and
Russell Calabrese*

DIRECTORS
*Maciek Albrecht and
R.O. Blechman*

WRITER
Katherine Fair

ART DIRECTORS
JoAnn Zelano and Richard Menard

CLIENT
*Rhode Island Department
of Economic Management*

AGENCY
Fitzgerald & Company, Inc.

PRODUCTION COMPANY
The Ink Tank

Maciek Albrecht

Working from a script, storyboard, and character provided by the client, Maciek Albrecht did this commercial ("Oscar") promoting a statewide environmental cleanup campaign.

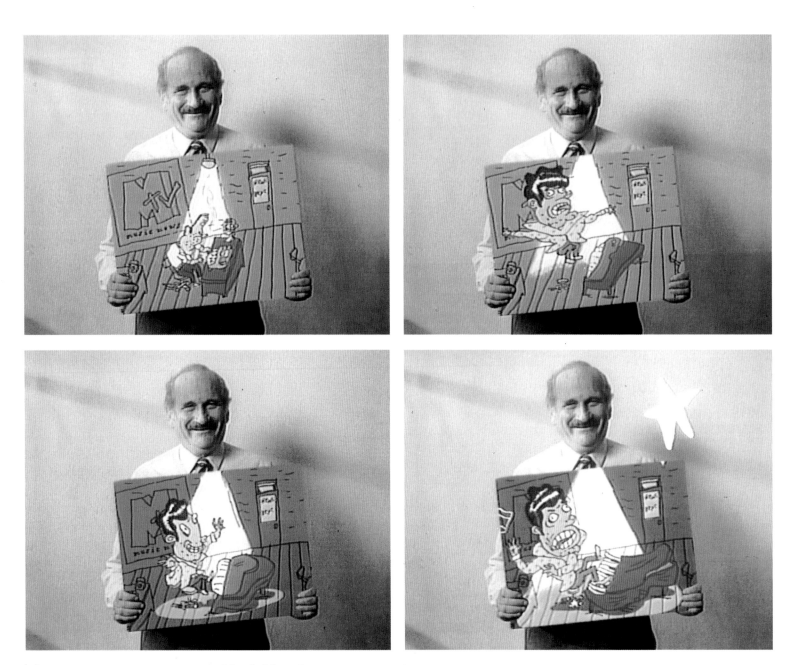

ANIMATOR
Tony Eastman

DIRECTOR
R.O. Blechman

ART DIRECTORS
Mark Marek and R.O. Blechman

CLIENT
MTV Networks

PRODUCTION COMPANY
The Ink Tank

Mark Marek

"Music News", a new program on MTV, was introduced in this film which played up the relationship between a piano and typewriter keyboards.

ANIMATOR
Tony Eastman

DIRECTOR
R.O. Blechman

ART DIRECTORS
Mark Marek and R.O. Blechman

CLIENT
MTV Networks

PRODUCTION COMPANY
The Ink Tank

Mark Marek

Blechman and Marek contrasted live action with animation for "24 Hour Rock'n Roll", a 10 minute station identification for a cable music channel.

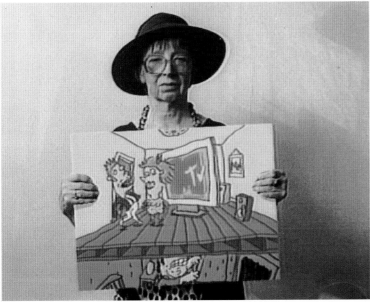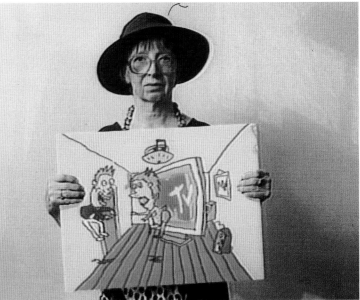

ELWOOD H. SMITH

Index

Illustrators

DANIEL ADEL, 124
52 West 76th Street #4
New York, NY 10023

MACIEK ALBRECHT, 250, 251
142 West 18th Street
New York, NY 10011

JULIAN ALLEN, 10, 11, 12, 13,
14, 15, 16, 17, 18, 190,191
31 Walker Street
New York, NY 10013

MARSHALL ARISMAN, 120, 197
314 West 100th Street
New York, NY 10025

KAREN BARBOUR, 104, 150
51 Warren Street
5th Floor
New York, NY 10007

MICHELLE BARNES, 146
111 Sullivan Street #3B
New York, NY 10012

KENT H. BARTON, 121
101 North New River Drive
Ft. Lauderdale, FL 33302

BASCOVE, 142, 143, 144
319 East 50th Street
New York, NY 10022

JAMIE BENNETT, 220
c/o Reactor Art & Design Limited
51 Camden Street
Toronto, Ontario M5V 1V2
CANADA

GUY BILLOUT, 37, 38, 39, 40, 41,
184, 185
225 Lafayette Street
Room 1008
New York, NY 10012

BARRY BLITT, 236, 237
301 Dupont #2
Toronto, Ontario M5R 1W1
CANADA

NANCY BLOWERS, 125
50 Walnut Street
Stratford, CT 06497

BRALDT BRALDS, 128, 177
455 West 23rd Street, #14B
New York, NY 10011

PHILIP BROOKER, 107
117 Palmetto Drive
Miami Springs, FL 33166

CHRISTINE BUNN, 115
681 Shaw Street
Toronto, Ontario M6G 3L8
CANADA

DAVE CALVER, 92, 140
271 Mulberry Street
Rochester, NY 14620

SEYMOUR CHWAST, 105, 194,
195, 196
c/o Pushpin Group
215 Park Avenue South
New York, NY 10003

ALAN E. COBER, 55, 56, 57,
58, 59
95 Croton Dam Road
Ossining, NY 10562

NORMAND COUSINEAU, 80
773A Champagneur
Outremont, Quebec H2V 3P9
CANADA

KINUKO Y. CRAFT, 96
c/o Fran Seigel
515 Madison Avenue
New York, NY 10022

JOHN CRAIG, 61
Route 2, Box 81
Tower Road
Soldiers Grove, WI 54655

ROBERT CRAWFORD, 158, 159
123 Minortown Road
Woodbury, CT 06798

JOSE CRUZ, 24, 25, 26, 27, 28
c/o Pushpin Group
215 Park Avenue South
New York, NY 10003

TOM CURRY, 106
302 Lake Hills Drive
Austin, TX 78733

STEPHAN DAIGLE, 208
5830 9th Avenue
Montreal, Quebec H1Y 2K2
CANADA

DICK DANIELS, 93
6404 Ballentine Avenue
Shawnee, Kansas 66203

JOHN DAWSON, 230
c/o Dawson & Dawson, Ltd.
Post Office Box 1479
Hailey, ID 83333

SANDRA DIONISI, 135
229 Montrose Avenue
Toronto, Ontario M6G 3G6
CANADA

BLAIR DRAWSON, 62, 63, 64
157 Waverly Road
Toronto, Ontario M4L 3T3
CANADA

ANDRZEJ DUDZINSKI, 94
52 East 81st Street, #4
New York, NY 10028

JOE DUFFY, 209
Duffy Design Group
701 Fourth Avenue South
Minneapolis, MN 55415

MIKE ESK, 85
c/o Canadian Business Magazine
70 The Esplanade
2nd Floor
Toronto, Ontario M5E 1R2
CANADA

MARK S. FISHER, 51
233 Ringe Avenue
Cambridge, MA 02140

VIVIENNE FLESHER, 32,
33, 147
23 East 10th Street, #1204
New York, NY 10003

DOUGLAS FRASER, 97, 138, 139
31-05 Newton Avenue
Astoria, NY 11103

KRISTEN FUNKHOUSER, 242
c/o Richard Salzman
1352 Hornblend Street
San Diego, CA 92109

NICK GAETANO, 181
c/o Harvey Kahn
50 East 50th Street
New York, NY 10022

ALLEN GARNS, 224, 225
86 West University
Mesa, AZ 85201

RALPH GIGUERE, 22, 23
322 South 11th Street
Philadelphia, PA 19107

ROBERT GIUSTI, 129
340 Long Mountain Road
New Milford, CT 06776

MILTON GLASER, 198
207 East 32nd Street
New York, NY 10016

DAVID GOLDIN, 246
111 Fourth Avenue
New York, NY 10003

ROBERT GOLDSTROM, 34
471 Fifth Street
Brooklyn, NY 11215

GENE GREIF, 90, 91
270 Lafayette Street
New York, NY 10012

MELISSA GRIMES, 66, 67
901 Cumberland Road
Austin, TX 78704

STEVEN GUARNACCIA,
202, 203
430 West 14th Street #508
New York, NY 10014

WALTER GURBO, 160, 161
208 East 13th Street
New York, NY 10003

JENNIFER HARRIS, 50
6723 Meadow Road
Dallas, TX 75230

MARTIN HARRIS, 130
4717 Nicollet Avenue South
Minneapolis, MN 55409

GARY HEAD, 156
3432 Gillham #3
Kansas City, MO 64111

DEBORAH HEALY, 186, 187
72 Watchung Avenue
Upper Montclair, NJ 07043

SANDRA HENDLER, 65, 229
1823 Spruce Street
Philadelphia, PA 19103

GARNET HENDERSON, 238
517 Bloomfield Street
Hoboken, NJ 07030

JOHN HERSEY, 44, 45
2350 Taylor Street
San Francisco, CA 94133

FRED HILLIARD, 214
5425 Crystal Springs
Bainbridge Island, WA 98110

BRAD HOLLAND, 86, 87, 88, 216
96 Greene Street
New York, NY 10012

JOHN N. HOWARD, 153, 154
336 East 54th Street
New York, NY 10022

PHIL HULING, 168, 169
33 East 22nd Street
New York, NY 10010

SETH JABEN, 183, 226, 227
54 West 21st Street
Studio 62
New York, NY 10010

RICK JACOBSON, 122
86 Gerrard Street East #20B
Toronto, Ontario M5B 2J1
CANADA

JOHN JINKS, 134
690 Greenwich Street
New York, NY 10014

JOEL PETER JOHNSON, 48
3144 Main Street
Buffalo, NY 14214

STEVE JOHNSON, 47
1219 Monroe Street Northeast
Minneapolis, MN 55413

GARY KELLEY, 78
301½ Main Street
Cedar Falls, IA 50613

Art Directors

Designers

Writers

Publications

Publishing Companies

Book Titles

Authors

Editors

About
American Illustration

American Illustration, Inc., has a Graphic Arts Weekend symposium on creativity that attracts people from all over the world. It is held in New York and features "Studio Visits" whereby students and professionals in the graphic arts field visit with illustrators, film animators, art directors and designers in their studios.

If you would like to know more about this and other American Illustration activities, or if you are a practicing illustrator, artist or student and want to submit work to the annual competition, write to:

American Illustration
67 Irving Place
New York, N.Y. 10003
(212) 460-5558

EDWARD BOOTH-CLIBBORN
President

DONNA VINCIGUERRA
Project Director

Committee Members

JULIAN ALLEN
31 Walker Street
New York, NY 10013

CAROL CARSON
138 West 88th Street
New York, NY 10024

STEVEN HELLER
New York Times
Senior Art Director
229 West 43rd Street
New York, NY 10036

DOUG JOHNSON
45 East 19th Street
New York, NY 10003

JOHN MACFARLANE
Saturday Night Magazine
511 King Street West
Suite 100
Toronto, Ontario M5V 2Z4

JAMES MCMULLAN
James McMullan, Inc.
222 Park Avenue South #10B
New York, NY 10003

GARY PANTER
505 Court Street #7J
Brooklyn, NY 11231

MARY SHANAHAN
Gentlemen's Quarterly
350 Madison Avenue
17th Floor
New York, NY 10017

ELWOOD H. SMITH
2 Locust Grove Road
Rhinebeck, NY 12572